STYLE ICONS

ARTS AND CRAFTS
MOVEMENT

STYLE ICONS

ARTS AND CRAFTS
MOVEMENT

TODTRI

A QUANTUM BOOK

Published in the United States by
TODTRI Book Publishers
254 West 31st Street
New York, NY 10001-2813
Fax: (212) 695-6984
E-mail: info@todtri.com

Visit us on the web!
www.todtri.com

ISBN 1-57717-251-5

QUMSIAC

This book is produced by
Quantum Publishing Ltd
6 Blundell Street
London N7 9BH

Printed in Singapore by Star Standard Industries (Pte) Ltd

CONTENTS

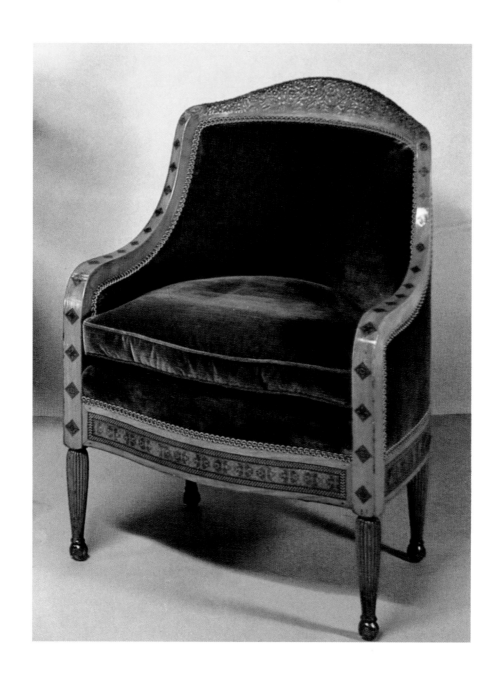

Arts and Crafts Movement

Furniture and Metalwork

INTRODUCTION

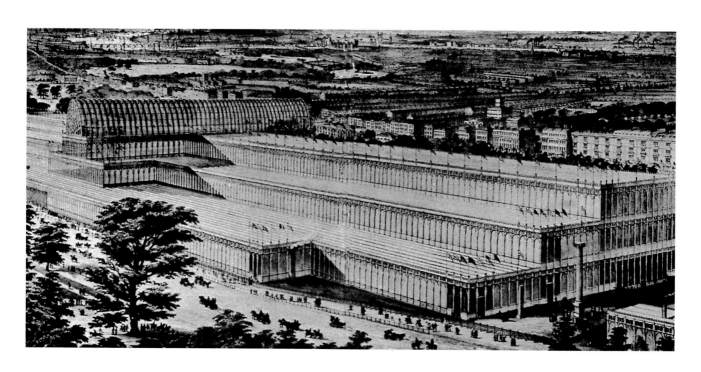

On May 1, 1851 Britain celebrated its industrial might with the opening of the "Great Exhibition of all Nations." The exhibition took place in Joseph Paxton's Crystal Palace, erected in London's Hyde Park. The glass and iron construction, some 1800ft (549m) long, 140ft (43m) high, and with a volume of 33 million cubic ft (934,000 cubic m), was erected in less than eight months.

Opposite: Joseph Paxton's innovative, pre-fabricated, iron-and-glass Crystal Palace, which housed the Great Exhibition of 1851.

Below: New machinery on show at the 1851 Great Exhibition.

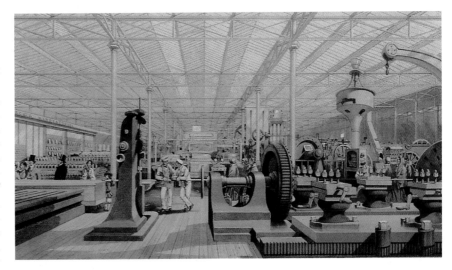

Sir Matthew Digby, secretary to the exhibition's executive committee, saw this vast undertaking as a reflection of the national character. The size of the venture represented national courage, and the nation's strength could be seen in the speed with which it was built. National wealth was displayed in the resources used in the building, and the country's intellect was symbolized by its architectural complexity. Moreover, the beauty of the Crystal Palace, according to Digby, demonstrated that "the British are by no means indifferent to the beautiful in fine arts." The building housed the work of 15,000 exhibitors, which was displayed in four categories: raw materials, machinery, manufactures, and sculpture and the fine arts. Queen Victoria summed up the exhibition's purpose in her reply to her husband's opening address. She hoped that it would "conduce to . . . the common interests of the human race by encouraging the arts of peace and industry," and that it would promote "friendly and honorable rivalry . . . for the good and happiness of mankind."

THE MISERY OF INDUSTRIALIZATION
Many of Victoria's subjects did not share her appreciation for the fruits of industry and free international trade and saw the onslaught of industrialiation as detrimental to the nation.

Since the beginning of the nineteenth century, many commentators had realized that industry had the capacity to generate wealth and misery in equal quantities. William Cobbett, writing as early as 1807, observed that the industrialized city of Coventry maintained a population of 20,000, almost one half of which were paupers. Industry had generated wealth but concentrated that wealth in the hands of a few people, serving to create "two nations."

The sense of loyalty and social responsibility that was understood to have existed between the various levels of society in the

Above: Pencil sketch of Edward Burne-Jones by Simeon Solomon, 1850.

Right: Luke Fildes, Applicants for Admission to a Casual Labor Ward, *oil on canvas, 1874.*

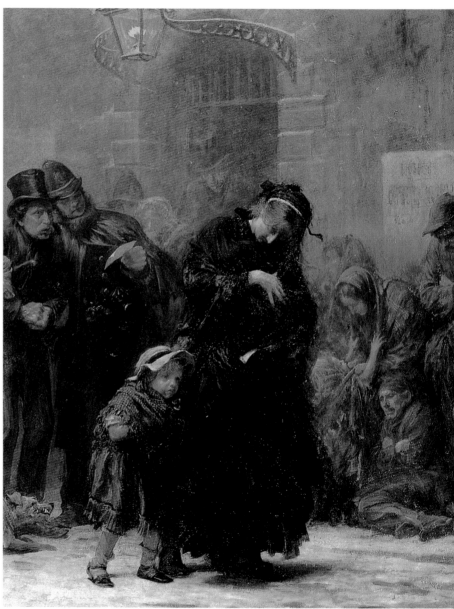

previous centuries was now absent. The creed of *laissez-faire* utilitarianism relieved the wealthy from any responsibility toward the poor. Some economists saw the conditions that Cobbett, Engels, and others described as an unfortunate but necessary evil. Social life in England was, in the eyes of many critics, gradually being undermined to generate a nation of masters and wage-slaves.

VOICES OF DISSENT
The climate of dissent in the late eighteenth and nineteenth centuries took on a variety of forms. At one end of the spectrum was the romantic, celibate "brotherhood" dedicated to art and chivalry, as conceived by William Morris (1834–96) and Edward Burne-Jones (1833–98) while at Oxford. This fraternity devoted itself to things of the spirit and determined to mask the horrors of industrialism beneath a veneer of art. At the other end of the spectrum, Karl Marx and Friedrich Engels saw within industrial society's class struggle inevitable revolution and the seeds of its own destruction. At various points between these extremes a host of other critics argued for democratic freedom and the emancipation of the industrial working classes or saw national salvation in the revival of the feudal ideals of a lost past. In many instances there was very little love lost between the factions. These dissenters, whether revolutionary or romantic, were, however, bound by the deep suspicion that was to be shared by artists and artisans of the Arts and Crafts Movement, the suspicion that society under industrialism was getting worse rather than better.

Right: William Morris pictured aged 23, when he was at Oxford.

ROMANTIC ESCAPISM
During the first half of the nineteenth century protests against the horror of the Industrial Revolution were common. The tone of these protests was often ineffectual, serving to create a means of escape from the unpleasantness of Victorian life rather than a remedy for its social ills. Aspects of some of the earlier paintings of Dante Gabriel Rossetti (1828–82) and his contemporaries and the poetry of William Morris serve as examples in which refined artistic sensibilities were used to eclipse the realities of the world. In essence, imagination afforded a romantic shelter from real life.

LITERARY CATALYSTS
Protests against industrialism attained a stronger and intellectually more coherent character in the writings of two of the most important catalysts of the Arts and Crafts Movement,

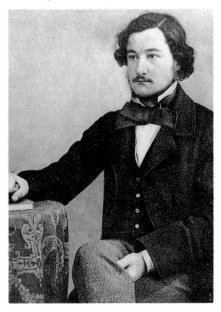

Above: The Girlhood of Mary Virgin, *by Dante Gabriel Rossetti, 1848.*

Right: Christ in the House of His Parents, *by John Everett Millais, 1850.*

Below: Thomas Carlyle, *by A. C. Armytage.*

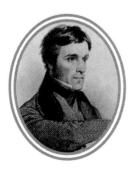

Thomas Carlyle (1795–1881) and John Ruskin (1819–1900). Both Carlyle and Ruskin were read avidly by the young Morris while at Oxford, and Ruskin in particular was to exert a strong influence on the Pre-Raphaelites, their counterparts in the United States, and on the development of the Arts and Crafts Movement on both sides of the Atlantic. Neither Carlyle nor Ruskin shared the socialist convictions of many of those active within the Arts and Crafts Movement. Both writers were conservative and Carlyle, at times, was deeply reactionary. The movement, however, gleaned from them a marked distaste for modern industrial capitalism that went beyond the sentimental and gradually began to take on a practical, philosophical form.

THOMAS CARLYLE

Carlyle's invective against the horrors of the modern age was directed at the twin evils of mechanized industrial society and the radical movements that had risen to oppose it. Utilitarianism, he said, demanded that if machinery proved a more efficient instrument of profit it should be used regardless of the consequences to less efficient human labor. Absent in both utilitarianism and its Chartist antidote was the old feudal notion of social responsibility and a sense of community explained by Carlyle in *Chartism*. The solution could be found in the restoration of a socially responsible hierarchy led by the "strong of heart" and "noble of soul." In essence, the restoration of these conditions could be found in a return to the chivalric ideals of medieval England. The restoration of these conditions would ensure that the serf would work under the paternalistic protection of the lord; labor would be dignified, and bonds of mutual cooperation would replace the chains

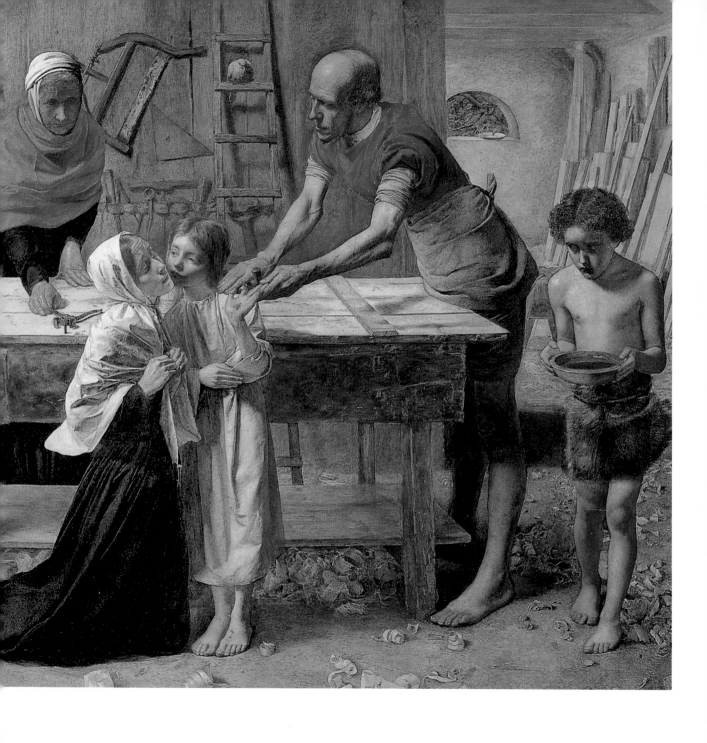

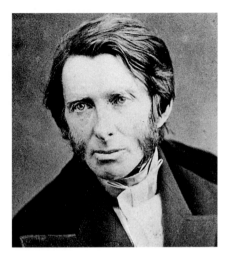

Above: John Ruskin, an early photograph.

Right: A drawing of Rouen Cathedral, by John Ruskin, c. 1850. Ruskin, whose writings on art and architecture influenced William Morris so much, was a fine amateur artist.

of industry wherein wage-slaves were bound to inanimate machines in their desperate need for cash.

JOHN RUSKIN

John Ruskin placed a similar emphasis on the value of work, in particular on the value of creative work. The "machine age," he argued, had created a division of labor in which it was impossible for men and women to find fulfillment in work. He objected to the refinement of contemporary Victorian design because it was dependent upon machinery, and machinery necessarily destroyed the creativity of human labor. Ruskin was less sentimental than many

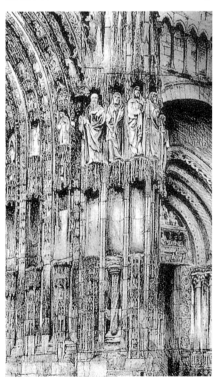

of his contemporaries about the charms of a medieval past. He nonetheless maintained that work in the Middle Ages, although hard and often unpleasant, was undertaken voluntarily by men and women, and retained its dignity.

The dignity found in simple and unsophisticated craftsmanship explains Ruskin's unbridled admiration for medieval building. He recognized the "fantastic ignorance" of the sculptors who had decorated medieval churches, and conceded the sophistication of his age in comparison to that of the past. He nonetheless saw the conditions under which medieval craftsmen worked as infinitely more wholesome than the mechanized drudgery of industrialism and maintained that it was to the spirit of this medieval model that nineteenth-century society must turn for salvation. Production, he insisted, would be for use rather than profit, and machinelike precision would be exchanged for an imperfect human finish.

A. W. N. PUGIN

One of the first architects and designers in Britain to give practical form to an antipathy for the modern industrial environment was A. W. N. Pugin (1812–52). Pugin employed an architectural style reminiscent of that of the Middle Ages. He distinguished himself from many late eighteenth- and early nineteenth-century Gothic revivalists by equating the appearance of medieval building with the spiritual refinement of the Middle Ages. The Gothic style had long been employed, either for its picturesque characteristics or as a nationalistic antidote to the international classical style. Pugin, however, maintained that Gothic was less a style than an architectural representation of Christian sentiment and was starkly contrasted to the crass and spiritually vacuous utilitarian building of his own age.

Although Ruskin and Morris dissociated themselves from Pugin (respectively for his Catholicism and his antipathy to working-class movements), the notion that art and architecture carry the capacity to redeem and improve society was an important departure in Gothic Revivalist architecture and one that was to recur in many manifestations of the Arts and Crafts Movement, both in Europe and the United States.

AMERICAN GOTHIC

Mid-nineteenth-century America began to share the European taste for Gothic architecture. In most cases American builders used the Gothic purely for its picturesque and visual

Above: A. W. N. Pugin's work in the Gothic Revival style often rivaled the original models in authenticity.

Left: Maiolica plate designed by A. W. N. Pugin, c. 1850.

Above: "The Hôtel de Ville, Paris," from A. W. N. Pugin's Contrasts, *published in 1836.*

Right: A detail of Lyndhurst, the mansion built in Tarrytown, New York, by Alexander Jackson Davis.

appearance. James Renwick Jr., for example, designer of Grace Church on New York's Lower Broadway and the Smithsonian Institution in Washington, D.C., used the Gothic with little regard for the historical associations that the style retained in Britain. Some architects, however, began to adapt and lend their own meaning to the style. The Gothic was seen by some as less pretentious than the sophisticated Greek Revival style that had dominated American building in the early nineteenth century.

Andrew Jackson Downing (1815–51), a landscape gardener and writer, saw within the Gothic style an element of honesty and practicality. The style was, he maintained, far better suited to the homespun aspirations of American citizens and could also serve to refine uneducated American tastes, cheapened by the mass-produced *objets d'art* that had flooded markets in the wake of the Industrial Revolution in the United States. Downing advocated, in some instances, the use of a more elaborate Gothic style in the design of homes for the wealthy. In general, however, he believed that good domestic American architecture could take its lead from the example set by more modest Tudor, Gothic, or Tuscan building, simple but soundly built architecture appropriate to the independent lifestyle of most rural Americans.

JAMES JACKSON JARVES
The notion of a specifically American sense of design and architecture was developed in the writings of the art collector and critic James Jackson Jarves (1818–88). Jarves, a keen collector of late-medieval Italian paintings, disliked the way in which European styles were being inappropriately used for American building to create "chaotic, incomplete, and arbitrary" architecture. Eschewing both "bastard Grecian" and "impoverished Gothic," Jarves advocated an independent path that was to be followed by architects and designers associated with the Arts and Crafts Movement in both Europe and the United States. Building, Jarves insisted, must be in harmony with its surroundings. He maintained that architecture grew out of the wants and ideas of a nation and could not be imported at will from a well of European styles and influence, be they Greek, Roman, or Gothic.

ARCHITECTURAL PROPONENTS
The development of a sense of artistic independence and the return to the commonsense values of the pioneer primarily occurred in writing rather than in shingle, bricks, and mortar. There are some exceptions, however,

Left: Rotch House, New Bedford, Massachusetts, by Alexander Jackson Davis, 1850.

Below: Trinity Church, New York, by Richard Upjohn, c. 1844–46.

including the architects Alexander Jackson Davis and Richard Upjohn. Davis, a friend of Downing, abhorred the symmetry of Greek classicism, preferring the more modest Gothic style. Two contrasting examples of his work are the large mansion Lyndhurst, built in Tarrytown, New York, and the less ambitious Rotch House, a comparatively small cottage in New Bedford, Massachusetts. Upjohn – architect of Trinity Church on New York's Broadway – contributed to a more sophisticated understanding of Gothic architecture not dissimilar to that of Pugin, seeing the Gothic style as an idiom uniquely able to communicate Christian feeling. Architecture was seen as a medium of faith.

THE DEVELOPMENT OF THE ARTS AND CRAFTS MOVEMENT

The Arts and Crafts Movement in Britain and the United States was thus built on separate

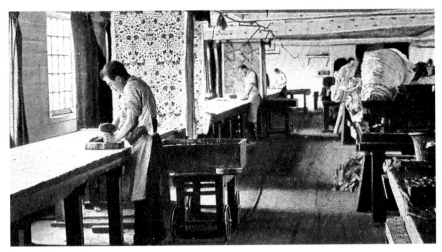

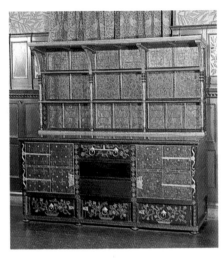

Above: According to Arts and Crafts reformers, many nineteenth-century factories utilized a "division of labor" to increase the speed of production.

Above right: A Gothic sideboard, in ebonized wood with painted and leather panels, designed by Philip Webb, c. 1862.

Below right: Josef Hoffmann, a founder of the Wiener Werkstätte, designed this elegant coffee pot.

but by no means independent cultural traditions. In Britain, the idea of a pre-industrial, medieval past articulated through the writings of Ruskin, Carlyle, and Pugin provided the British Arts and Crafts Movement with a strong sense of the artistic, moral, and social refinements of a technologically less sophisticated age. This British ideal of a feudal past has an American counterpart in the image of the pioneer. The traditions according to which the American Arts and Crafts Movement developed were those of a respect for work, independence and self-sufficiency, and the desire

to fashion a national culture remote from the fanciful notions and historical traditions of the Old World – Europe.

These two separate but linked traditions, which shared a distaste for sophistication, a strong sense of independence, and a belief in the sanctity of work – ideals embodied in the furniture and metalwork explored in this book – were respectively to determine the shape of the Arts and Crafts Movement in Britain and the United States throughout the remainder of the nineteenth century and also into the twentieth century.

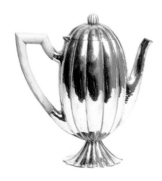

ARTS AND CRAFTS
FURNISHINGS

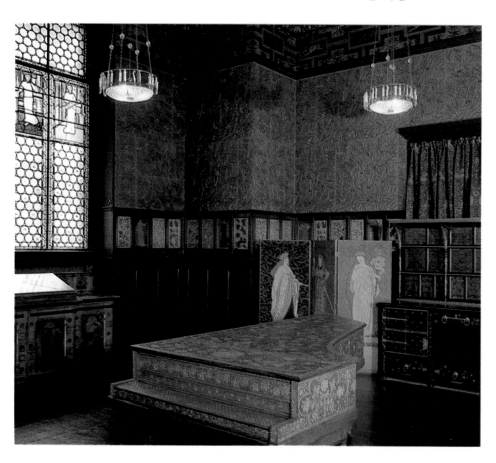

Previous page: The William Morris Room in the Victoria & Albert Museum, London. The windows are by Burne-Jones; the screen by Jane and William Morris; the piano's gesso work by Kate Faulkner; and the walls by Philip Webb.

Opposite: The drawing room at Standen; the chair with cushions in the foreground is by Morris & Co., as are the hand-knotted carpet and wallpaper.

Below: Title page from Clarence Cook's The House Beautiful, *1878, which introduced tasteful art and design to the American bourgeoisie.*

"**H**ave nothing in your homes that you do not know to be useful or believe to be beautiful," advised William Morris. Indeed, the Arts and Crafts Movement was first and foremost an effort to reform the domestic environment, and design reformers obeyed Morris by eliminating the superfluous and unsightly from their surroundings. They were single-minded in their purpose, hoping to improve living conditions and thereby also to strengthen the character of the individual.

But they differed in their approach, as there was no clear-cut path to follow in achieving their goal. Consequently, Arts and Crafts interiors vary greatly, from minute detail to overall character. They are similar in that all unite the useful with the beautiful, yet they are different, as each is a unique expression of a particular set of influences, including designer, client, time, period, location, as well as cultural milieu.

ARTS AND CRAFTS INTERIOR STYLE
An Arts and Crafts interior can best be defined by establishing what it is not. It is never pretentious or intimidating in its scale, arrangements, or textures. It shuns overly realistic patterns, shoddy craftsmanship, and imitation materials. It is not slavishly imitative in its use of historical models, nor is it overburdened with archeological motifs or classical ornamentation. It is seldom stylistically pure and, above all, it rejects the worldly trappings of its other Victorian contemporaries.

In these and other ways, the Arts and Crafts interior contrasts markedly with other Victorian examples. It is a product of the nineteenth century, yet it rejects many Victorian conventions governing esthetics, construction, and materials. For these reasons, the Arts and Crafts interior is viewed as a precursor to the Modern Movement. It illustrates the first important stage in the evolution from the nineteenth-century esthetic of conspicuous consumption to the twentieth-century argument that less is more.

AN INFLUENTIAL INTERIOR: RED HOUSE
The prerequisite characteristics of the Arts and Crafts interior were introduced by Philip Webb in Red House, Bexley Heath, in Kent, designed in 1859 for William Morris and his bride, Jane Burden. In designing this innovative structure, Webb established several fundamental principles which influenced, to one degree or another, every subsequent Arts and Crafts interior designed over the next 70 years.

The first principle demonstrated by Red House is that in form, ornament, and material each interior must be a logical outgrowth of structure and plan. The second principle is that each interior must have a distinctive character befitting its particular function, but it must, at the same time, provide a variation upon a greater theme which links room to room. The third principle is that each interior must reveal its structural components honestly. The fourth principle is that each interior must use appropriate materials with integrity, from broadest surface to smallest detail.

Besides establishing these important principles, Red House presents a striking lesson

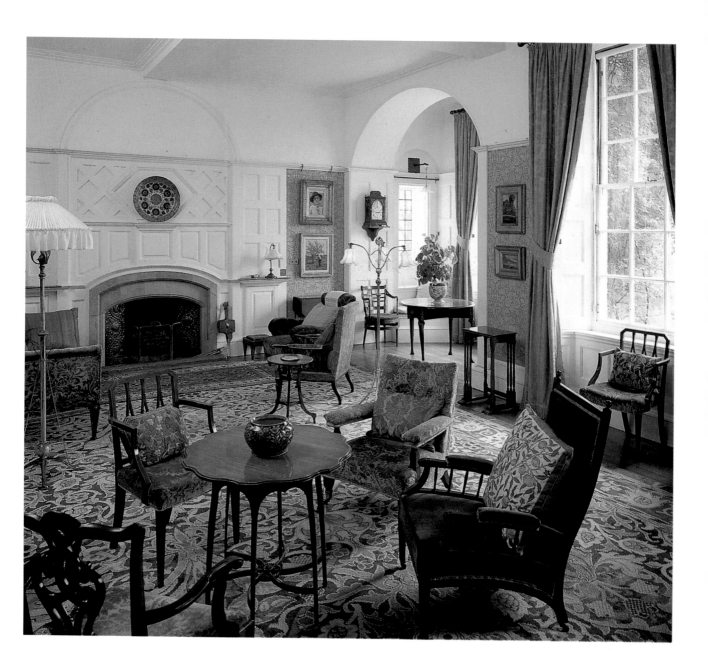

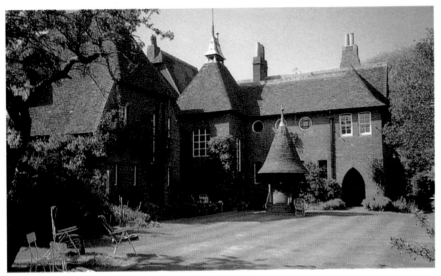

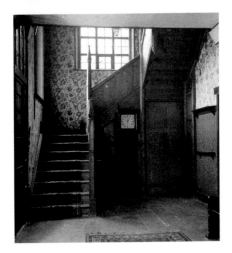

Top: Red House, Bexley Heath, Kent.

Above: The entry/stair hall, Red House.

pre-industrial look often did not incorporate much actual handwork, particularly in later years. But the ideal and symbolism were all important. From hand-sawn planks and hand-blocked wallpapers to metals pockmarked by the planishing hammer or corners enlivened by the draw knife, the surfaces of the Arts and Crafts interior highlight the skilled touch of

in the application of historical models for contemporary use. The house reflects the shared passion of both architect and client for the Middle Ages, but it does so with modified, vernacular forms and simplified Gothic ornamentation. Both form and ornament acknowledge a historical source but update its essential characteristics for use in a mid-nineteenth-century dwelling.

THE ARTS AND CRAFTS CHARACTER

Every interior of the design-reform movement has a distinctive character, determined by such factors as cultural influences and local context. They can therefore appear collectively more different than one another than similar. But they nevertheless share several commonalities regarding the use of materials, the selection of patterns and finishes, as well as the inclusion of certain planning features.

One similarity is the appearance of handcraftsmanship, although this rustic,

the artisan or craftsman. These handcrafted finishes replace the lifeless, machine-produced veneers of the Victorian era. They are testimonies to the process of "man"-ufacture and, as such, are signatures of the individual worker. They are evidence of the maker's personality which, in turn, makes an Arts and Crafts interior even more personable.

Left: "Trellis" wallpaper, designed by Morris and Webb, first produced in 1862.

Center left: The attic bedroom of William Morris's Kelmscott Manor, with green-stained furniture by Madox Brown, c. 1861.

Below: Hanging (detail) worked in silk on linen by Ann Macbeth, Glasgow, Scotland, c. 1900.

NATURAL MATERIALS

In most Arts and Crafts interiors, such handcrafted finishes appear in tandem with informal materials and textures. Rough-cut stone, rough-hewn beams, seeded glass, grainy woods, and plain-woven wools, linens, or cottons replace the polished, fragile textures associated with formal, high-style interiors. These humble, inviting materials are used in a fashion that accentuates their imperfections. They are durable and have been chosen to age gracefully. They welcome, and are enhanced by, daily interaction with the user.

While Arts and Crafts interiors glorify handcrafted finishes and informal textures, they also demonstrate a traditional approach to the construction of architectural elements and furnishings. Timbered ceilings evoke the framing techniques of the early housewright. Cut-stone floors, walls, and fireplaces demonstrate the painstaking methods of the mason. Spindled backs recall the skills of the

Right: "Evenlode" printed cotton, indigo discharged, designed by Morris and registered in 1883, the first of the Morris designs to be named after a tributary of the River Thames.

Below: An interior view of Hill House, Dunbartonshire, Scotland, designed by Charles Rennie Mackintosh, 1904.

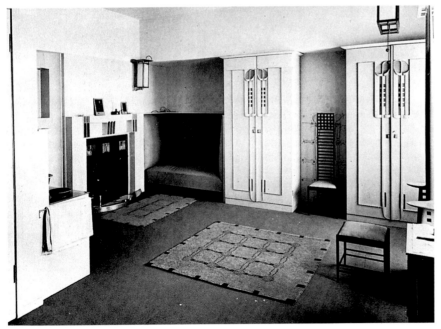

Windsor-chair-maker, and paneling, storage pieces, and seat furniture made of solid woods with exposed joints reflect the techniques of the early joiner and turner. Even the approach to ornamentation tends to be traditional: run-moldings, incised lines, chip-carving, or painting add interest to surfaces when structural polychromatic or integrated patterns are not already sufficient. In Arts and Crafts interiors, the forms of elements and furnishings might be progressive in their suave simplicity, but the manner in which they are wrought, assembled, and embellished is nevertheless often retrospective.

DECORATIVE MOTIFS

Their provincial sympathies are exemplified by the decorative motifs found on surfaces, textiles, furnishings, and objects: many are of humble origin, associated for generations with the folk tradition. The decorative vocabulary consists of simple, geometrical shapes and conventionalized natural motifs, used individually or as repetitive patterns or borders. Popular devices include the tulip, rose, leaf, and bird. But chief among these is the heart, which appears on forms as diverse as leaded glass by Will Bradley, cupboards by Charles Rennie Mackintosh, chair backs by C. F. A. Voysey, and firedogs by Ernest Gimson.

Justifications for the popularity of these folk motifs are at least threefold. Firstly, they are compatible stylistically with the provincial nature of many Arts and Crafts designs. Secondly, they are as simple and direct in form as are the shapes and surfaces that they embellish. And thirdly, they evoke the positive, homely virtues that design reformers hoped to restore to daily life. But they are by no means used in a simplistic fashion: rather, they are manipulated in a sophisticated

manner which belies their humble origins. In the hands of an accomplished designer, they assume an air of calculated *naïveté*.

Equally sophisticated are the patterns that are derived from natural sources and are often regional in their character. Morris's distinctive chintzes, wallpapers, and carpets immortalize the wild flowers and vegetation growing along streams and in country gardens in southeastern England. Mackintosh's sinuous wall stencils and embroideries provide variations upon the traditional Glasgow rose, which flourishes in Scotland's gray, damp climate. Frank Lloyd Wright's stained-glass windows, lighting fixtures, and carpets capture with angular precision the essence of weeds, seed pods, and trees growing wild on the prairies of the American Midwest. And Candace Wheeler's appliqués

and tapestries transform in subtle tone-on-tone the thistles, pine cones, ivy, and shells of the northeastern United States. All of these have a freshness and originality that results from a close observation of nature. But, by virtue of color, composition, scale, and modeling, they are transformed from the commonplace into the extraordinary.

CREATING WARMTH AND LIGHT

In dimension, Arts and Crafts interiors range from grand to modest, yet all are inviting and approachable. Such qualities are the combined result of finishes and furnishings, but they are due as well to conventions regarding fenestration and planning. Like the interiors of the late Middle Ages, or those of the Elizabethan age, Arts and Crafts interiors express a desire

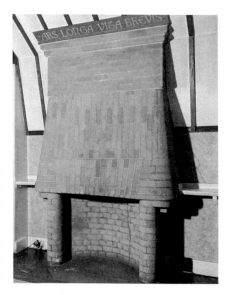

Above: A fireplace in an upstairs drawing room, Red House, Bexley Heath, by Philip Webb, 1859–60. In shape, this fireplace resembles those found in medieval castles.

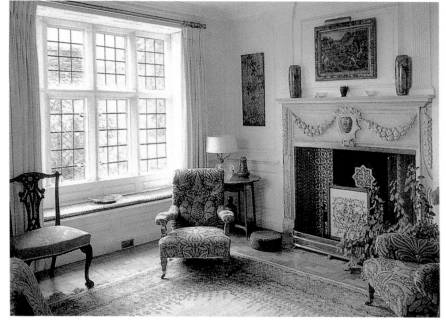

Left: The drawing room at Kelmscott Manor. The armchairs are covered with "Peacock and Dragon," a woven woolen fabric designed by Morris.

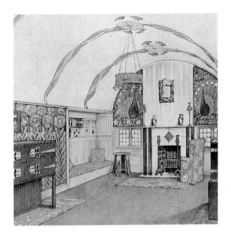

Above: A design for a living room by M. H. Baillie Scott, 1911.

Right: An artist's impression of a dining room, published in The Craftsman *by Stickley's United Crafts, 1904.*

for light and warmth. In pursuit of such attributes, architects identified as priorities the size, shape, and placement of windows and the location of the fireplace, the focal point within most spaces.

THE INGLENOOK

The fireplace was the hub of domestic activity, and its stature as such was frequently augmented by structural furnishings or fireside windows. Known as an inglenook, this enclosed fireplace bay became an intimate room-within-a-room. Its coziness was often accentuated by a lowered ceiling or raised floor level. The importance of the inglenook as an Arts and Crafts planning feature was recognized by the German architect and critic Hermann Muthesius, who traced its origins to Anglo-Saxon homes in his influential book of 1904–5, *The English House.*

The treatment of the inglenook varies, but it can be found in "reformed" interiors throughout Europe and America. It appears in cottages and country estates designed by C. F. A. Voysey; in the Prairie-style homes and "Craftsman" bungalows of Frank Lloyd Wright or Gustav Stickley; in the Esthetic or Colonial Revival interiors of the northeastern United States; and in the Glasgow-style rooms by Mackintosh and his American emulator Will Bradley. The inglenook is a ubiquitous feature in entrance halls, stair halls, drawing rooms, and dining rooms. It serves both a practical and a decorative purpose, but, above all, it is significant for its symbolic connotation: it is the heart of the Arts and Crafts interior and is often located at the center of the plan. Its symbolic importance may explain the prevalence of the heart-shaped motif on the hoods, implements, and furniture used in its proximity.

CEILINGS AND FRIEZES

The intimate atmosphere of the Arts and Crafts interior is often determined by the ceiling, which is purposefully lowered or detailed to accentuate the horizontality of the room. A lowered ceiling is often complemented by an ornamental frieze, a decorative horizontal strip defining the upper third of the wall. The frieze is frequently painted with a narrative mural or a large-scale repetitive border, but it might just as often be covered with stenciling or wallpaper to distinguish it from the wall surface below. In the nursery, it might include a motto or inscription, carefully selected to mold the character of the room's youthful occupant. The

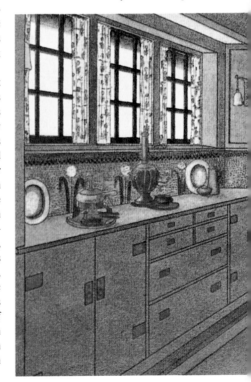

frieze in such cases becomes a permanent work of art, integrated into the very structure of the building's interior.

The frieze may, on the other hand, be plain, to contrast with built-in furniture, fabric, wallpaper, or paneling below. A plain frieze is often trimmed with a picture molding, plate rail, or shallow ledge used to support small watercolors or prints, ceramics, or carefully selected *bric-à-brac*. Defined by the frieze, these decorative elements appear as an extension of the interior architecture rather than as distracting foreground clutter. The plain frieze can have a practical purpose as well: Voysey advocated the use of a light-colored frieze to reflect

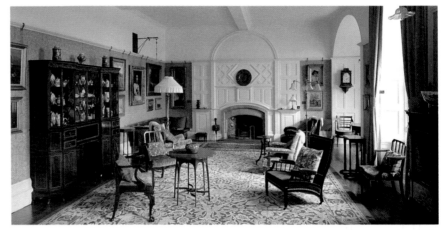

natural daylight. Others, such as Wright, extended a frieze of uniform width from room to room to establish visual continuity throughout a structure.

A UNIFIED ENSEMBLE
Such continuity is perhaps the most striking and, indeed, the most universal aspect among interiors of the design-reform movement. Finishes, textures, patterns, and other elements might vary according to the demands of a client, but the architect always strove to unite the interior from large scale to small. Each was viewed as an ensemble, to be coordinated from background to furnishings to accessories. A unified result depended on the sensitive eye of the designer, who had to pay attention to every detail of the interior while orchestrating the whole.

Despite such commonalities, Arts and Crafts interiors differ greatly in overall appearance. They range from subtle to brilliant, from Spartan to crowded and overstuffed, and from eclectic to stylistically pure. They express a universal quest for logic, unity,

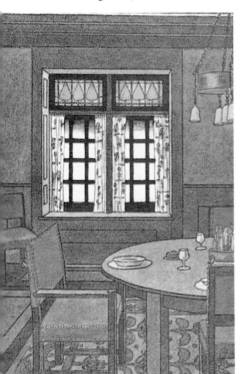

Above: The drawing room, Standen, Sussex, by Philip Webb, 1892–94.

Below: The dining room of the Palais Stoclet, designed by Josef Hoffmann and incorporating marble veneers and mosaics by Gustav Klimt.

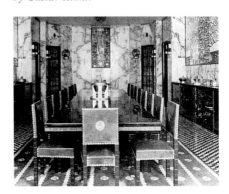

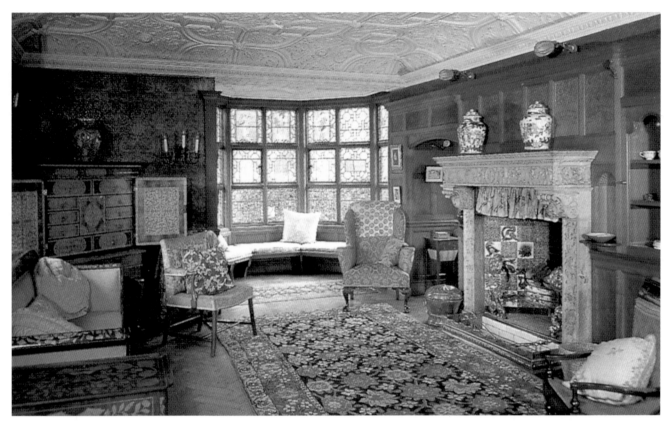

Above: The drawing room, Wightwick Manor, Staffordshire, by Edward Ould, 1887. The heaviness of the interior architectural features is counteracted by the products from Morris & Co., eighteenth-century antiques, and oriental porcelains.

honesty, and integrity in design, yet each presents a personal interpretation of usefulness and beauty.

THE USE OF COLOR
Color, as one component of beauty, is treated variously by Arts and Crafts architects and designers. Voysey, M. H. Baillie Scott, Carl Larsson, and Bradley include large blocks of vivid color to define interior planes boldly. Others, such as Mackintosh or Josef Hoffmann, utilize an achromatic palette of whites, grays, and blacks enlivened with strategic touches of brilliant color. Another group offers a conservative approach: Philip Webb, Edward Ould, Stanford White, and Henry Hobson Richardson incorporate chintzes, wallpapers, or oriental rugs as subtle, multicolored accents. The majority, however, eliminate bright color altogether, choosing instead to emphasize the dull tones of structural materials, such as wood, stone, brick, plaster, metal, or leather.

TEXTILES
Like color, textiles are partially responsible for the usefulness and beauty of an Arts and

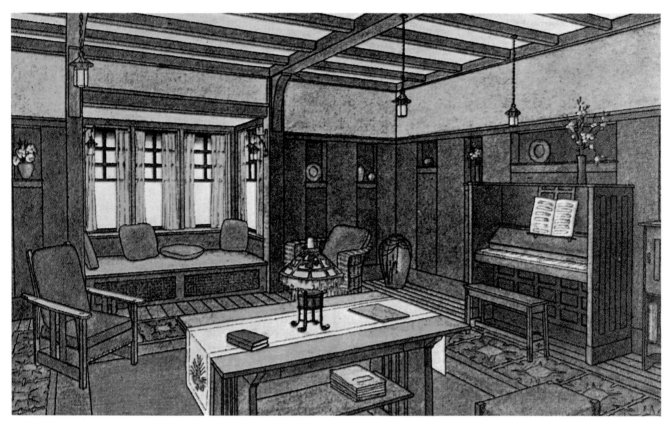

Crafts interior. In some interiors, every form is padded and every surface draped, while in later interiors and those designed by architects fabric and cushioning are kept to a minimum. The relative presence or absence of those elements affects profoundly the overall character of the room.

In some Arts and Crafts interiors, textiles are utilized as they had been throughout the nineteenth century. Comfortable seating pieces display buttons, tufts, and trims, while draperies hang at the windows. Tapestries line walls above the dado and patterned rugs cover the floor. Lambrequins adorn mantels, and cloths extend from table top to floor. As a result, the features of the room and frames of seat furniture are obscured rather than exposed. Textiles used in so generous a manner are particularly evident in Arts and Crafts interiors in England, Scandinavia, and the United States. They are especially prominent in interiors furnished by enterprises having a vested interest in their use, such as Morris & Co., Liberty & Co., and Associated Artists.

What distinguishes these draped and upholstered interiors as products of the Arts and

Above: A Craftsman living room, illustrated in The Craftsman.

Right: An interior of the Kaufmann House by Frank Lloyd Wright, 1936.

Opposite page, bottom: An interior of Frank Lloyd Wright's house, Taliesin, built in 1911.

Crafts Movement are the woven or printed patterns that they contain. The patterns are modeled subtly and appear relatively flat to emphasize the flatness of the planes which they cover. They tend to be stylized and carefully composed, in contrast to the undulating, naturalistic patterns of the Victorian age. Such stylization discourages the impression conveyed by large-scale, realistic patterns – that the user is sitting or walking upon living specimens of flowers or foliage.

ALTERNATIVES TO TEXTILES

In contrast to such interiors, with their softened edges and curvilinear forms, are those that eliminate textiles wherever possible. In these relatively ascetic spaces, leather panels replace fixed upholstery, and trimmings of any sort are kept to a minimum. Stained-glass windows substitute for draperies to screen unwanted views or to filter natural daylight, and area rugs are placed selectively (if at all) on otherwise bare floors. These interiors reveal unabashedly every angle, plane, and edge. In character, they contradict the more modest, "feminine" esthetic characteristic of the Victorian era.

These stark, "reformed" interiors, designed by the Greene brothers, Wright, Stickley, Gimson, Hoffmann, and others, present a strict interpretation of usefulness and beauty that thrives upon eliminating every superfluous detail. By restricting the excessive use of textiles, they have established a precedent that has continued to be influential today. They are regarded as functional and protomodern, in contrast to other Arts and Crafts interiors that utilize fabric in a more generous fashion.

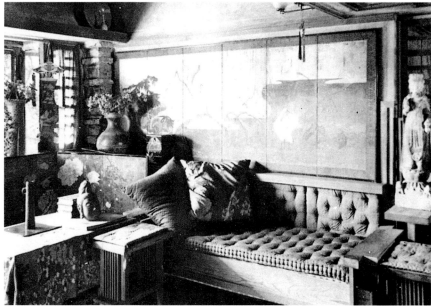

Below right: Dining room, general interior, Gamble House, Pasadena, California, by Charles Sumner Greene and Henry Mather Greene, 1908. Interiors by the Greene brothers contain influences ranging from vernacular to oriental. Each element is crafted allowing the exposed joinery to assume a decorative role.

THE INFLUENCE OF OTHER STYLES

During the life span of the Arts and Crafts Movement, this varied approach to the use of color and textiles reflected the influence of other styles and movements then in vogue. Some had little impact on Arts and Crafts interiors, while others affected everything from color and texture to form and motif to broader issues of planning and arrangement. Among these were the Gothic Revival and High Victorian Gothic styles, the Old English, Queen Anne, Colonial, and Georgian revivals, as well as national Romanticism and the English Domestic Revival Movement.

Such influences caused some design reformers to take an eclectic approach, assembling interiors that incorporated vestiges of several contemporaneous styles. But other designers regarded such stylistic eclecticism as antithetical to the goals of the Arts and Crafts Movement. They elected to pursue a purer approach which included only the slightest trace of any outside influence.

The presence of these influences demonstrates that Arts and Crafts interiors were not created in isolation. All were products of the nineteenth century, and, as such, could not escape the dual stronghold of revivalism and eclecticism that had dictated the evolution of style during the late eighteenth and nineteenth

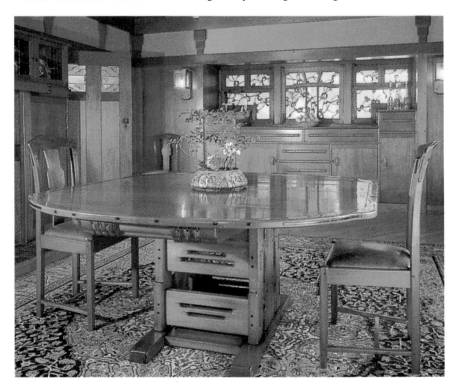

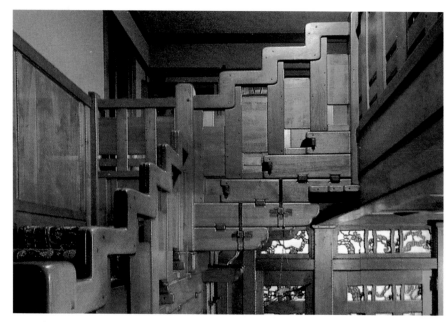

Left: The entry/stair hall, Gamble House, Pasadena, California, by Charles Sumner Greene and Henry Mather Greene, 1908. Sculptural in finish and presence, the staircase is exquisitely crafted. The continuous mouding that defines the treads and risers resembles the trim on a Japanese hako-kaidan, or stairway chest.

centuries. Nor could they resist the beckoning of more progressive trends, such as the Art Nouveau style, the *Jugendstil,* or that of the Secessionist Movement. These diverse influences infused the interiors of the design-reform movements to different degrees, depending on the stylistic proclivities of architect, designer, and client.

STYLISTIC ECLECTICISM

Such stylistic eclecticism is illustrated by Arts and Crafts interiors that combine medieval architectural features with Jacobean wainscoting, oriel windows, and elegant furniture reminiscent of Hepplewhite and Sheraton. In others, the forthright forms of joiner and turner coexist with pseudooriental finishes and sinuous Art Nouveau ornamentation. Still others explore the "greenery-yallery" color schemes, cluttered arrangements, and oriental

bric-à-brac promoted by the Esthetic Movement. And in the northeastern United States, some "reformed" interiors blithely mix Morris chintzes and Colonial antiques with Mission-style furnishings, Japanese fans, and peacock feathers. Even the idiosyncratic interiors of Mackintosh or the Greene brothers include Chinese porcelains or oriental rugs. As in all interiors, these seemingly disparate elements provide a striking contrast of age and culture which serves to enrich the whole.

The Arts and Crafts Movement strove to improve life by simplifying the home and work environment, but it presented more options than restrictions to those wishing to achieve that goal. Design reformers consequently interpreted its principles broadly and, as a result, the interiors of the design-reform movement are often more challenging to analyze than their more conservative contemporaries.

CONFLICTING INTENTIONS

The complex character of the Arts and Crafts interior can perhaps be attributed to the fact that it expresses conflicting intentions: it reflects a nostalgia for attributes from the past, while it values a fresh perspective and an original approach. It seeks to provide an environment that is both warm and comfortable, but it argues convincingly that each interior must be efficient and easy to maintain. It incorporates whimsy and subtle humor, expressing a *joie de vivre* and an appreciation of the simple things in life, but it never forgets its mission nor its sobriety of purpose. It provides a congenial background for handiwork and other personal touches, but maintains that a spare, uncluttered atmosphere alone provides quiet and repose. Such dualities reflect its pivotal position in the history of design. It embraces the time-honored achievements of the past yet it anticipates the accomplishments of the Modern Movement.

Right: A modern reconstruction of an American Shaker interior.

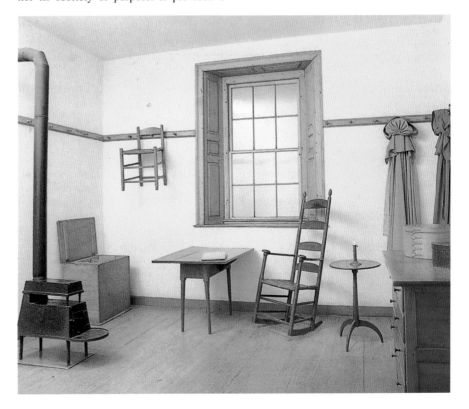

ARTS AND CRAFTS
FURNITURE

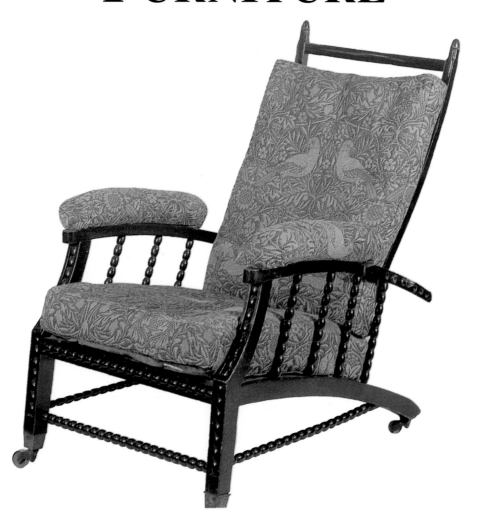

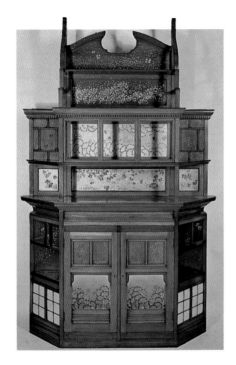

An ideal of furniture made for beauty's sake as much as for use united Arts and Crafts achievement in this complex area. Architects, designers, and craftsmen throughout Europe, as well as the United States, were preoccupied with the production of furniture that would play both a symbolic and a practical role in the domestic environment.

The resulting plurality of style and intention, characteristic of the whole range of Arts and Crafts production, defies simple definition. Furniture was made not only in response to changing values but also to specific needs, so that the work of Scandinavian designers, for example, is very different from that of their Viennese counterparts. Social concern could be described as one common factor, but there was no common consensus to show how that concern might be demonstrated in the design of tables and chairs, sideboards, and settles. An ideal of the past and the significance of tradition also played an important role, but again we should ask ourselves: "Whose past and what traditions were relevant to designers at the turn of the century?"

RED HOUSE

When William Morris invited his friend and colleague Philip Webb to design his first home, Red House, in 1859, the issues were more clear cut. Morris's youthful idealism had been determined by Romanticism in art and literature and by the Gothic revivalists' rejection of the machine age. The furniture that Webb and his colleagues designed for Red House represented an early attempt to create "the blossoms of

Previous page: A chair produced by Morris & Co. in ebonized wood and tapestry.

Above: A mahogany cabinet by E. W. Godwin and J. A. M. Whistler, c. 1878.

Right: A wall cabinet designed by Philip Webb, c. 1861–62, and painted with scenes from the life of St. George by William Morris.

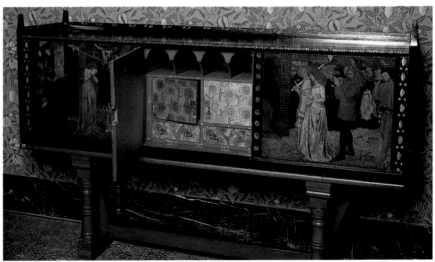

the art." Webb produced solid tables in oak, and additional furniture was designed on commission by others in those early years. The medieval inspiration was lauded when the Morris exhibit was awarded two gold medals at the International Exhibition of 1862. The jury reported: "The general forms of the furniture . . . and the character of the details are satisfying to the archeologist from the exactness of the imitation, at the same time that the general effect is excellent."

WARINGTON TAYLOR

It is interesting that the first person who seems to have felt some concern about the cost and elitism of such commissions was not William Morris but Warington Taylor, the business manager of Morris & Co. ("the Firm"). In 1865 Taylor told Webb: "It is hellish wickedness to spend more than 15/- on a chair when the poor are starving in the streets." What was needed, he wrote, was "moveable furniture . . . something you can pull about with one hand. You can't stand fixtures now that there are no more castles."

It is claimed that Taylor introduced the now familiar rush-seated "Sussex chair" to the Firm, variants of which remained in production for many years. He also introduced the "Morris easy chair" with an adjustable back. It is significant that he had found examples of these in the workshop of a Sussex carpenter, for

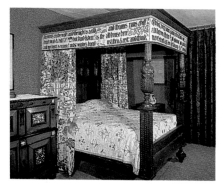

Above: Morris's bed at Kelmscott Manor, with hangings and cover designed by May Morris in about 1893.

Left: The "Sussex chair," a rush-seated armchair of ebonized beechwood adapted by Webb from a traditional model.

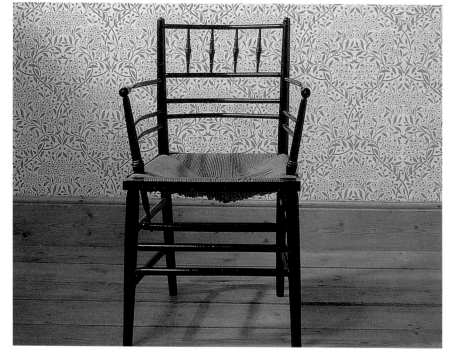

Right: A "Morris" adjustable-back oak armchair, adapted by Webb from a "Sussex" type in about 1866.

Below: A "Sussex chair" designed by Morris & Co. in 1866.

Bottom right: An oak center table made by Morris & Co. This design is attributed to Philip Webb and George Jack. It was designed in the 1880s or early 1890s.

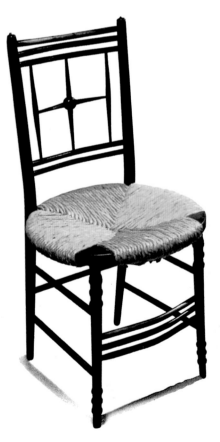

variants of vernacular or folk furniture were to form a major part of Arts and Craft production, especially in Scandinavia, where the peasant dwelling rather than the medieval palace was to be the primary source of inspiration. Taylor was not totally scathing about his employers' efforts, however, for he approved of the fact that their furniture had no style: "It is original, it has its own style: it is in fact Victorian."

MORRIS & CO.'S FURNITURE

As Morris became more preoccupied with wallpaper and textile design, he tended to delegate furniture commissions to his colleagues, and, in the 1880s, when George Jack, Mervyn Macartney, and W. A. S. Benson were involved in this area of the Firm's production, the furniture became more Georgian than Victorian, in keeping with the taste of their patrons, most of whom were drawn from the ranks of the upper-middle classes. Madox Brown, however, the Pre-Raphaelite painter who was one of the Firm's founder members, produced a range of "working men's" bedroom furniture, designed so that it could be copied by local carpenters and artisans.

THE CENTURY GUILD

Following the Morris precedent, several architect/designers set up their own enterprises in the 1860s and 1870s. The architect Arthur Heygate Mackmurdo, for example, established his Century Guild in 1882, designing furniture, as well as fabrics which were made for him by specialized firms. His furniture was eccentrically stylized, its essentially conventional forms frequently embellished with a fretwork motif of undulating lines. His dining chair is his most familiar design, perhaps because it has been so frequently categorized and

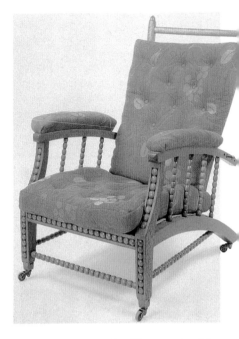

illustrated as proto-Art Nouveau (a claim which Mackmurdo would have rejected).

GIMSON AND BARNSLEY

The Century Guild was disbanded in 1888, but an equally short-lived group was to lead the establishment of a workshop which had

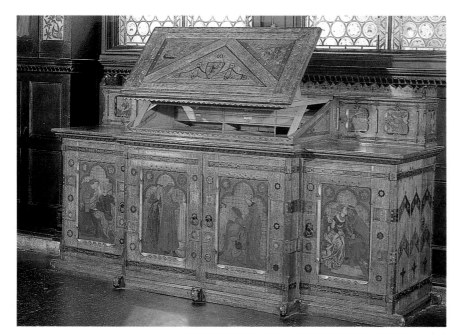

Left: An oak cabinet designed by J. P. Seddon and decorated with scenes from the honeymoon of King René of Anjou by Madox Brown, Burne-Jones, Morris, and Rossetti, 1862.

Below: An oak writing desk by A. H. Mackmurdo, c. 1886.

a far more lasting influence on ideals for Arts and Crafts furniture. Kenton & Co. was founded in 1890 when several young architects, including W. R. Lethaby, Ernest Gimson, Mervyn Macartney, Sidney Barnsley, and Reginald Blomfield, set out, in the words of Blomfield, "to produce the best possible

furniture of its time, with the best materials and the best workmanship." Although this enterprise was forced to close through lack of capital in 1892, Gimson and Barnsley went on to set up on their own in rural Gloucestershire, thus establishing a dynasty of designer/craftsmen in furniture and proving against all odds that the English craft ideal could be reconciled with financial survival.

Gimson's furniture, in fact, epitomizes the craft ideal of "honest workmanship." He is perhaps best known for his rush-seated chairs, so similar to Shaker designs, which draw directly on a vernacular tradition. But he also produced exquisite cabinets inlaid with mother-of-pearl, silver, and ivory, made from native woods such as oak, elm, yew, and walnut. This work, of course, replaced the earlier painted furniture of Webb and Morris

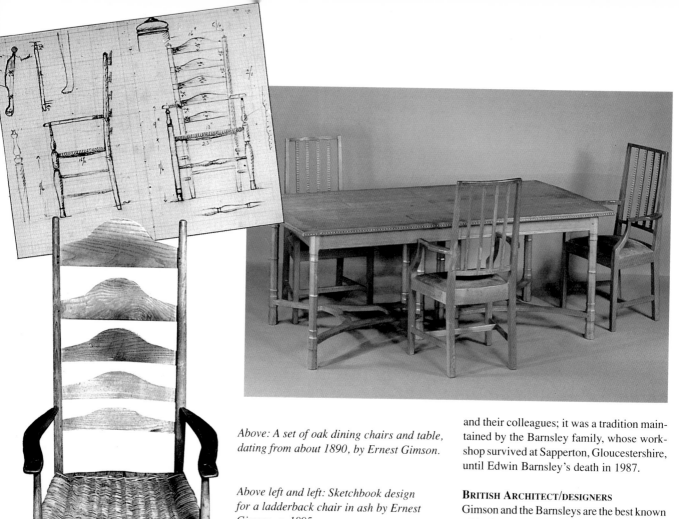

Above: A set of oak dining chairs and table, dating from about 1890, by Ernest Gimson.

Above left and left: Sketchbook design for a ladderback chair in ash by Ernest Gimson, c. 1895.

and their colleagues; it was a tradition maintained by the Barnsley family, whose workshop survived at Sapperton, Gloucestershire, until Edwin Barnsley's death in 1987.

BRITISH ARCHITECT/DESIGNERS
Gimson and the Barnsleys are the best known of the British designer/craftsmen who specialized in furniture production. Most Arts and Crafts furniture was designed by architects, either to supplement their incomes or to complement the houses they created. C. F. A. Voysey, for example, conceived his houses as "total design," aiming to supervise the design, or design himself, every item of their furnishing. His furniture, like his architecture, is deceptively simple and understated – "poor people's furniture for the rich," according to the claims of the more cynical.

Edwin Lutyens and, above all, Baillie Scott designed or conceived furniture and interiors for "dream houses" which were internationally admired and emulated, representing an ideal of domesticity that struck a chord among the middle classes throughout Europe and the United States.

SCANDINAVIAN ARTS AND CRAFTS FURNITURE

The home was also the focus for an ideal of design and craftsmanship in Sweden at the turn of the century. Ellen Key, the Swedish sociologist and esthetician, expounded the principle in her book *Beauty for All* in 1897: "Things must . . . fulfill their purpose in a simple and expressive manner, and without this they do not achieve beauty even if they satisfy practical requirements."

Sweden was the most industrialized of the Scandinavian countries in the nineteenth century and had promoted schemes for design reform since the 1840s. These reform schemes were coordinated by the Swedish Society for Craft and Design (Svenska Slojdforeningen), which was launched in 1845. With its motto "Swedish handicraft is the father of Swedish independence," Svensk Form (as it is now known) concentrated on essentially practical programs which encouraged self-sufficiency in local industries and enterprises.

By the 1890s, when the "renaissance" associated with Art Nouveau, as well as with the Arts and Crafts Movement, was spreading throughout Europe, Sweden already had an established tradition of design reform on which to draw. It also had a surviving tradition of local or vernacular craftsmanship, especially in the textile and furniture industries, a tradition which was studied and preserved in museums and art schools. As far as the

Left: A round oak table by Heal & Sons, London. Heals retailed furniture to the middle classes.

Below: "Brita's Forty Winks," illustration for Ett Hem *by Carl Larsson, 1899.*

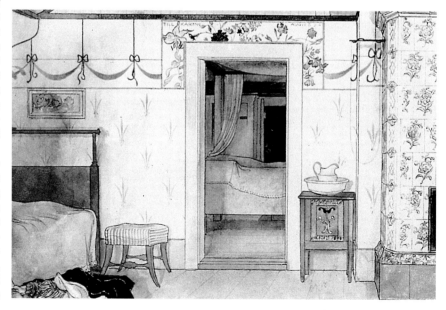

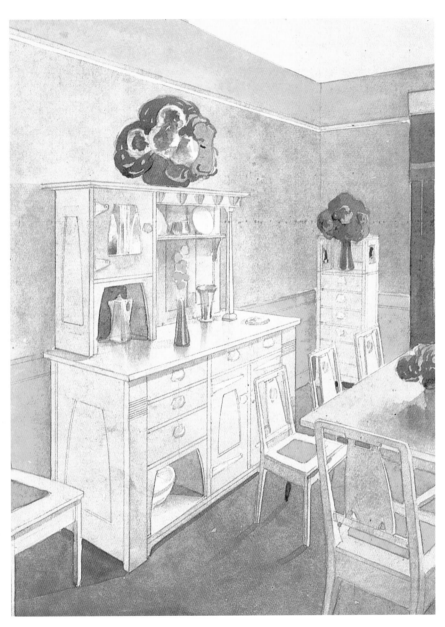

country's furniture production was concerned, local light industries, such as those in the province of Smaland, were able to maintain their output of low-cost and unpretentious designs for the domestic market.

CARL LARSSON

One house in particular provided a focus for Swedish domestic ideals in the 1890s: the country home of the painter Carl Larsson, Sundborn. One summer, Larsson painted his house and family; these watercolors were exhibited in the Industrial Exhibition in Stockholm in 1897 and aroused so much interest that they were published in a book two years later. *Ett Hem* [*A Home*] set the style for a generation. Larsson's 'best' furniture dated from the eighteenth century, whereas the workaday furniture could have been produced on his own estate. It was these simpler objects which attracted the interest of Swedish furniture designers. Carl Westmann, for example, designed furniture in the spirit of *Ett Hem* and, like Eric Josephson, produced designs for "workers' furniture."

CARL WESTMANN AND ALF WALLENDER

Westmann was one of the most prolific furniture designers during this period and, besides drawing on vernacular traditions, was also obviously influenced by the work of the British, Belgians, and Viennese. Alf Wallender, who is probably best known for his work in ceramics for Rorstrand, also designed simple furniture which was exhibited in workers' institutes, as well as more elaborate pieces for private commissions.

CARL MALMSTEN

Carl Malmsten, the winner of several prizes in a competition for furniture for Stockholm's

town hall, set up his own workshop and embarked on a prestigious and controversial career as a furniture designer. He produced experimental pieces as well as luxurious, inlaid cabinets, but also concentrated on simple designs in the craft tradition, work which was celebrated in the 1950s when 'Swedish Grace'enjoyed international prestige.

FINNISH FURNITURE

Within the context of Scandinavian developments, the Finnish interpretation of Arts and Crafts ideals was unique. Finland had been part of the Swedish Empire until the beginning of the nineteenth century, when it came under the jurisdiction of Russia. Toward the end of the nineteenth century, however, the Finns began to discover their identity. The Friends of Finnish Handicraft was established in 1879 and the country's architects and designers also looked to folk architecture.

At the Paris World Fair of 1900, the Finnish Pavilion, which included work by Louis Sparre (who was, in fact, Swedish), was awarded several medals. Before working on the World Fair pavilion, Sparre had produced designs for "Finnish-style dining-room furniture" and in 1897 had set up the Iris Workshops in Porvoo for the production of textiles, ceramics, and furniture. Sparre

Opposite: An interior by Louis Sparre, Finland, c. 1903.

Below left: A white-painted table by Charles Rennie Mackintosh, Scotland. Elegant and innovatory designs such as these were highly acclaimed on the European continent; they were considered "decadent," however, by the traditionalists of the English Arts and Crafts Movement.

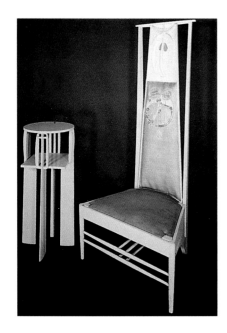

Above: A table and chair with stenciled canvas back by Charles Rennie Mackintosh, c. 1901.

Right: An armchair veneered in amboyna wood, designed by Koloman Moser, 1904.

designed the "Iris" furniture which was marketed in Finland and St. Petersburg, Russia.

HVITTRASK

One of the most celebrated special architectural commissions in Finland was Hvittrask, buildings by Saarinen, Gesellius, and Lindgren, used as studios and homes for their families. Hvittrask was furnished throughout with designs by the trio and Sparre. Saarinen designed all the furniture for the main building; the chairs in the living room and dining area are based on traditional prototypes, while the bedroom furniture was obviously inspired by the work of the Scottish designer Charles Rennie Mackintosh.

VIENNA SECESSION FURNITURE

Mackintosh's work caused a sensation in Vienna when it was exhibited at the Vienna Secession Exhibition of 1900. The impetus for the formation of the Wiener Werkstätte in 1903 was certainly based on the English precedent and Josef Hoffmann's "manifesto" for the workshops has a distinctly Arts and Crafts

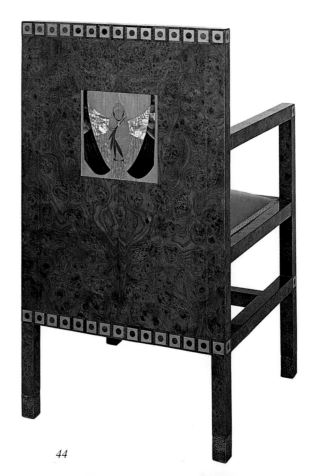

ring: "Our point of departure is purpose: utility is our prime consideration." How far Vienna Secession furniture and design can be defined as Arts and Crafts is debatable, however.

Koloman Moser, for example, designed some of the most luxurious pieces associated with the group. His magnificent cabinets, with their elaborate veneers and inlays, belong to the grand traditions of cabinet-making. His more starkly geometrical designs, however, many of them in black and white, are innovative and iconoclastic.

Adolf Loos, the architect, designer, and polemicist, loathed the elitism that came to be associated with Vienna Secession work. The furniture he designed was unpretentious and functional, demonstrating his understanding of the nature of materials and the relationship of material to form. These qualities can be related to the machine, as well as to craft production, and it is significant that Loos used Thonet bentwood chairs in several of his commissions. One of the first was for the Café Museum in Vienna in 1899: the tables have solid bentwood bases and marble tops; his billiard table has brass fittings, a device he frequently employed to protect chair legs; and the chairs are standard designs by Thonet.

THONET BENTWOOD CHAIRS

Thonet bentwood chairs had been in production since the 1840s, when Michael Thonet took out his first patents for bending and reshaping strips of wood. In the 1850s the firm began to expand and by the end of the century Thonet had become a household name: its

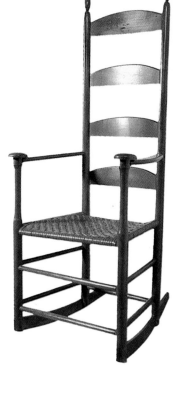

Above: A nineteenth-century Shaker chair. Shaker furniture anticipated many of the concerns of the Arts and Crafts Movement in the United States.

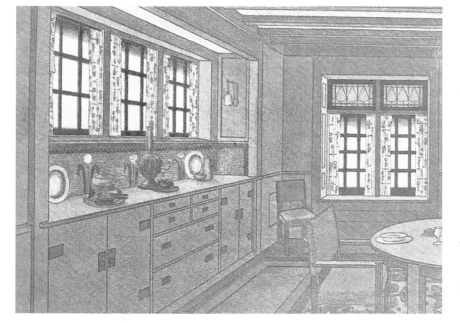

Left: "A Craftsman Dining Room," as featured in The Craftsman, *U.S.A., Gustav Stickley, c. 1904. "Craftsman" interiors were designed to combine easily mass-produced fittings with a homely and comfortable atmosphere.*

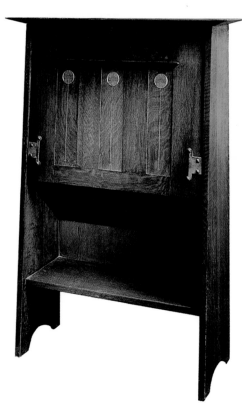

Above and right: Gustav Stickley is best known for his strong, sturdy designs. These fall-front desks are typical, made of an indigenous wood, oak, in a plain and simple "nonstyle."

familiar chairs were not only used in cafés throughout Europe but were also exported to the United States. The Vienna Secession designers had work produced by Thonet, and when Le Courbusier was equipping his Pavilion de L'Esprit Nouveau for the Paris Exhibition of 1925 he included Thonet dining chairs. Thonet relied on machine processes to produce furniture which achieved the egalitarian ideals of the craft tradition: it was simple, functional, and unpretentious. Above all, the standard ranges were inexpensive and therefore available to all.

GERMAN FURNITURE

The need for inexpensive, machine-produced furniture which was expressive of craft values was also acknowledged in Germany. In 1907 an organization called the Deutsche Werkbund was established in Munich, aimed at "the improvement of industrial products through the collaboration of art, industry, and craft." The organization included manufacturers among its members, and associated organizations, such as the Dresden and Munich Werkstätte, began to revise their attitudes toward machine production. In Dresden, the Vereinigte Werkstätte für Kunst in Handwerk was founded in 1898 by Karl Schmidt, who had been trained as a carpenter.

TYPENMÖBEL

Among the designers working for Schmidt's successful furniture workshop at Hellerau was Richard Riemerschmid, whose early furniture included cabinets and bureaux with elaborate veneers and inlays. In 1907, however, the workshops began to concentrate on serial or semimass production and introduced ranges of *Typenmöbel* ("type furniture") – chairs and cabinets made from standardized components.

The financial success of these enabled the workshops to amalgamate with the Munich Werkstätte and together they built a "garden city" at Hellerau, where the furniture workshops remained the focus of the community.

Bruno Paul, a founder member of the Munich Werkstätte, was involved in the design and production of *Typenmöbel*. He conceived his first furniture for his own house, which led to commissions from private clients. In 1908 he began to design furniture which could be produced by semimass-production techniques, concentrating on a limited number of designs. The components of his chairs, tables, and cabinets were standardized, but were produced in different woods and finishes so that a unity of design could be demonstrated throughout a house.

These experiments in standardization succeeded in breaking the barrier of elitism. Although only the middle classes could

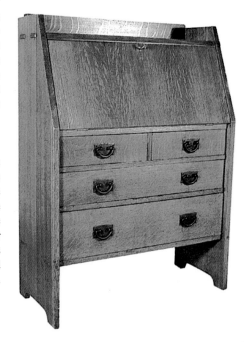

afford it in Germany, several large-scale industries, such as Krupps and A.E.G., furnished their workers' houses with designs based on similar principles.

ARTS AND CRAFTS FURNITURE IN AMERICA

The impact of British Arts and Crafts ideals for furniture on American designers is best epitomized by the works and philosophy of Gustav Stickley, editor of the magazine *The Craftsman* (1901–16). When he set up his own workshops with his brothers at Binghamton, New York, it was Shaker simplicity that he tried to emulate, however. It was not until 1899, when, now a convert to the ideals of Ruskin and Morris, he formed the Gustav Stickley Company in Eastwood, New York, that he consolidated his own ideas. Stickley is best known for his "Mission" furniture: strong, sturdy designs, mainly in oak, which were intended to evoke the "simple life" of the early

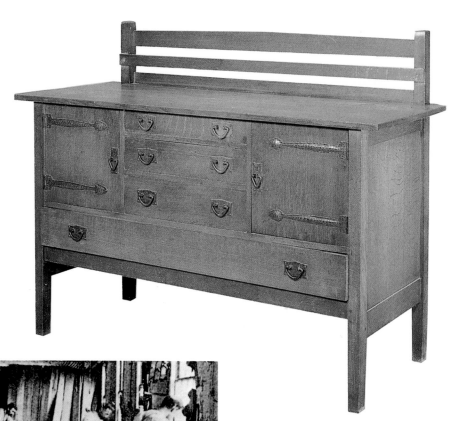

Above: A sideboard produced by the workshops of Gustav Stickley, of oak and oak veneer with hammered copper hinges and handles, c. 1910–16.

Left: A photograph published in The Craftsman *of Gustav Stickley's Craftsman Workshops, c. 1902–3.*

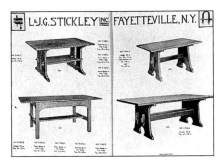

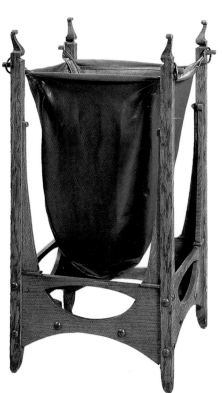

Above: Pages from the L. & J. G. Stickley catalog, 1922. L. and J. G. Stickley, brothers of Gustav Stickley, set up a rival enterprise in 1900.

Right: A garbage basket designed by Charles Rohlfs made of American white oak with an attached leather bag, c. 1910.

pioneers. The success of this furniture and its adaptability to machine production meant that he had many competitors. In 1900 he launched United Crafts in the Craftsman Building in Syracuse, organized along cooperative lines. Commercial success, however, encouraged him to overextend his empire and he eventually became bankrupt.

ELBERT HUBBARD AND CHARLES ROHLFS
Also designing furniture during this period was Elbert Hubbard, who established his Roycroft Guild venture in East Aurora, New York. In 1897 he introduced a line of

furniture very similar to Stickley's "Mission" range, but his enthusiasm was condemned as naïvely populist. The furniture made by another Buffalo craftsman at the turn of the century was more in keeping with the mainstream Arts and Crafts tradition. Charles Rohlfs's early pieces were also in the "Mission" style. Most of his work, however, was elaborately carved and pierced, and he was one of the few American furniture-makers to use Art Nouveau ornamentation.

THE GREENE BROTHERS

American architects, too, made a significant contribution to Arts and Crafts furniture design. The Greene brothers' Gamble House, in Pasadena, California, built between 1908 and 1909, is an example of "total design." Charles

Left: The morning room at Standen; the table in the foreground is by Philip Webb.

Below: A cabinet and chair by the Greene brothers for the Charles M. Pratt house, Ojai Valley, California, c. 1909. The furniture was made by Peter Hall, a cabinetmaker who worked with the brothers.

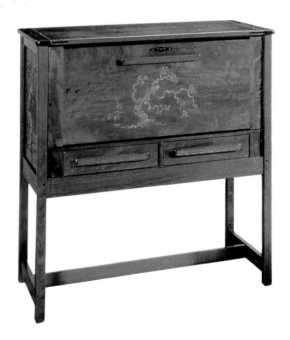

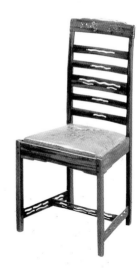

Right: An armchair designed by Frank Lloyd Wright.

Below: A side chair by Frank Lloyd Wright for the Aline Barnsdell house, Los Angeles, 1920.

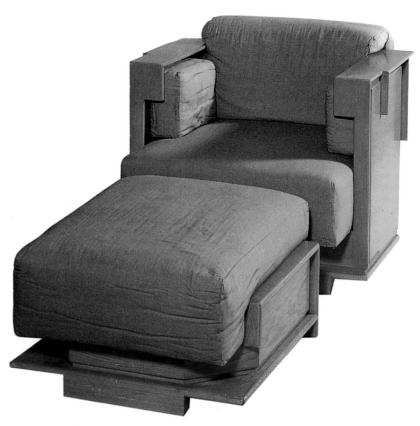

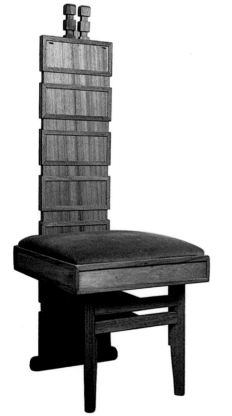

Sumner Greene, like so many of his contemporaries, had made the pilgrimage to England, and the furniture that he and his brother Henry Mather Greene produced is a celebration of an ideal of the home. Like Mackintosh's, the work of the Greene brothers displayed Chinese influences, including curved splats borrowed for the Chippendale style. But Japan, they felt, had transformed carpentry into art, and their work is distinguished by this ideal.

FRANK LLOYD WRIGHT

Frank Lloyd Wright also designed furniture within an architectural context. When he conceived the Robie house and its furniture in 1908, the early associations of his work with the "Missions" and the early pioneers were abandoned. Wright's furniture was designed to make a statement about the relationship of form to space. It is therefore no coincidence that the Dutch designer Gerrit Rietveld was asked shortly before World War I to reproduce some of Wright's furniture for an avant-garde house in The Netherlands. Wright transformed the Arts and Crafts esthetic to complement that 'geometric sense of things' that is so characteristic of Modern Movement achievements.

ARTS AND CRAFTS
METALWORK

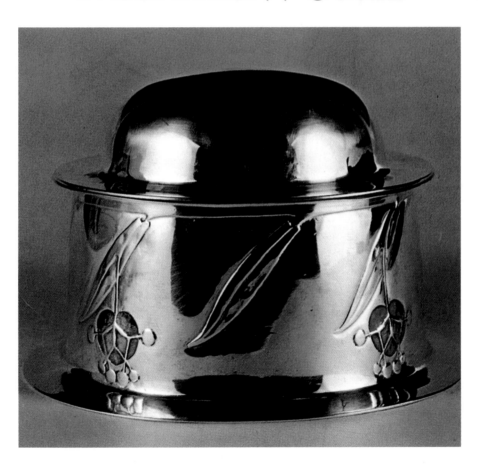

Previous page: A Liberty & Co. "Cymric" silver and enamel covered box, 1900.

Below right: Silver cutlery by Josef Hoffmann for the Wiener Werkstätte, Austria, 1903–4. This pleasantly functional cutlery is closely related to that designed by Charles Rennie Mackintosh in 1901 for the Ingram Street Tea Rooms, Glasgow, Scotland.

The character of most materials is greatly determined by its limitations. Metals can be made to do almost anything, from shaping a jug to roofing a steeple, and their nature is a matter of interpretation. The Arts and Crafts Movement formed its own arbitrary rules and taboos about metals and the way in which they should be handled – rules that its adherents frequently ignored to good effect.

Gold, silver, and bronze might be cast, but iron never. Wrought iron should not be bolted or welded. Saw-piercing was *infra dig,* platinum frowned upon; gems, companions to the noble metals, should be semiprecious and uncut. No machinery should be used, a prohibition which, in a modern world, it was impossible to observe to the letter. On the other hand, Arts and Crafts designers played havoc with orthodox trade practices by mixing base and precious metals, setting domestic silverware with gems and enamels and embellishing furniture with decorative metal plaques and the sort of hinges used on outhouses.

HANDCRAFT VERSUS MACHINE PRODUCTION
Metal has no visible grain, unlike wood or leather, and mechanical methods cannot reveal its hidden nature. Arts and Crafts designers set great store by the hammer finish, the skin of callused metal that grows under the worker's hand in the rough-and-tumble

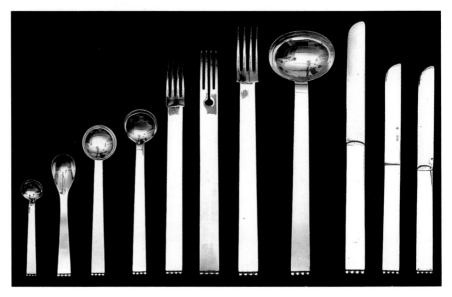

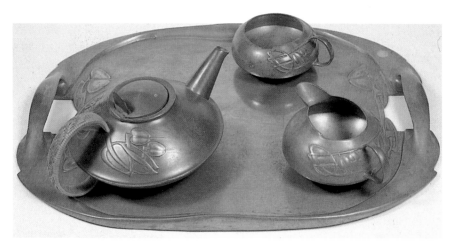

Left: A "Tudric" tea set designed for Liberty & Co. by Archibald Knox, 1904.

Below: A Morris & Co. whistling kettle made of copper and brass. It is an example of simplicity of design which anticipates the work of the Deutscher Werkbund and the Bauhaus in Germany.

of creation. The artist/craftsman tolerated inequalities of surface or form – even encouraged them: they held the eye in a way that the precision and symmetry of a machined object could never do.

The versatility of the metals suited them to multiple production, and in the first half of the nineteenth century mechanical techniques largely took over from handcraft. Wrought iron was almost entirely replaced by cast iron in architecture and the home. Hollowware, instead of being hand-beaten into shape over an iron stake, was either "spun" – squeezed into shape on a lathe against a suitably formed "chuck" – or stamped out on a press. Jewelry, too, was punched out wholesale. Competition was savage and production meant that the vital connections between designer and workman and workman and metal were being loosened; it was these bonds that Arts and Crafts longed to see remade.

IRONWORK

By the middle of the nineteenth century, the craft of wrought ironwork was fast giving way to cast iron in the decorative arts. As a decorative medium, cast iron had serious limitations. Its intense heat in the molten state often caused it to burn the surface of the sand mold when it was poured, with a consequent loss of depth and precision. Nor was there any chance of chasing in the lost detail with a hammer and chisel, cast iron being too brittle. The traditional way in which to create relief in ironwork was by building it up layer by layer in laminations of pierced and fretted metal, or by forging, filing, and chiseling it into shape, methods which gave great richness of detail but were quite unsuited to multiple production. The most effective use of cast iron in the decorative arts is in the simple, rhythmic patterns seen in railings and balustrades.

WROUGHT IRON

A wave of church restoration in the second part of the nineteenth century encouraged the revival of wrought ironwork. Architects such as Sir George Gilbert Scott replaced the vanished screens of medieval church buildings with versions of their own. The fashion for wrought iron grew as the Arts and Crafts

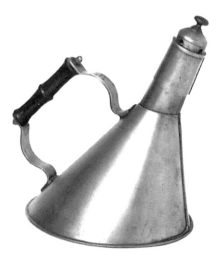

Right: A silver-gilt and enamel candlestick by A. W. N. Pugin, England.

Below: A candlestick of forged iron by Ernest Gimson and Alfred Bucknell, England, c. 1908. A combination of sound engineering and good design utilizes the characteristics of the metal simply and naturally.

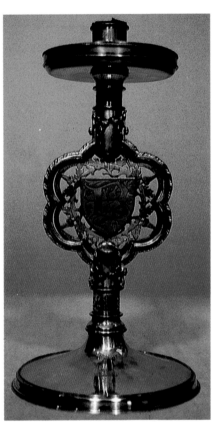

CHARLES RENNIE MACKINTOSH

Although iron is liable to corrosion and needs to be painted to protect it from the weather, its great strength makes it suitable for architectural work. Cryptic and elegant, Charles Rennie Mackintosh's ironwork for the Glasgow School of Art remains the subject of discussion. The brackets to the studio windows in the northwestern façade combine support and decoration with the prosaic function of holding up the window-cleaner's planks. Their tops end in curious knot motifs which have been compared with the hilt of a Scottish broadsword. The railings below are tipped with the spear-shaped leaves which C. F. A. Voysey introduced and are supported by tall iron staffs crested with pierced roundels which have been identified as *mon*, Japanese heraldic shields.

Inside the building, a balustrade is strengthened by vertical bands of iron punched with oval holes, like those in a well-worn harness. The T-girders supporting the roof are split and scrolled into knots, a device in the true Arts and Crafts spirit which emphasizes rather than disguises the nature of the object. The ironwork gives the school an embattled look, as though it were defending the Glasgow arts against all-comers.

ANTONIO GAUDÍ

Antonio Gaudí, architect of the fantastic cathedral of the Sagrada Familia in Barcelona, understood how light could be interrupted and transformed by a skeletal membrane of wrought iron. The iron gates which he made for the grotto in the Parc Güell, with their meandering patterns and paired wing forms, were intended to be seen looking out against the harsh Catalan light. Gaudí was the son of a coppersmith of the city of Reus in Tarragona

Movement gained momentum, particularly in fire irons for the fashionable inglenook, to which the heat-resistant metal was well suited. The furniture-maker Ernest Gimson designed fire irons to be made up in brass and iron by Alfred Bucknell, a son of the village blacksmith of Tunley, Gloucestershire. Bucknell could breathe life into iron by the simplest possible means, using no more decoration than a few licks with the file or punch. He had an intuitive understanding of the plastic qualities of forged iron and his partnership with Gimson was close.

and had grown up with metalwork and metal-workers, and this total familiarity with the medium allowed him to push the metal to its limits. His iron drifts, twirls, squirms, and tangles; it beguiles and repels, soothes, and lacerates, but it always behaves like iron. The wings of the Jabberwocklike guardian of his dragon gate were made of iron mesh to give them a vibrant translucency. The gates of the entrance to the Mila House in Barcelona were designed like the veining of a leaf or an insect's wing and glazed.

SAM YELLIN

In the United States, the best ironwork was made in commercial workshops. There was a keen demand for hand-wrought architectural ironwork in America during the first third of the twentieth century and superb work was done by such craftsmen as Frank Koralewsky in Boston, Cyril Colnik in Milwaukee, and the Polish-born Samuel Yellin in Philadelphia. A sensitive and cultivated designer, much of Yellin's work was based on medieval originals, using the same traditional techniques – the collared joints not only clenching the scroll-work together but also picking out its melodic pattern with a simple counterpoint. Although he used the latest technology, Yellin believed that "there is only one way to make good decorative ironwork and that is with the hammer at the anvil . . ."

FRANK KORALEWSKY

Frank Koralewsky was an immigrant who had served his apprenticeship in the Pomeranian town of Stralsund. It was his belief that it was possible to match the magnificent metalwork of the late Middle Ages and Renaissance. To prove his point, he devoted his spare time for six or seven years to producing his handsome

and intricate "Schneewittchen" lock, which retold the fairy tale of Snow White. Relief panels inlaid with gold, silver, and bronze illustrated episodes in the story and even the hidden parts of the lock were decorated.

LOUIS SULLIVAN

Although the use of cast iron ran squarely against the doctrines of the Arts and Crafts Movement, in the hands of the Chicago architect Louis Sullivan the medium transcended its own nature. The buildings he designed were often richly and fantastically decorated in a distinctive style which combined Renaissance and Gothic elements with angularities and

Left: Detail, ironwork from the north front of the Glasgow School of Art by Charles Rennie Mackintosh, 1897 to 1899. The tall staff rising above the railings is decorated with a pierced disk.

Below: Detail, dragon gate, by Antonio Gaudí for the Güell Estate, Barcelona, 1884. The wrought-ironwork was carried out in the workshops of a Barcelona locksmith under Gaudí's supervision.

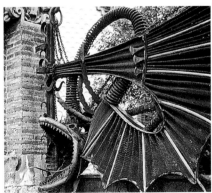

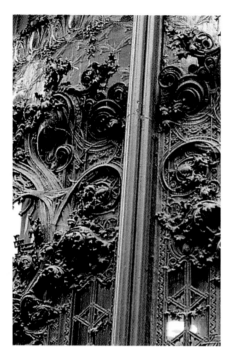

Above: Detail, Carson Pirie Scott store, Chicago, by Louis Sullivan, 1899–1904. Using plaster models and refined molding techniques, the American ironfounders at the turn of the century achieved the excellence of detail and surface usually associated with cire-perdue *bronze casting.*

Right: An electric kettle for A.E.G. designed by Peter Behrens in Germany, c. 1908.

webbed plane surfaces. The magnificent Carson Pirie Scott department store in Chicago was ornamented in this way. The intention was to set the display windows almost like jewels in frames of delicate, cast-iron ornamentation. No more than (½" (1cm) thick, the decoration combined meticulous detail with deep modeling, some of it even freestanding.

COPPER

The warm glow of copper was a part of the ambience of the Arts and Crafts home. Copper is easy to work and so appeals strongly to the amateur. John Pearson, of the Guild and School of Handicrafts, was claimed by Ashbee to have been an unemployed potter from the De Morgan factory who had taught himself copperwork by studying it in the British Museum. His large copper platters were boldly ornamented with fishes and birds and such guild motifs as the ship and peacock.

Birmingham was a great center for the mass-production of brass and copper goods, turning out everything from bedsteads to cooking pots. The Birmingham Guild of Handicraft was founded in 1890 on the principles laid down by Ashbee and Morris. No machinery was used except the lathe, essential for the production of domestic light fittings in which the guild specialized. Lugs, handles, and other additions fitted to its vessels were often fixed with rivets; silver boxes were assembled in the same way.

Domestic copperwork was even more popular in the United States than in Britain, although there were many points of comparison in the work produced on both sides of the Atlantic. The pieces produced by the Roycroft Guild's copper workshop, for example, demonstrate their links with the British Arts and Crafts Movement in their robust, hammer-finished copperwork with

exposed rivet heads. Dirk Van Erp began his career as an art metalworker by hammering brass shell cases into vases. These found a ready market and in 1908 he opened a store in Oakland before beginning a short-lived partnership with Eleanor D'Arcy Gaw, a designer, weaver, and metalworker who had trained with Ashbee, creating a highly successful range of ornamental copperware, including the table lamps with tinted isinglass shades for which Van Erp is best known.

COPPER LAMPS

The introduction of electricity to the home offered opportunities and challenges to the designer. In 1895 electricity was installed in Ashbee's home, the Magpie and Stump, in Chelsea. The lamps hung by strands of twisted wires from roses of beaten metal or were grouped with pendent spheres of glowing, translucent enamel. For the Glasgow School

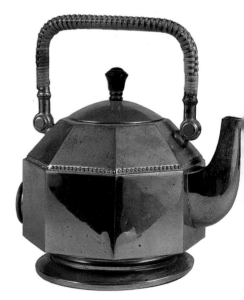

of Art, Mackintosh made a fall of 13 copper lamps, each like a tower pierced with a grid of square windows and lined with purple glass. In the lecture theater, his boat-shaped lampshades of hammered brass exuded just enough light for note-taking.

BRASS

Brass is less easily raised into hollowware than copper and its traditional use has always been in illumination. Some of Bucknell and Gimson's finest work is to be seen in their brass candle sconces, the flat backplates pierced with simple, vigorous decoration.

Robert Riddle Jarvie of Chicago specialized in candlesticks and lanterns. His popular candlesticks, sold in his Jarvie Shop, were typically modeled in forms which subtly suggest tall-stemmed flowers, cast in brass, copper or bronze and either brush-finished or patinated. He later made silver presentation pieces.

True to the Arts and Crafts dictum that the function of an object should be celebrated rather than hidden, a great deal of care was given to hinges and fittings around the home. Copper was rather soft for this purpose, but hinges were often made in brass. The hinges that Voysey designed for William Morris's

Above: A copper repoussé *vase from the workshops of the Keswick School of Industrial Art, England, c. 1900. The simple,* repoussé *decoration is typical of the work of the school.*

Left: A copper urn by Frank Lloyd Wright, made by James A. Miller, Chicago, c. 1900. The formal decoration of repoussé *paneling was designed as a complement to Wright's geometrical interiors.*

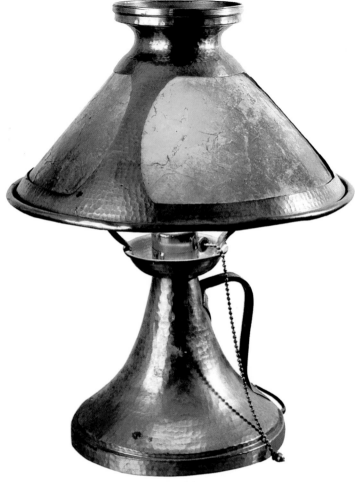

Above: A copper "weed vase" designed by Frank Lloyd Wright, made by James A. Miller, Chicago, c. 1894.

Above right: A copper electric desk lamp by Dirk Van Erp, U.S.A., c. 1901.

"Kelmscott Chaucer Cabinet," with their heart-shaped tips and openwork decoration of birds, are a fine example of his work. Mackintosh designed shallow *repoussé* metal plaques to decorate his furniture and interiors, using the same vocabulary as in his other two-dimensional designs: ellipses, peacock eyes, and the familiar girls.

Mackintosh's influence is seen strongly in the early metalwork designed by Josef Hoffmann for the Wiener Werkstätte, particularly the windowlike piercing, the strong perpendiculars, and 90° angles. Although Glasgow designs remained significant in the

Wiener Werkstätte, after Koloman Moser left in 1906 they gave ground to an agreeably blowzy Viennese style: brass and silver tea sets, smoking sets and fruit bowls, their tapered and fluted bodies like well-boned corsets, the handles cusped like Cupid's bows.

TIFFANY & CO.
At the 1878 Paris Exposition, the New York firm of Tiffany & Co. showed wares made of base-metal alloys laminated with fine gold and/or silver, causing a sensation by breaking a Western convention against marrying the base and noble metals. Eccentric, eclectic, and empirical, Tiffany & Co. broke rules; invented new ones; built altar candlesticks of thick bronze wire and set them with uncut quartz pebbles; and made a Native American loving cup of pink metal with handles of sheep horns. The firm began experimenting with enamel before 1900 as a decoration for the bases of lamps. The enameled copper vessels it made

Above: A metal lampshade designed by Charles Rennie Mackintosh, c. 1900.

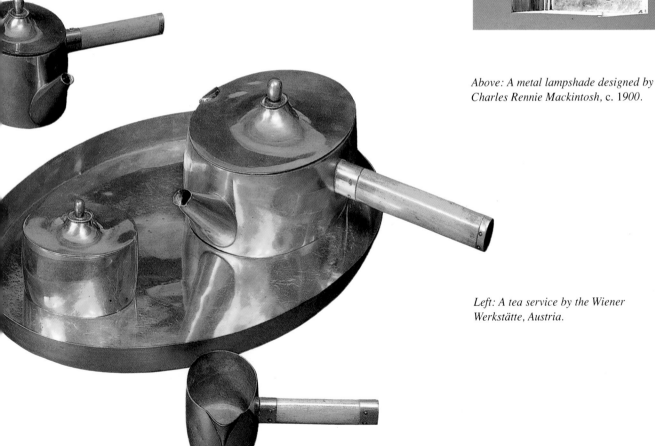

Left: A tea service by the Wiener Werkstätte, Austria.

Right: A brass tea set, with handles of pale wood, by Josef Hoffmann for the Wiener Werkstätte, c. 1905.

Below: A silver vase by Josef Hoffmann for the Wiener Werkstätte, c. 1904.

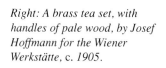

have the tactile, precious quality of the stoneware bowls used by the Japanese in the tea ceremony, the enamel seeming to grow on them like a luminescent skin.

GOLD AND SILVER

Arts and Crafts jewelers and silversmiths were skilled, versatile, and sensitive and evolved a great variety of styles. Nevertheless, a "family" likeness runs through their work. Most of their work was in silver, with some jewelry in 18-carat gold. Platinum was hardly ever used, but steel, copper, and aluminum also sometimes appear in jewelry.

There was a characteristic aversion to the slick finish. The hammered surface was universal in silver and sometimes, instead of

being polished, the metal was lightly rubbed with fine emery. Riveting often replaced soldering. Gems and enamels were set quite promiscuously in both jewelry and silverware, but according to strict conventions. The domed cabochon style of cutting was almost invariably used in simple, close settings, giving a natural, spontaneous effect, as though the stones were budding from the metal. The palette was restricted to the more subdued, semiprecious stones, especially opal, moonstone, veined turquoise matrix, cat's eye, garnet, amethyst, and the irregularly shaped Mississippi pearl; star rubies and sapphires were acceptable. The purpose was not simply to lend color to the object, but also a mood of mystery and glamor.

BOTANICAL DESIGNS

The Art of Decorative Design by Christopher Dresser, a trained botanist, encouraged jewelers and metalworkers to seek inspiration in living plants. The naturalistic botanical designs – unassuming jewels of lush, willowy foliage, touched with enamel and inhabited by little birds – of the British jewelers Arthur and Georgina Gaskin had many imitators. Bernard Cuzner, who headed the metalwork department of the Birmingham School of Art, also used botanical motifs.

Beautifully observed and realized, London architect Henry Wilson's stylized roses, figs, and pomegranates are not so much caricatures of nature as tokens of her power. His work is not only finely conceived but elegantly engineered. The borders of checkered enamel give Wilson's jewels a heraldic feeling, while animals and finely modeled human figures also

Below: A Liberty & Co. silver and enamel casket by Archibald Knox, 1903.

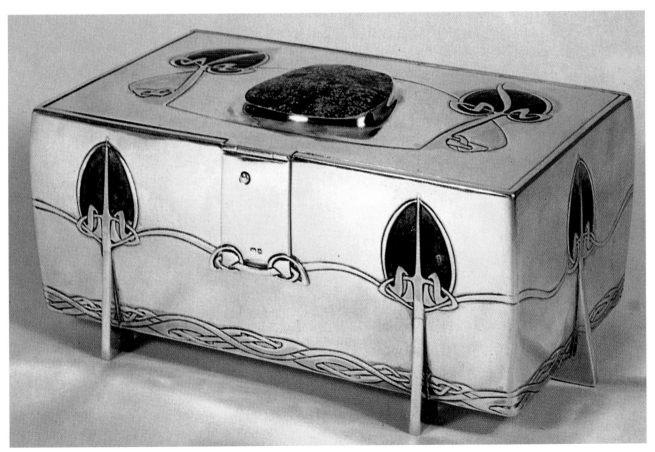

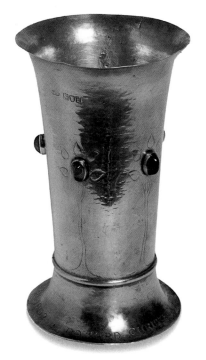

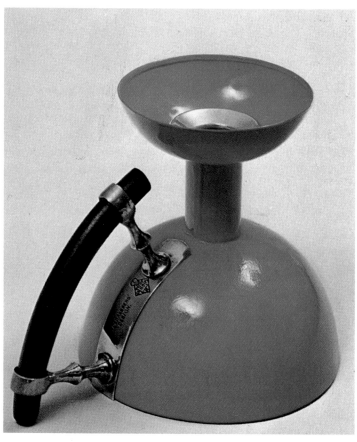

Above right: A candlestick in painted copper, brass and wood by Christopher Dresser, made by Perry & Co, 1883.

Above: A christening mug made for Lord David Cecil by members of the Guild of Handicraft, 1902.

appear in his work.

The coolly stylized jewels that Otto Czeschka designed for the Wiener Werkstätte were pretty and wearable two-dimensional patterns of hollylike leaves and toy birds, set with random groupings of cabochon gems and composed with arrangements of thin chain.

TIFFANY & CO. AND ARTHUR STONE
Wild flowers – dandelion, nightshade, blackberry – were prominent among the art jewelry

made by Tiffany & Co. before World War I. The collection also included Byzantine and Art Nouveau designs, and the gems with which the pieces were set were often of American origin.

The simplicity and nearness to nature of the work of Arthur J. Stone was greatly admired in Europe. His plain, classical silver is clearly in the New England tradition. Some of his work is decorated with finely observed chasings of plants; the barbed leaves of the arrowhead were particular favorites. He

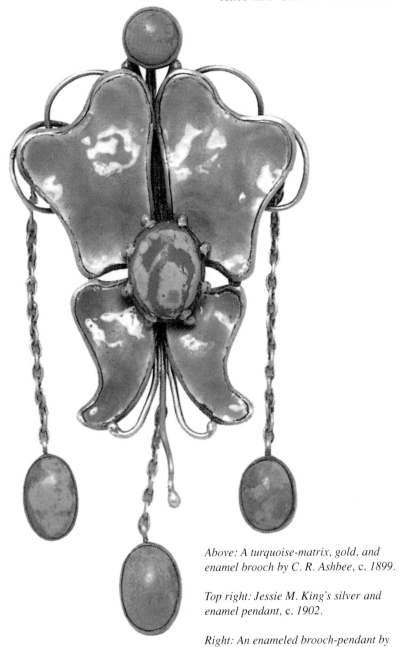

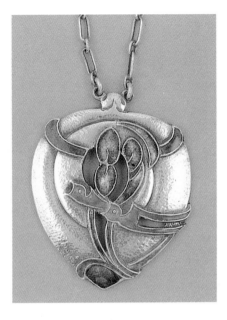

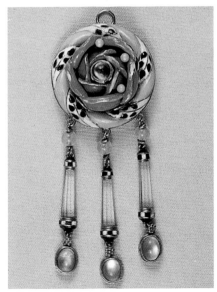

Above: A turquoise-matrix, gold, and enamel brooch by C. R. Ashbee, c. 1899.

Top right: Jessie M. King's silver and enamel pendant, c. 1902.

Right: An enameled brooch-pendant by Henry Wilson, c. 1913.

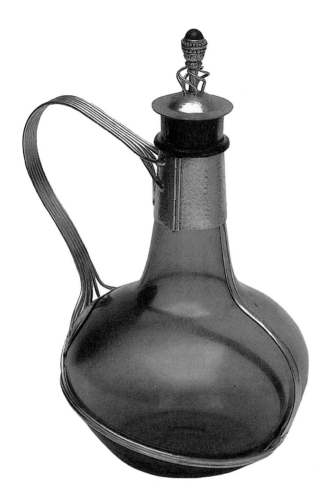

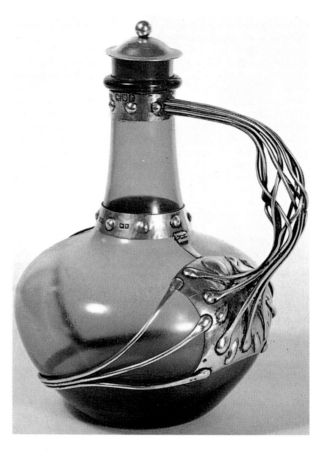

Above: A glass decanter with silver mounts by C. R. Ashbee, c. 1904–5.

Above right: A silver-mounted jug by C. R. Ashbee at the Guild of Handicraft, c. 1900; green glass by Powell's of Whitefriars.

carried out the chasing himself, occasionally adding touches of gold inlay. Even the hammer finish on his silverwork was barely perceptible.

EIGHTEENTH-CENTURY FASHIONS
Eighteenth-century fashions were popular with most Edwardians and they also appear to have infiltrated the silverware of the Arts and Crafts Movement. The most distinctive work by Arthur Dixon, of the Birmingham Guild of Handicraft, is in the Queen Anne style – round-bodied vessels, vases, jugs, teapots, and coffee pots with sensible fruitwood knobs and handles, devoid of any decoration other than a hammer finish.

Tiffany & Co. launched a fine range of table silver which was inspired by Queen Anne design, as was the simple, paneled and globular domestic silver produced and sold in her Chicago Kalo stores by Clara Barck Welles. In Copenhagen, Denmark, Georg Jensen's rich

but unpretentious domestic silver, with its plump, hand-hammered surfaces ornamented with succulent clusters of fruits and flowers, evokes the bourgeois comforts of the Age of Reason.

CLASSICAL INFLUENCES

Since the prophets of the Arts and Crafts revival were mainly gentlemen of classical education, the influence of antiquity is inescapable. The bowl that Ashbee designed for jam or butter, with its round, shallow body, double handles, and trumpet-shaped foot, has features in common with Greek drinking vessels. This enchantingly simple but striking design, with

its wide-looped handles which part at the top and cling to the body with little suckers, is an Arts and Crafts classic and was successfully imitated by Marcus & Co. of New York. For the most part, it was the nature worship of antiquity that appealed to Arts and Crafts designers. Vines, figs, and pomegranates often appeared in jewelry, as did the god Pan.

WILLIAM BURGES

Although "Brummagem Gothic" was a powerful force in nineteenth-century decoration, the medieval element in Arts and Crafts came in a direct line of descent from Pugin. The silver designs of his disciple, William

Below: A dessert service, silver set with enamel and gems, by William Burges for the Marquess of Bute, made by Barkentin and Krall, England, 1880–81. The style is an architectural Gothic, and the bottom of each branch is formed as a tiny, otterlike head, with a carnelian-bead pendant from its jaws.

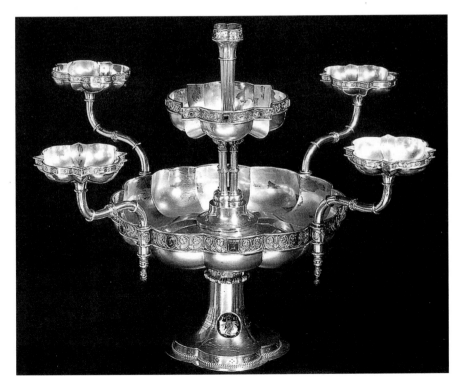

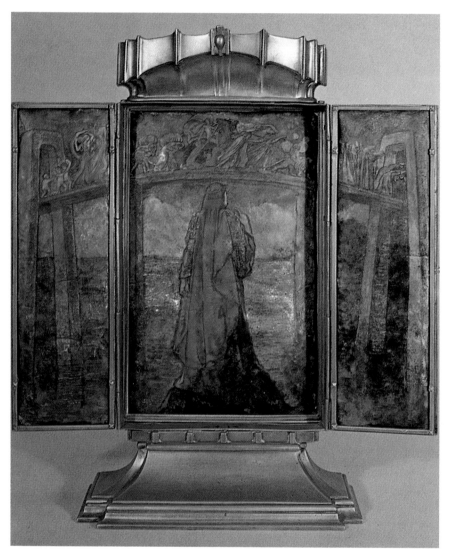

Above: An enameled triptych by Alexander Fisher, c. 1900.

Burges, were as eccentric as his personality. Brilliantly playful and idiosyncratic, totally unlike Pugin's chaste silver, they team with living creatures – cats, spiders, mermaids, and mice. He often blended bizarre assemblages of coins, enamels, Chinese hard-stone carvings, and Japanese ivories and contrasted suave engraving with sharp relief and quiet *champlevé* enamel with showy *émail en ronde bosse* in a way that makes every element act as the antidote to the another.

THE JAPANESE INFLUENCE

Western designers went to visit Japan and Japanese craftsmen came to teach enameling and metalwork, exerting a deep influence on such leading figures as Mackintosh and Dresser. Tiffany & Co. began to make silver decorated in the Japanese style, hammer finished and applied with gold and copper butterflies, bottle-gourd vines, wistaria, and subaqueous waterscapes full of fishes, frogs, and weeds. The firm made bowls and vases of Japanese inlaid silver and copper which at the same time reproduced the baskets used by the Hopi, Zuni, and Navajo tribes.

The revival of enameling began in France, and it was Dalpeyrat of Sèvres who introduced enamel to British Arts and Crafts. In 1886 he gave a series of demonstrations to students in London, including Alexander Fisher. Fisher's painted enamels are of extraordinary quality, the colors rich and subtly graduated. In the exquisite "Love Cup" jewel by the Edinburgh-based Phoebe Traquair, the scene is finite and complete. Her enamels have the shimmering mystery of Celtic legend.

Arts and Crafts Movement

Movement

Textiles and Interiors

THE ARTS AND CRAFTS PHILOSOPHY

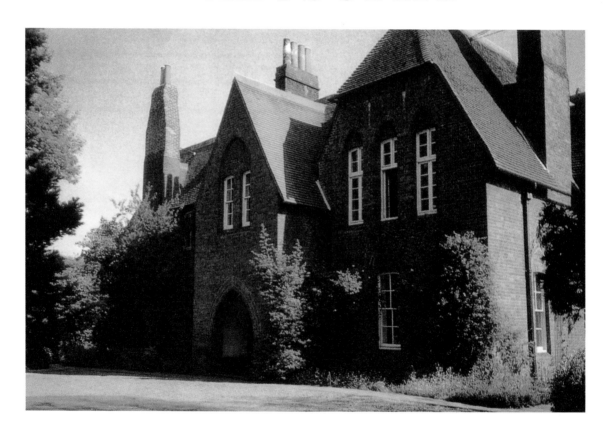

The Arts and Crafts movement developed in England as a protest against the character of mid-Victorian manufactured products and slowly evolved during the period between 1850 and 1920 into an international campaign for design reform that affected all aspects of the environment, from architecture and gardens to interior furnishings, finishing materials, and fittings. Throughout its lifespan, its supporters argued that design affects society – that the character of the living and working environment molds the character of the individual.

These were devout reformers who feared that mid-nineteenth-century design had gone astray. They not only condemned the shoddy workmanship, indiscriminate use of materials, inefficient forms, and elaborate ornamentation that characterized most mid-Victorian manufactured products, but believed that such products had a deleterious effect upon society. By initiating a program of reform, they hoped to improve the quality of design and thus to strengthen the character of the individual and of society as a whole. To achieve their goal, they strove to ensure that traditional methods of handcraftsmanship would survive, despite competition with machine production, to ameliorate the working conditions of artisans and craftsmen, and to encourage artistic collaboration among workers. Their intention was to improve the quality of life for everyone by restoring integrity to the objects common to daily living.

INTERNATIONAL EXHIBITIONS

The clamor for design reform had begun largely in reaction to the falling standards of taste as exemplified by products shown at international exhibitions. These enormous world fairs, which took place regularly throughout the nineteenth century, were six-monthly celebrations of industrial technology and of the potential of the machine. Beginning with the Great Exhibition of 1851, which was held in London, they stood as testimonies to the changing esthetic and technical standards of an era.

Products ranged from mass-produced, everyday wares to one-of-a-kind presentation pieces. Those in the former category often introduced newly developed materials or patented mechanisms; those in the latter were remarkable primarily for their size, complexity, and cost, or investment of labor. Stylistically, most demonstrated a reliance upon the past, their retrospective appearance contradicting the fact that they embodied the latest developments in technology.

THE "MACHINE AGE" CONDEMNED

Although such fairs were intended to glorify the accomplishments of the "machine age," to design reformers they invited more criticism than approbation. Surveying the manufactured products on display, many disapproved not only of what was being made, but also of how it was made, and with a degree of enthusiasm that belied their relatively small numbers they set about changing both.

They questioned whether it was appropriate to utilize new materials and processes in order to create elaborate works that recalled, with

Opposite: William Morris' Red House in Kent, England, embodied many of the ideals espoused by the Arts and Crafts Movement.

Below: A stoneware vase by Adrien-Pierre Dalpyrat, with ormolu mounts by Keller, exhibited at the Paris Exhibition of 1900.

varying degrees of accuracy, the historical styles of the past. They pondered the relative merits of machine production as it affected form, ornament, and finish. They weighed up the manner in which materials were selected and used. And they objected to the fact that most goods were manufactured in stages, using a so-called "division of labor."

The comprehensive vision of the independent pre-"machine age" craftsman, true or false, had been replaced by the limited perspective of the machine operator, who labored in relative isolation. Designers seldom had contact any longer with the craftsmen who implemented their ideas, and few workers ever saw the finished product. Manufacturers had little exposure to the consumers who used their wares and could not therefore assess their reactions. What had once been an integrated, cyclical process had become segregated and linear, and the resulting lack of communication caused standards of design and construction to deteriorate.

Reformers hoped to improve design by restoring conditions that they believed had been typical before the Industrial Revolution. They addressed such issues as the training, education, and working conditions of the designer or craftsman; the esthetic or technical attributes of the end product; and the manner in which products became available to the public. In addition, they considered the effect which products common to daily living had upon the user's environment, and the appropriateness of the products for their intended purpose. Whether or not they were interested

Right: Design for a dado by Walter Crane. Born in Liverpool in 1845, Crane was both a designer and a theorist.

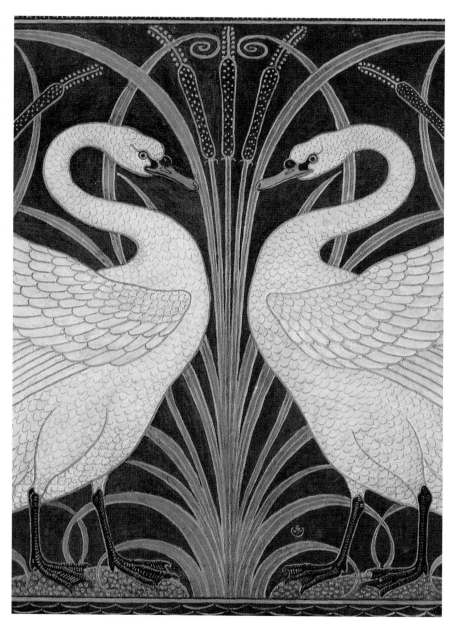

Below: A Morris & Company embroidered screen dating from around 1889, probably designed by May Morris, William's second daughter, for the drawing room of Bullerswood, the grand home of the Sanderson family.

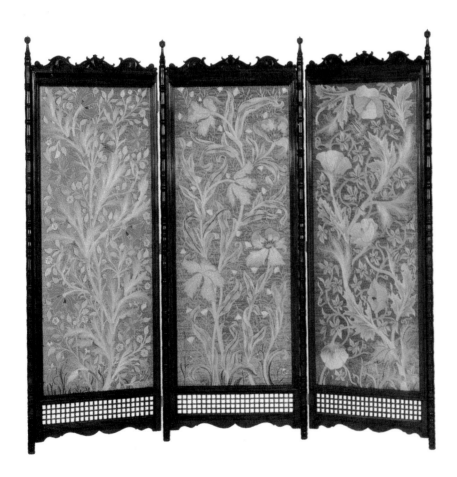

in changing every stage of the design process, all of the reformers hoped for essentially the same outcome: the restoration of dignity to the maker; integrity to the product; discrimination to the user; and artistic cooperation throughout the design process.

THE ARTS AND CRAFTS PHILOSOPHY

Although the questionable standards of mid-Victorian manufactured products undoubtedly justified the need for reform, the ideals of English design reformers would never have gained international acceptance without the benefit of a strong and widely publicized philosophical argument. This was propounded chiefly by three ardent advocates, A. W. N. Pugin, John Ruskin, and William Morris, who, by word and deed, spread the message not only throughout Britain but also throughout the industrialized world.

A. W. N. PUGIN

The design reformer's major premise, that the character of the living and working environment molds the character of the individual, evolved from a related idea promulgated by Pugin in the 1830s. A designer, writer, and the son of a French *émigré* architect, Pugin believed that the character of a nation was expressed by its architecture and applied arts. He recommended that English architects and designers should abandon their allegiance to Graco-Roman models in favor of Gothic examples from the late Middle Ages, the greater suitability of the latter, he argued, stemming from its association with a Christian rather than a pagan culture. He made this case passionately in such influential books as *Contrasts* and *The True Principles of Pointed or Christian Architecture*.

As well as their symbolic appropriateness,

*Right: A maiolica plate designed by
A. W. N. Pugin, c. 1850. Pugin designed
both buildings and their contents.*

*Far right: Wallpaper with Tudor rose and
portcullis, with the initials of Queen
Victoria, designed by Pugin for the
Houses of Parliament, London.*

*Below: The church of All Saints, Leek,
Staffordshire, England, by Gerald Horsley.
Pen and watercolor, 1891.*

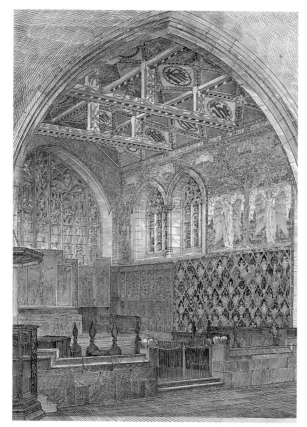

Pugin maintained that Gothic and other styles from the Middle Ages were superior for their integrity. He admired the functional nature of the plan, the expressive quality of the façade, and the integration of structure and ornament that characterized medieval architecture. He suggested that such features were absent from contemporary British architecture, and he recommended that architects and designers could learn valuable lessons by studying the work of their medieval predecessors. "There should be no features about a building which are not necessary for convenience, construction or propriety," he wrote.

With a similarly pragmatic attitude, he stated: "All ornaments should consist of enrichment of the essential construction of the building," advocating a degree of decorative restraint. His belief in the moral and esthetic superiority of the Gothic style inspired a generation of architects and designers (many of whom trained supporters of the Arts and Crafts movement) and stimulated enthusiasm for the Gothic Revival style in Britain and abroad.

JOHN RUSKIN

Like Pugin, John Ruskin, architectural critic and first Slade professor at Oxford (1868), equated the character of the nation with that of its architecture. He believed that the nature of contemporary British architecture would improve if it were designed to express qualities exemplified by the Romanesque and Gothic styles. In *The Seven Lamps of Architecture* (1849), he identified those qualities as Sacrifice, Truth, Power, Beauty, Life, Memory, and Obedience, and explained how each might be conveyed by form, ornament, or construction.

In *The Seven Lamps of Architecture*, Ruskin provided esthetic recommendations, arguing

Below: A portrait of John Ruskin by T. B. Wirgman.

Bottom: A photograph of John Ruskin, the historian, educator, and writer.

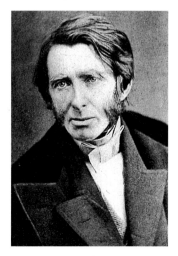

in favor of simplified massing (Power), naturalistic ornamentation (Beauty), historicism of style (Obedience), and an honest use of materials (Truth). He also addressed the issue of construction, demonstrating that he was as concerned with the process of building as with the finished product. He suggested that architecture must reflect the thoughtfulness and feeling of each individual involved in its construction. "I believe the right question to ask, respecting all ornament," he wrote in "The Lamp of Life," "is simply this: Was it done with enjoyment . . . was the carver happy while he was about it?"

Ruskin continued to explore this theme in *The Stones of Venice* (1851–53), an influential work in three volumes that provided an in-depth analysis of Venetian architecture from the Middle Ages. In one section, an essay entitled "On the Nature of Gothic," Ruskin summarized the qualities that gave medieval architecture its distinctive character. These included Rudeness (imperfection or lack of precision), Changefulness (variety, asymmetry, and random placement of elements), Naturalism (truthfulness or realism as opposed to conventionalisation), Grotesqueness (delight in the fantastic), Rigidity (conveyed by sprightly or energetic forms and ornament), and lastly Redundance (achieved through the repetition of ornament). He viewed each quality as an extension of the craftsman's personality and believed that each was essential to achieving an architecture of character.

As long as the "division of labor" degraded the "operative [or worker] into a machine,"

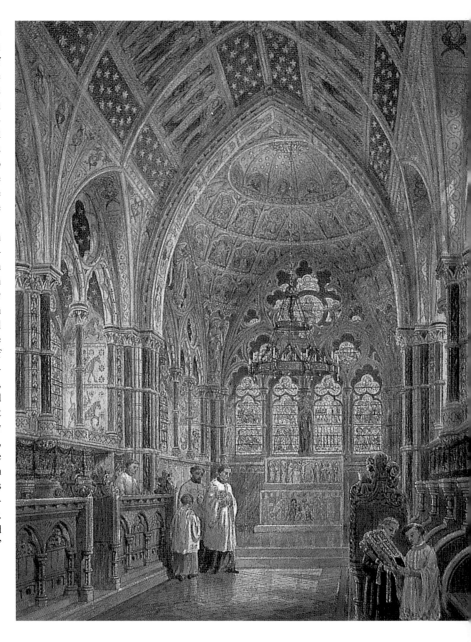

Right: The design by William Burges for St. Mary's, Alford-cum-Studley, Yorkshire, England, c. 1872. Watercolor by Axel Naig.

architecture would fail to achieve the qualities of medieval architects. He advocated changing the design process to foster an environment of "healthy and ennobling labor." To achieve such an atmosphere, he proposed "three broad and simple rules" to be applied by architects, designers, and manufacturers.

1 Never encourage the manufacture of an article not absolutely necessary in the production of which Invention has no share.
2 Never demand an exact finish for its own sake, but only for some practical or noble end.
3 Never encourage imitation or copying of any kind, except for the sake of preserving records of great works.

Without dictating a specific formula for design reform, Ruskin established an ideal, and for the next 70 years that ideal, as set forth in "On the Nature of Gothic," continued to inspire reformers.

WILLIAM MORRIS

The leader among these was William Morris, who began to study at Oxford in 1853, two years after the Great Exhibition in London, and in the year in which "On the Nature of Gothic" first appeared. As a student, Morris developed a profound affection for the culture of the Middle Ages, stimulated by his familiarity with Ruskin's works, his appreciation of Oxford's medieval architecture, and his travels in France to the cathedral cities of Amiens, Beauvais, and Chartres. His sensitivity to his surroundings was strengthened by a two-year apprenticeship in the Oxford

Below left: William Morris pictured when at Oxford, aged 23.

Below right: A photograph of Edward Burne-Jones and William Morris by Hollyer, taken in about 1890.

office of the Gothic Revival architect George Edmund Street. Although he abandoned architecture to take up painting, the time that Morris spent in Street's office was invaluable, for it was there that he developed a life-long friendship with the senior clerk, Philip Webb, whom he had met at Oxford.

This friendship was one of several fortuitous connections made by Morris at Oxford. While there, he also met a fellow painter, Edmund Burne-Jones, and still another painter and poet, Dante Gabriel Rossetti, both of whom, with him, were later to be members of the Pre-Raphaelite Brotherhood. Like Webb, they shared Morris's passion for the culture of the Middle Ages. They were inspired not only by its architecture, art, and craft, but also by the artistic cooperation which had fostered their creation.

RED HOUSE

The commitment of these friends to the artisanry and atmosphere of the Middle Ages was tangibly expressed in Red House, the marital home designed by Webb for Morris and his bride, Jane Burden. The house is as significant for the manner in which it was built and furnished as for its warm and unassuming appearance. Proudly handcrafted by workers involved throughout the building process, it was in essence a communal labor of love to which Morris's entire circle of artistic friends contributed. A unified whole, related from large scale to small, from site to hardware, and from

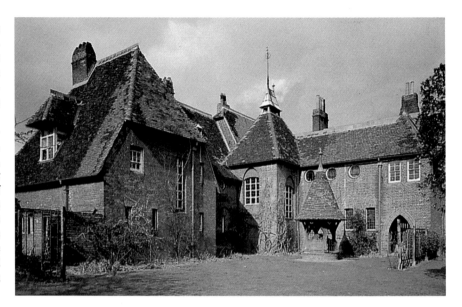

Above right: Red House, Bexley Heath, Kent, England, designed by Philip Webb for William Morris and his bride.

Right: A caricature by Rossetti, Morris Presenting an Engagement Ring to Jane.

exterior to interior, it has become a monument of the Arts and Crafts movement, not so much for what it is but for what it symbolizes.

MORRIS, MARSHALL, FAULKNER & CO.

The collaborative effort manifest in Red House prompted the formation in 1861 of Morris, Marshall, Faulkner & Co., "Fine Art Workmen in Painting, Carving, Furniture and the Metals." The company specialized in ecclesiastical and residential commissions, and its reputation flourished as the result of exposure at various international exhibitions. It was organized somewhat in the manner of a medieval gild; its members, including Burne-Jones, Webb, Rossetti, and Ford Madox Brown, developed their designs, carried them through to completion, collaborated with one another, and dealt closely with clients, deriving satisfaction all the while from their work process and its outcome.

In 1875, Morris assumed full responsibility for the firm, abbreviating its name to Morris & Co. The enterprise produced a wide range of interior furnishings, finishing materials, and fittings, and provided advice regarding interior decoration. Among Morris's many personal responsibilities during the 1870s, 1880s, and 1890s were the design and production of over 600 chintzes, woven textiles, and hand-blocked wallpapers, a task that involved his researching dyes, weaves, and printing techniques. As designer, craftsman, and entrepreneur, his goal was ambitious: to provide a tasteful and affordable alternative to the products of the Industrial Revolution, which he condemned as "masses of sordidness, filth and squalor, embroidered with patches of pompous and vulgar hideousness."

Morris's considerable talents extended to poetry, printing, preservation, writing, and

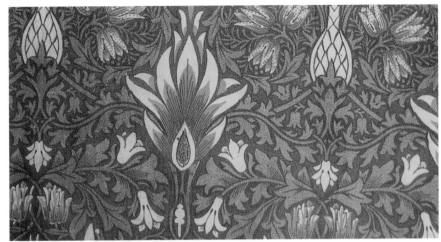

Top: "Snakeshead" printed cotton, 1876, designed by William Morris, and one of his own favorites.

Above: Linoleum designed by William Morris in 1875, available in two colorways. This was Morris's only design for this medium, although linoleum was very popular at the time.

politics. In his later years, he devoted much of his time and energy to the cause of social reform, formally allying himself to socialism in 1883. At the Kelmscott Press, which he operated from 1891 to his death in 1896, he hand-printed Utopian polemics, such as his novel *News from Nowhere*. "What business have we with art at all," he often asked, "if we cannot all share it?" This query prompted scores of his followers to embrace socialism with enthusiasm, convinced that design reform was impossible to achieve unless preceded by social, political, and economic changes.

Throughout his career, Morris struggled to reconcile his artistic ideals with his political inclinations. His commitment to the creation of products that reflected the highest standards of design and construction seemed constantly at odds with his desire to produce them at a cost that middle-class consumers could afford. His dedication to utilizing the esthetic and technical skills of craftsmen to their fullest potential, in a Ruskinian atmosphere of "healthy and ennobling labour," conflicted with the necessity of using machine production wherever possible to eliminate the drudgery of certain tasks and to reduce production costs. It was a dilemma that he never fully resolved while director of Morris & Co., and it continued to plague his followers in the years to come.

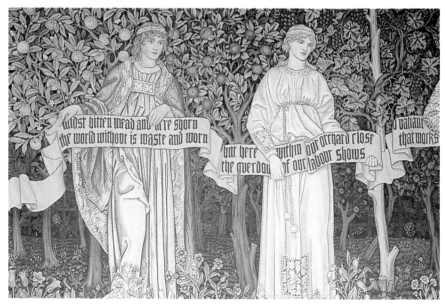

Top left: "Dove and Rose" woven silk and wool double cloth, designed by William Morris in 1879.

Top right: "Trellis" wallpaper by William Morris, 1864.

Right: "The Orchard Tapestry" by William Morris, 1890.

PRACTITIONERS AND DISSEMINATION

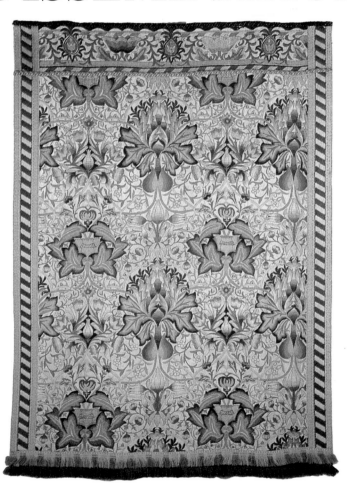

Although Morris & Co. may have been only a qualified success from an economic standpoint, it nevertheless served as a testimony to the merits of artistic cooperation. It inspired a host of imitators throughout England, in both urban and rural locations, where small groups of architects, designers, craftsmen, and critics banded together in organizations dedicated to design reform.

Among these were the Century Guild, founded in 1882 by the architect Arthur Heygate Mackmurdo; the Art Workers' Guild, formed in 1884 by pupils of the architect Richard Norman Shaw, and which still exists; and the Guild of Handicraft, organized in 1888 by the architect Charles Robert Ashbee.

Many of them were patterned on medieval gilds, and, as such, established certain esthetic and technical standards for their supporters, who were sometimes ranked according to their level of expertise in a particular craft. Some groups assumed educational roles, offering lectures, workshops, and classes. Most held regular exhibitions to promote the work of members and to elevate public taste. The most venerable of these was the Arts and Crafts Exhibition Society, which used the name suggested by the bookbinder T. J. Cobden-Sanderson. During the lifespan of the Arts and Crafts movement, similar gilds and societies developed throughout Britain, Europe, and the United States, and were the primary means by which the ideals of the movement were disseminated.

Previous page: "Artichoke" embroidered hanging, in crewel wools on a linen ground, by William Morris, 1877.

Left: A tile panel designed by Edward Burne-Jones, probably painted by Lucy or Kate Faulkner in around 1861.

THE CENTURY GUILD

A pupil in John Ruskin's Oxford drawing class, and a companion on Ruskin's visits to Italy, Mackmurdo established the Century Guild on the advice of his teacher in 1882. In the following year, the Century Guild's workshops were opened in partnership with Selwyn Image, who worked in several media. Other members of the gild included the potter William De Morgan, the designer Heywood Sumner, the sculptor Benjamin Creswick, the textile designer and metalworker H. P. Horne, and the metalworker Clement Heaton. Mackmurdo himself had trained as an architect but had, in addition, attempted to learn several crafts, including brasswork, embroidery, and cabinetmaking.

The purpose of the Century Guild was to accommodate craftsmen active in a number of *métiers* and to unite the traditionally separate disciplines of architecture, interior design, and decoration. It also aimed to raise the status of such crafts as building, fabric design, pottery, and metalworking in order that they might take their place alongside the professionally respectable "fine" arts.

Unlike the many medievalists associated with the Arts and Crafts movement, Mackmurdo admired Italian Renaissance and even Baroque architecture, and used the styles in his designs for several houses, including his own, Great Ruffins. The furniture produced by the gild was equally eclectic, ranging from the restrained

Right: A poster designed by Arthur Heygate Mackmurdo. Mackmurdo's work is dichotomous in character, at times angular and pragmatic, and at other times curvilinear and highly ornamental. Thus he was equally influential upon practitioners of Arts and Crafts and Art Nouveau.

and utilitarian to a style of decoration that anticipated the asymmetrical arabesques of the Esthetic movement and Art Nouveau. The gild was eventually dissolved in 1888.

THE ART WORKERS' GUILD

Selwyn Image was later active in another fraternity, the Art Workers' Guild. The gild was established in 1884 and was, in part, formed from a group of young architects employed in the architect Richard Norman Shaw's practice, among them William Richard Lethaby, Gerald Horsley, Ernest Newton, E. S. Prior, and Mervyn Macartney. In 1884 Shaw's assistants merged with a group of writers, designers, and theorists known as "The Fifteen," led by Lewis Forman Day. Walter Crane, John Sedding, and Henry Holiday were also in the Art Workers' Guild.

The Art Workers' Guild shared most of the concerns of other Arts and Crafts ventures: it sought a handcrafted, well-designed environment in which artists, architects, and craftsmen would assume collective responsibility for buildings and their contents. It is, however, difficult to discern within the gild any clear sense of social purpose. It also seems to have kept a deliberately low profile.

THE GUILD OF HANDICRAFT

Charles Robert Ashbee's Guild and School of Handicraft evolved from a Ruskin reading class held at Toynbee Hall in the East End of London under the direction of Ashbee, an associate of Morris, and H. M. Hyndman. Whereas much

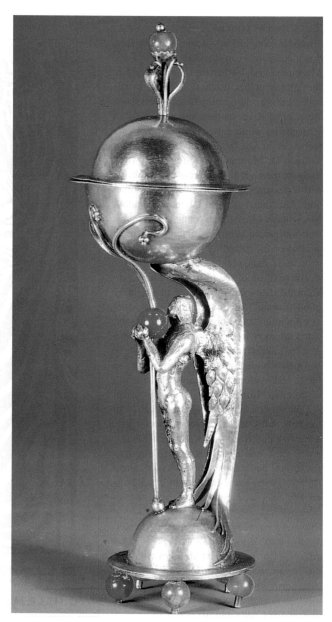

Right: A silver salt cellar by C. R. Ashbee, made by the Guild of Handicraft, 1899–1900. The figure was probably worked by William Hardiman, Ashbee's chief modeler.

of the produce of the Arts and Crafts movement in the 1880s and 1890s had become increasingly eclectic in style and intention, often employing highly refined standards of craftsmanship and, in some instances, mechanized production, Ashbee's gild marked a distinct return to the Ruskinian and socialist principles that characterized the earlier work of the Arts and Crafts movement.

Ashbee insisted that crafts should be self-taught, the skill of the craftsman gradually evolving as his familiarity with the medium increased. He deliberately recruited unskilled workers, educating them through the gild's classes. Labor within the gild's workshops was undivided, with each craftsman involved with the whole production process. Moreover, gild members were encouraged to work cooperatively, each one in appreciation of the strengths and weaknesses of his or her comrades. The work produced by the gild – particularly its metalwork and furniture – was simple in design.

In 1902 the fortunes of the gild changed after it moved from the East End to Chipping Camden in Gloucestershire. The countryside was a more appropriate setting for a craft fraternity, and Ashbee established workshops in the run-down village with some 50 of his craftsmen and their families. By 1905, however, the gild's finances were looking precarious. A manager was appointed, and attempts were made to raise capital from shareholders but the company eventually went into voluntary liquidation.

THE SPREAD OF ARTS AND CRAFTS IDEALS TO AMERICA

Contact between the British Arts and Crafts movement and artists, architects, and designers in the United States was, at first, limited. The

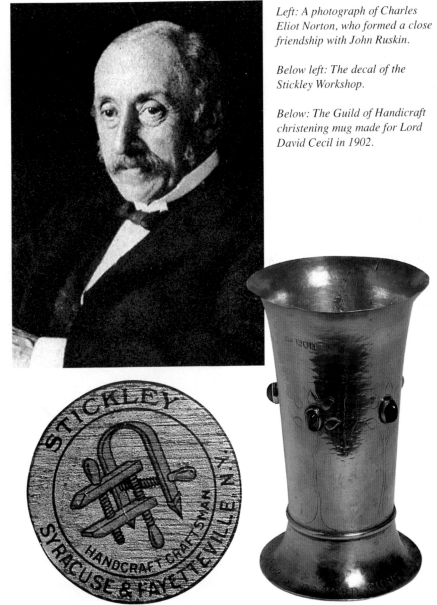

Left: A photograph of Charles Eliot Norton, who formed a close friendship with John Ruskin.

Below left: The decal of the Stickley Workshop.

Below: The Guild of Handicraft christening mug made for Lord David Cecil in 1902.

Above: The ethnographical room by Paul Hankar at the Exposition Internationale, Brussels, 1897.

Right: A Tiffany magnolia vase in silver, gold enamel, and opals, which was exhibited at the World Columbian Exposition, Chicago, 1893.

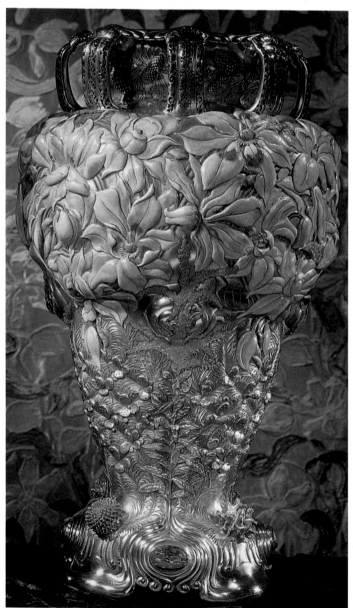

work of Downing, Renwick, and Jarves had been influenced by the revival of a Gothic style in Britain in the late nineteenth century, and Ruskin's writing had been enthusiastically received by some American painters and critics. A more substantial grasp of the movement and its application to American culture did not occur, however, until the Centennial Exposition held in Philadelphia in 1876.

Interest in the Arts and Crafts movement in the United States was, for the most part, inspired by British contributors to the exhibition. Robert Norman Shaw exhibited several influential designs for buildings in the Queen Anne style, and equally important in the evolution of the American craft ideal were the other British Arts and Crafts exhibits. Jeffrey & Co. – the firm that had printed Morris's first wallpapers – Fairfax Murray, Walter Crane, and the Royal School of Art Needlework had all contributed to the exhibition. In addition, the work and, to a lesser extent, ideals of William Morris were becoming increasingly well known in the United States.

Below: A silver tea set designed by Edward C Moore for Tiffany & Co.

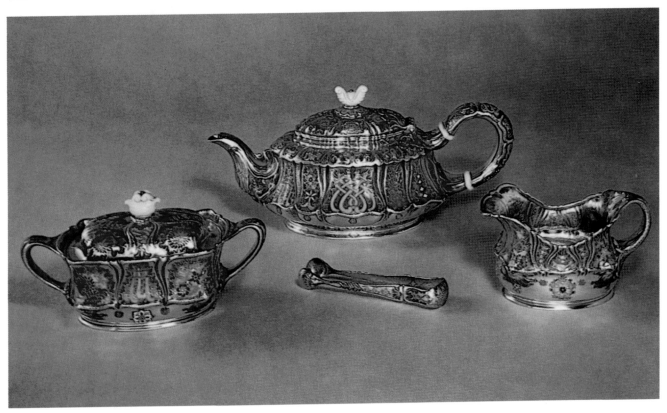

Below: An inkwell produced by the Wiener Werkstätte, which operated between 1903 and 1932.

THE SOCIETY OF ARTS AND CRAFTS

One of the oldest and most influential of the American groups was the Society of Arts and Crafts in Boston (S.A.C.B.), which was established in 1897 and is still in operation. Modeled on the Arts and Crafts Exhibition Society, it began as a group of 71 architects,

designers, craftsmen, philanthropists, and connoisseurs, but within 20 years it had attracted an international membership of close to 1000. The S.A.C.B. provided an important philosophical connection between the British and American branches of the Arts and Crafts movement, which was fostered by

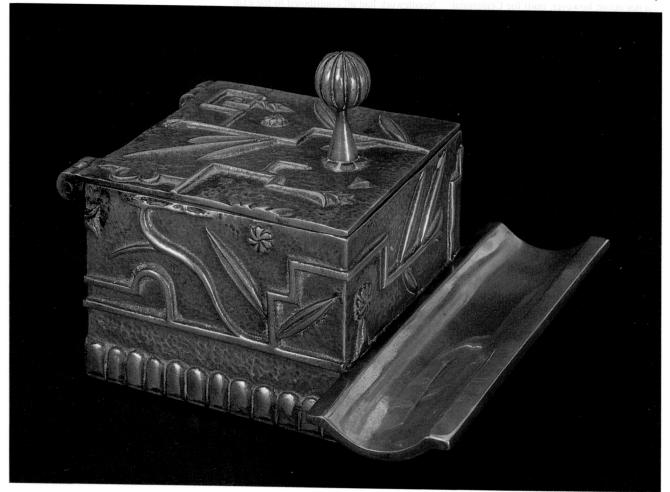

Charles Eliot Norton, the first president of the S.A.C.B. and a professor of fine arts at Harvard.

CHARLES ELIOT NORTON

While traveling in Europe between 1855 and 1857, Norton met John Ruskin, initiating a social and professional relationship that lasted for 45 years. Their friendship was fueled by a variety of shared pleasures and mutual concerns, including respect for the culture of the Middle Ages, dedication to the preservation of ancient architecture, and a belief in the restorative powers of the countryside. Their dismay at the encroachment of industrialization upon rural areas paralleled their concern for the working conditions of the contemporary craftsman. To both, early Italian cathedrals were symbolic of a more joyous and productive age, and as a buffer against the assault of the present each surrounded himself with the artifacts and arts of the past.

Later, while living abroad with his wife and young family, Norton also came to know Morris, Rossetti, Burne-Jones, and the essayist Thomas Carlyle. As a result of these contacts he became a life-long supporter of the goals and campaigns of the Arts and Crafts movement. Norton endeavored to revive the Arts and Crafts spirit in Boston and throughout the United States.

ARTS AND CRAFTS EXHIBITIONS

Few who acknowledged the need for design reform could escape the compelling arguments

Left: A cover for Deutsche Kunst und Dekoration [German Art and Decoration] *designed by Margaret Macdonald Mackintosh.*

Right: "Michaelmas Daisy" wallpaper designed by Morris & Co. and first produced in 1912.

Below: "Medway" printed cotton (registered in 1885), created by Morris at Merton Abbey using the original indigo discharge system.

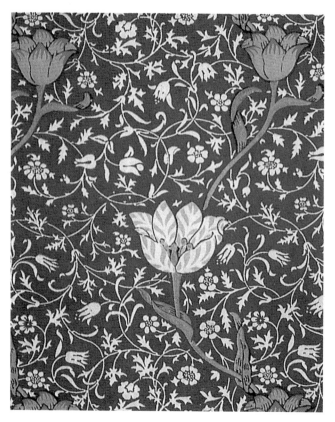

of such writers as Norton, Pugin, Ruskin, or Morris, whose works continued to inspire supporters into the second decade of the twentieth century. The challenge for their supporters lay first in translating their ideals into reality and then in convincing the public of the advantages offered by the products of the design-reform movement. One means was through public exhibitions of handicrafts, which were regularly held at local, regional, and national levels, under the auspices of various design-reform organizations, and were dedicated to elevating the standards of public taste. Since most of them were competitions as well as exhibitions, they also raised the technical and esthetic standards of the participants by stimulating a healthy professional rivalry.

WORLD FAIRS

World fairs provided an opportunity for international exposure, although their emphasis upon contemporary developments in machine technology seemed somewhat antithetical to the goals of the Arts and Crafts movement. Initially, design reformers participated in these events in limited numbers. Morris, Marshall, Faulkner & Co., for example, was among the few to represent the cause at London's International Exhibition of 1862. But eventually numerous adherents began to take advantage of the fairs to promote their work. They contributed hundreds of noteworthy displays, for example, to the palaces of manufactures, varied industries, and art at the Universal Exposition held in St. Louis, Missouri, in 1904.

Above: "Willow Boughs" wallpaper, designed by William Morris in 1887. Such a wallpaper emphasizes the flatness of the wall and avoids a false illusion of depth.

Below: Metal baskets designed by Josef Hoffmann, the cofounder of the Wiener Werkstätte and a member of the Vienna Secession, c. 1905.

This exposition was proof of the widespread and growing acceptance of Arts and Crafts ideals, with exhibits from every part of Britain, most major cities in the United States, and from many European countries, including Austria, Belgium, Denmark, France, Germany, The Netherlands, Italy, and Sweden. Together with those from Canada, the Far East, and South America, they demonstrated that the

Anglo-American movement for design reform had become international in scope.

THE DISSEMINATION OF THE IDEAL
The acceptance of the movement outside Britain can be attributed to a variety of other features. Its products and propaganda were featured in a growing number of periodicals with an international audience, including *The*

Studio, The Craftsman, Arte Italiana Decorativa ed Industriale, Art et Décoration, Dekorative Kunst and *Kunst und Handwerk*, as well as in such influential books as *Das Englische Haus [The English House]*, written by the German architect Hermann Muthesius.

The cause was the focus of international lecture tours during the last decades of the nineteenth century by such leading figures as Christopher Dresser, Oscar Wilde, Walter Crane, and C. R. Ashbee. Its attitude and approach were transmitted through travel or study abroad, and through the interchange between nation and nation of skilled designers and craftsmen. Imported and domestic examples of "art produce" were sold at an increasing pace in retail stores, which ranged from sales rooms associated with Arts and Crafts gilds or societies, to mail-order concerns, speciality stores, and department stores (the most

Below: A box made of various woods designed by Koloman Moser, the cofounder with Hoffmann of the Wiener Werkstätte, c. 1905.

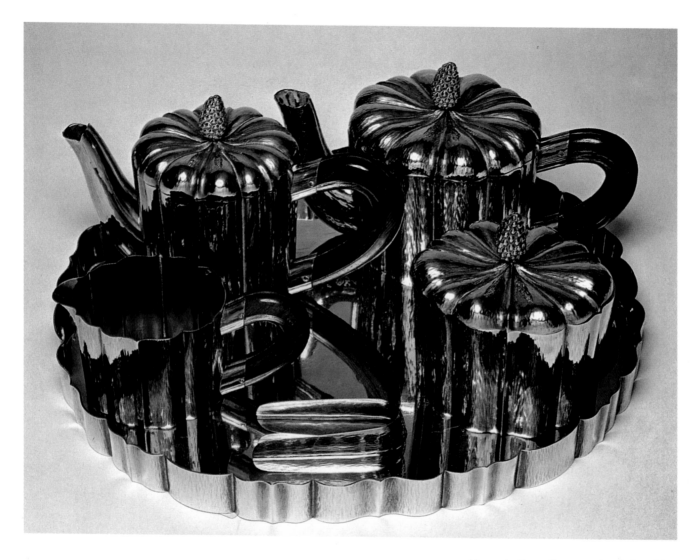

Above: A silver-gilt tea service designed by Josef Hoffmann in 1904.

influential being the London enterprise founded in 1875 by Arthur Lasenby Liberty).

EUROPEAN GILDS

While all of these played a part in furthering the Arts and Crafts ideal, the most effective means of dissemination remained the gild or society, based on British or American examples. Many organizations dedicated to design reform were established throughout Europe at the turn of the century, among them the Austrian Wiener Werkstätte and German Werkbund groups, and societies such as the Dansk Kunstfudforening (Danish Society for Industrial Arts), and the Svenska Slojdforeningen (Swedish Society of Industrial Arts).

THE WIENER WERKSTÄTTE

Founded in Vienna in 1903 by Josef Hoffmann and Koloman Moser, and financed by Fritz Wärndorfer and Otto Primavesi, the Werkstätte were influenced by the example of Ashbee in England and the many craft workshops that were springing up in Germany, and also claimed kinship with Ruskin and Morris. In their Werkstätte manifesto, Hoffmann and Moser made no distinction between the fine and applied arts and stressed that the design of objects should reflect the innate qualities of the materials from which they were made. These principles were applied to virtually all conceivable fields, from architecture and

Right: "Holland Park"-design Hammersmith carpet. This design was first produced for the home of A. Ionides at 1 Little Holland Park in 1883; Morris used it again for this carpet, made in about 1886–89, for Clouds, the country house of the Honorable Percy Wyndham.

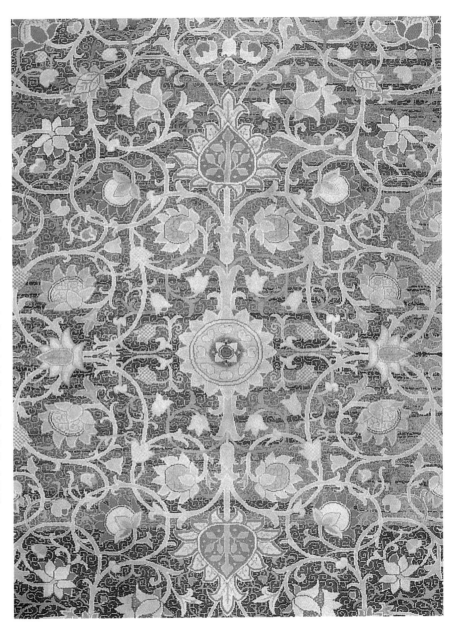

interior design, to fashion and cutlery, all of which were to be coordinated to reflect a distinctly modern spirit.

The Werkstätte maintained a very high public profile in both national and international exhibitions in Vienna, Rome, Cologne, and Paris, and stores selling Werkstätte products were located not only in fashionable quarters of Vienna, but also in Germany, Switzerland, and the United States.

The Werkstätte were ambivalent in their attitude to industry, vacillating between a respect for the handcrafted and the realization that no contemporary design workshop could ignore the increasing trend toward industrialization. A high respect for craftsmanship and the creative autonomy of its designers, a strong antipathy against poorly designed and mass-produced goods, and

funding from wealthy patrons did little to help the Werkstätte face up to the harsher side of the business world. In practice, the workshops' ideals proved contradictory.

THE UNION OF ART AND INDUSTRY

Although the European gilds differed in structure and membership, all promoted high standards of design and craftsmanship, and artistic cooperation. In doing so, they not only continued the campaign that had been launched by Pugin, Ruskin, and Morris, but also anticipated the union of art and industry that was to become the focus of design reformers during the twentieth century. In focusing on textiles and interiors, this book examines two of the main areas in which Arts and Crafts ideals were successfully harnessed to industrial practices.

Below: "Bachelor's Button" wallpaper, designed by William Morris in 1892, one of his few late wallpapers.

BRITISH TEXTILES AND INTERIORS

Previous page: An embroidered piano cover by C. R. Ashbee and the Guild and School of Handicraft.

Below: William Morris, photographed dressed in a hat and smock for work in the dye house.

Right: "Flowerpot" printed cotton, indigo discharged, designed by Morris and registered in 1883.

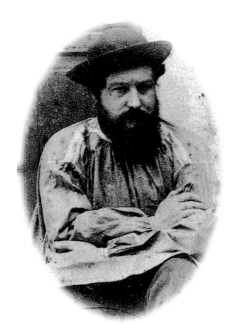

In an essay on art and crafts, William Morris wrote: "The special limitations of the material should be a pleasure to you, not a hindrance: a designer, therefore, should always thoroughly understand the process of the special manufacture he is dealing with, or the result will be a mere *tour de force*."

Nowhere did he himself apply this dictum more stringently than in his work with textiles. As in other fields, he wanted not only to recreate the beauty of medieval examples, but to recreate them under working conditions that would gratify their makers.

THE QUEST FOR AUTHENTIC COLOR

He soon realized, however, that the enduring color qualities that he admired in such historic textiles as the tapestries in great European cathedrals could not be achieved with commercial, synthetic dyes. He therefore set about reviving the ancient techniques of vegetable dyeing, conducting his earliest experiments in 1865 on wool and silk embroidery yarns at the premises of Morris, Marshall, Faulkner & Co. in Queen Square, London. These were, however, limited in scope, and in order to delve more deeply into the art he enlisted the aid of Thomas Wardle, a silk dyer and printer from Leek in Staffordshire. Their chief sources included early references, such as John Gerard's *Herball* of 1597 and 1636, as well as contemporary practical manuals, of which *L'impression des Tissus*, by Persoz, published in Paris in 1846, appears to have been the most useful. But it was not until 1881, when the firm acquired the Merton Abbey Tapestry Works, that he began to achieve truly successful dyes.

MERTON ABBEY

The tapestry works, which had been built in the eighteenth century as silk-weaving sheds

and were taken over by textile printers in the nineteenth century, were well located on the banks of the River Wandle, which provided a constant water supply. Here Morris installed the dye vats which enabled him to reinstate the ancient technique of indigo discharge printing. Indigo, along with woad, had been used for centuries to create deep and lasting blues, but the pigment could not be printed directly since it oxidized on contact with the air. The fabric had therefore to be dyed and the pattern afterwards discharged – or erased

Below: "Evenlode" printed cotton, indigo discharged, designed by Morris and registered in 1883, the first of the Morris designs to be named after a tributary of the River Thames.

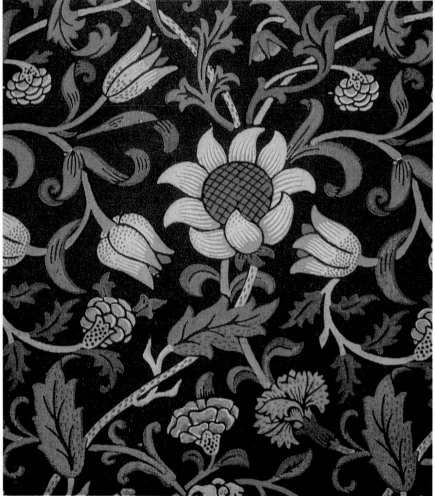

Below: A painting of the pond at Merton Abbey by Lexdon Lewis Peacock (1850–1919). The Firm moved to this idyllic setting on the banks of the River Wandle in Surrey in 1881.

– with a bleaching agent. This laborious process had been superseded for commercial printing by the introduction of the mineral Prussian-blue dye toward the end of the eighteenth century.

Morris, using the original indigo-discharge system, created some of his most memorable narrative designs, among them "Brer Rabbit," "Bird and Anemone," and "Strawberry Thief,"

for which Philip Webb is believed to have drawn the birds. "Strawberry Thief" is one of several where additional colors were added by overprinting.

BLOCK-PRINTING

For all of these, as for his other Merton Abbey printed textiles, Morris used hand-block-printing, the commercial application of which

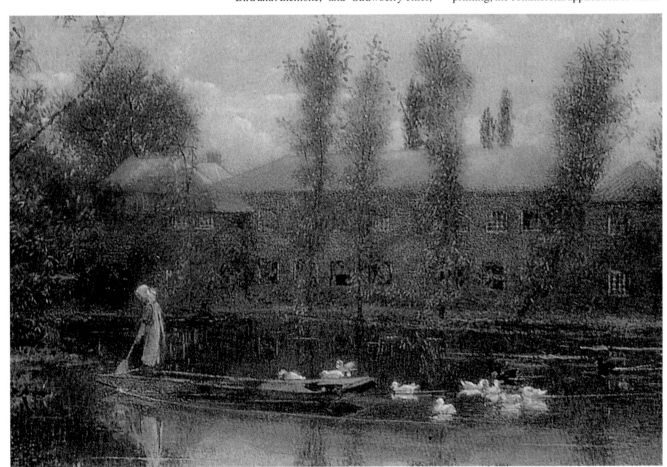

had fallen off considerably by the late nineteenth century, although it was still retained for some wallpaper and high-class furnishing and dress prints. The new and faster method of continuous printing using engraved-cylinder machines had largely taken over.

Block-printing held many attractions for Morris. It provided job satisfaction for the worker, offered no limitations to the color and scale of designs, and provided him with scope for farther experiments in discharge printing. On the negative side were the comparative slowness and the high cost. Although neither deterred Morris, they did mean that the fabrics were too expensive for anyone except the relatively rich. With this venture, nevertheless, he breathed new life into an old craft and paved

Left: "Brer Rabbit"' printed cotton, designed by Morris and registered in 1882. The name of this design refers to the Uncle Remus stories, which Morris and his children enjoyed.

Below: "Strawberry Thief" printed cotton, indigo discharged, designed by Morris and registered in 1883.

Right: "Wild Tulip" wallpaper by William Morris, 1884. Here, and in later papers, Morris makes extensive use of dots, produced by driving metal pins into the wood block, as shading on leaves and as background.

the way for farther developments in the twentieth century.

MORRIS'S PATTERN DESIGNS

His pattern designs both for textiles and wallpapers had a more immediate impact on the retail trade. From the *naïveté* of such early wallpaper designs as "Daisy," "Trellis," and "Fruit" (also known as "Pomegranate"), he soon advanced to the sophisticated complexity of overlaying "nets," or diapers, and diagonal "branches." These were often inspired by historic textiles, particularly Indian, Turkish, Persian, and Italian. The Italian silk-cut velvets acquired by London's South Kensington (now Victoria and Albert) Museum in 1883, for instance, have long been associated with such later print designs as "Wey," "Wandle," and "Kennet." Morris's woven textiles reflected the same sources.

WEAVING

Morris's involvement with weaving came later and brought him less personal gratification. Having mastered the principles by practicing with a toy hand loom, he acknowledged that the mechanical Jacquard loom could achieve the desired effects. Somewhat surprisingly, he regarded this method as an acceptable variant on hand-loom weaving. He had sufficient technical knowledge to produce the point papers which guided the weavers, who were, for the most part, outside contractors.

Historical models were, again, the chief sources for Morris's designs in weaving. Mythical beasts, birds, and dragons frequently appear, as do the familiar "turnover," or mirror-image, effects. Some of his designs were adapted directly from medieval Italian brocades and Spanish silks. His carpets, in turn, reveal strong links with their Eastern heritage.

CARPETS

Morris was more practical – realistic, in terms of public needs and public purses – in his carpet production than in any of his other endeavors. He was less insistent on historical precedent for the general market, even going as far as to create one pattern, a composition of repeating African marigolds, that was produced on linoleum, as well as a number of striking designs for manufacture by machine. His most respected carpets, however, were hand-knotted, employing traditional techniques of the ancient oriental carpets of which he was both a student and a collector. In his own homes, he used them more often as wall hangings than as floor coverings.

He by no means intended to copy, writing in a Morris & Co. brochure: "We people of the West must make our own hand-made Carpets if we are to have any worth the labour and money such things cost: and that these, while they should equal the Eastern ones as nearly as may be in material and durability, should by no means imitate them in design, but show themselves obviously to be the outcome of modern Western ideas." He and J. H. Dearle designed almost all of the carpets that were hand-knotted at Merton Abbey.

Above right: "Fruit," also known as "Pomegranate," wallpaper by William Morris, 1864. One of the first three wallpapers designed by Morris, it did not sell well.

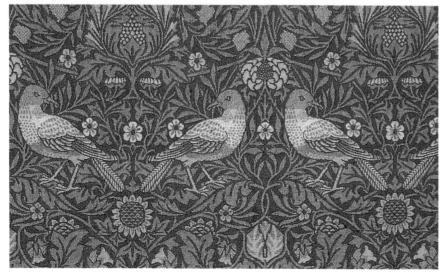

Right: "Bird" woven-wool double cloth, designed by William Morris in 1878 for the drawing room at Kelmscott House.

Below: A design for a rug by William Morris. Morris drew his carpet designs about one-eighth of the full size.

Below right: "Marigold" printed cotton by William Morris. It was first used as a wallpaper and was registered as a textile design in 1875.

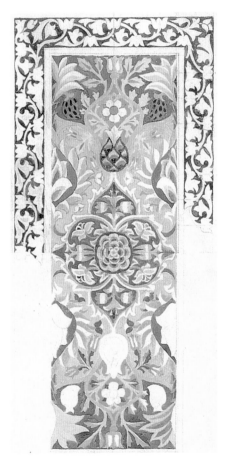

MORRIS'S TAPESTRIES

For Morris, tapestry constituted "the noblest of the weaving arts." Since it could be produced only by hand, it remained for him the most philosophically and technically linked to its medieval roots. Although his deep admiration for tapestry stemmed from his formative visits to France in the 1850s with Edward Burne-Jones, it was not until 1879 that he set up his first experimental loom in his bedroom at Kelmscott House, where he taught himself to weave with the help of eighteenth-century French manuals. After three months he produced an intricate panel, "Acanthus and Vine" – more affectionately known as "Cabbage and Vine" because of "the leaves' unruliness." It employed the "turnover" device, which he had already used to good effect in his woven designs.

This success led him to establish a loom at Queen Square, where he took on J. H. Dearle as an apprentice, who was to become one of the Firm's leading designers in all its many disciplines. Dearle subsequently trained others in the high-warp, or vertical, tapestry technique which Morris used, and which differed considerably from the horizontal, low-warp method of the only existing English producer, the Royal Windsor Tapestry Works. Production began on a large scale with the move to Merton

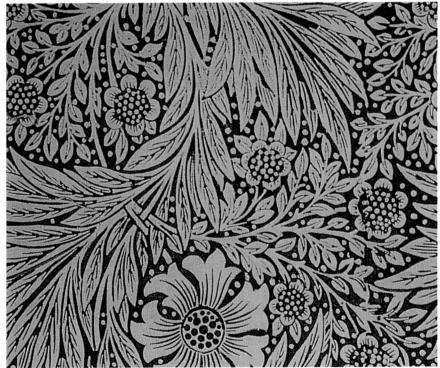

Abbey in 1881, where three looms could be accommodated, with as many as three weavers each working at at time, and capable of producing huge, wall-sized tapestries.

The designs came mostly from Morris and Burne-Jones. The latter was responsible for virtually all of the Pre-Raphaelite figures, some of which were originally intended for stained glass. Morris designed only three complete tapestries but provided much of the decorative detail for Burne-Jones's figures. Dearle also supplied background foliage and eventually complete schemes.

Morris's involvement stimulated a revival

Below left: "Lily" Wilton pile carpet, designed by William Morris in about 1875. It was one of the most popular of Morris's designs for machine-made carpets.

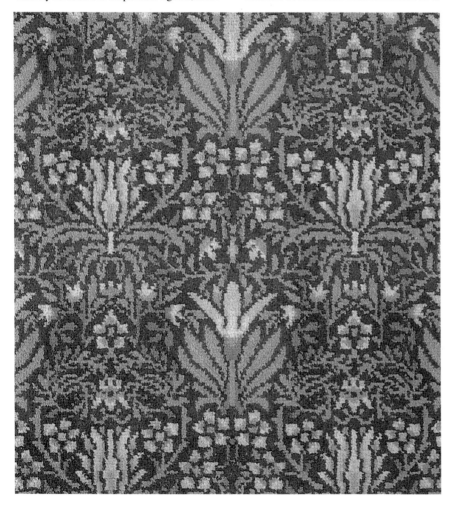

Below right: "Acanthus and Vine," Morris's first tapestry, which he called "Cabbage and Vine" because of the difficulty which he had with the acanthus leaves. It was woven in about four months in 1879 on the loom which Morris set up in his bedroom at Kelmscott House.

in tapestry production in Britain for a century. The Dovecot Studios, founded as the Edinburgh Tapestry Weaving Company in 1912 with weavers trained at Merton Abbey, was a direct outgrowth. The Merton Abbey Tapestry Works continued to produce for private houses, churches, and other large public places until World War II.

BRITISH EMBROIDERY

In Britain, the standard of embroidery had declined both technically and artistically by the middle of the nineteenth century. Originality had been discouraged a century earlier with the appearance of printed charts and patterns and had by now been almost obliterated by the popularity of Berlin woolwork. The influence of Pugin, among others, had brought about a dramatic upgrading in church embroidery from the 1840s.

MORRIS'S EMBROIDERIES

The architect G. E. Street, in whose office Morris was briefly articled during 1856, had been a prime mover in this renaissance. Street, a confirmed medievalist, undoubtedly helped to shape the young man's ideas about the ancient art. Certainly, embroidery was the first textile technique with which Morris became personally involved. He studied early English

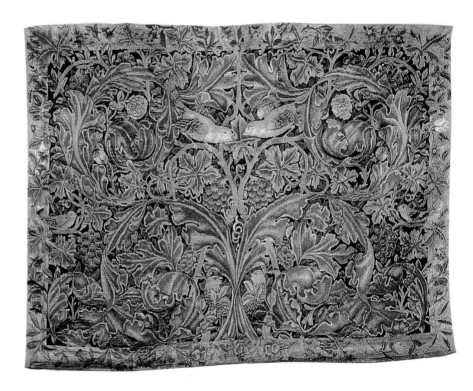

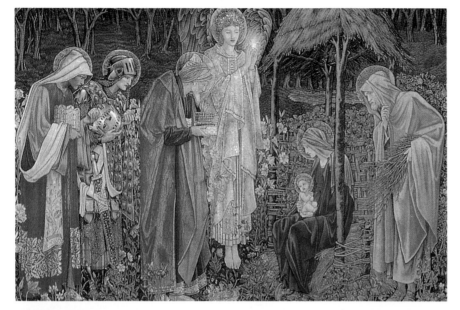

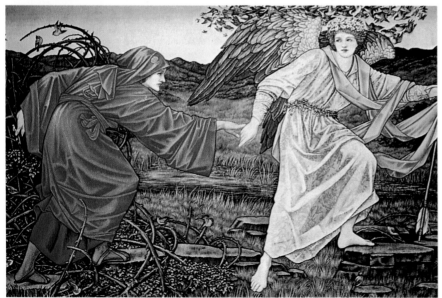

medieval ecclesiastical embroideries – *opus angelicanum* – but in his own early attempts he appears to have used wool yarn couched, or laid, on woolen fabric rather than the metal threads associated with ecclesiastical work.

His first known embroidery, repeatedly incorporating the words "If I can," was worked in aniline-dyed crewel wools with irregular long and short stitches, which created a heavy, tapestrylike piece. Having accomplished this, Morris embroidered no more, but, acting as teacher, passed the production on to others. He designed several friezes and panels for Red House, which were embroidered by his wife, Jane, and her sister, Elizabeth Burden. With the founding of Morris, Marshall, Faulkner & Co. in 1861, both domestic and ecclesiastical embroideries were undertaken, with the Firm's participating members all contributing designs and the work being performed only with yarns dyed to their specifications in their own premises.

MAY MORRIS AND THE ROYAL SCHOOL OF ART NEEDLEWORK

In 1885, Morris's daughter, May, took control of the embroidery section. A skilled craftswoman, she herself became an influential figure, the author of definitive book, *Decorative Needlework,* and a teacher in major

Above left: "The Adoration of the Magi," a tapestry designed by Edward Burne-Jones in 1887 and woven by Morris & Co. in 1890.

Left: "Love Leading the Pilgrim," a tapestry by William Morris and Edward Burne-Jones.

Below right: "Vine" embroidered hanging, designed by Morris and worked by May Morris and her assistants in around 1890.

Arts and Crafts schools, both in Britain and in the United States. These included the prestigious Royal School of Art Needlework in London, for which Morris and Burne-Jones had produced designs in its fledgling days.

Founded in 1872 under the patronage of Queen Victoria's daughter, Princess Christian of Schleswig-Holstein, the school was dedicated to the restoration of "Ornamental Needlework for secular purposes to the high place it once held among decorative arts." It provided training and employment for educated young women and encouraged them to reproduce the best examples of old English needlework. Its goal was the perfection of practical skills rather than of creativity, which

seems an ironic contradiction of Arts and Crafts ideals. Designs were provided in the form of sketches by leading artists and designers – Selwyn Image, G. F. Bodley, Walter Crane – some, including Morris patterns, are still available today.

OTHER EMBROIDERY SOCIETIES

Other, similar organizations grew up elsewhere. The Leek Embroidery Society, in Staffordshire, was established in 1879 by Elizabeth Wardle, the wife of the silk-weaver Thomas Wardle, who had helped Morris with his early dyeing experiments. The society gained a reputation for ecclesiastical work, heavily applying silk and gold threads to plain

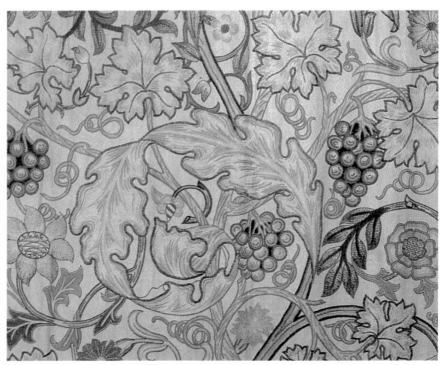

and printed tussore silk, brocades, velvets, and velveteens. It also used Thomas Wardle's silks, some of which had been printed with William Morris's designs.

In the south of England, at Haslemere, Surrey, Godfrey Blount established in 1896 the Peasant Art Society as part of a working community of artists and craftspeople, known as Peasant Industries, which looked to peasant crafts as a source of design. The society created hangings made of hand-woven linen, vegetable-dyed and appliquéd. With flat, unshaded areas and strong outlines, it achieved an effect that suggested stained-glass windows.

Liberty & Co., already known as a supplier of "art fabrics," was also instrumental in reinstating embroidery as a creative activity. The opening of its costume department in 1884 reinforced the importance of historical models as a source of visual and practical reference. Traditional crafts were also influential, and smocking became a speciality.

SCOTTISH EMBROIDERY

In Scotland, new ideas in embroidery were disseminated through educational institutions and exhibitions, the major contributors and innovators being women. Phoebe Traquair, one of the most talented, was skilled as a muralist, bookbinder, and enameler, as well as an

Below left: A hanging (detail) worked in silk on linen by Ann Macbeth, Glasgow, Scotland, c. 1900. This early piece shows how appliqué was developed to significant effect by Macbeth, following the example of Jessie Newbery.

Below: An artists' view of the Royal School of Art Needlework's workroom in 1904.

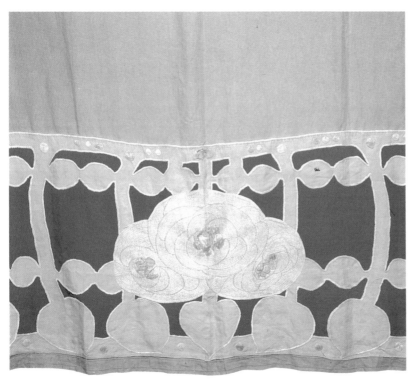

Below: An embroidery attributed to Anne Knox-Arthur, Glasgow, Scotland, c. 1900–10. The delicate colors and abstract motifs worked on coarse fabric are characteristic of the Glasgow style.

Right: A table runner in embroidered silk and linen, with appliqué cotton and cotton braid, attributed to Charles Rennie Mackintosh, Glasglow, Scotland, c. 1900–1. This piece was worked by Margaret Macdonald Mackintosh.

embroiderer. Her most ambitious piece of needlework, the "Denys" series, consisted of four screens depicting allegorical figures, and was extravagantly wrought in gold and silk thread on linen. This was displayed by the Arts and Crafts Exhibition Society in 1903, and other pieces of her work were exhibited regularly in Europe and the United States.

At the same time, the Glasgow School of Art was becoming a focus for a special form of creative activity in which art embroidery played a pronounced role. Leadership came first from Jessie Newbery, a teacher at the school, and later from three of her students: the Macdonald sisters, Frances and Margaret, and especially Ann Macbeth, who produced needlework in what became known as the "Glasgow style." This evolved by way of the techniques developed by Morris and the Royal School of Art Needlework into something distinctive and recognizable, involving the use of appliqué, minimal amounts of stitching and needle-weaving, on homely fabrics, such as hessian, unbleached calico, flannel, and linen. The purposes were practical – cushion covers, bags, belts, collars – and individual creativity

was encouraged. The decorative techniques were bold and simple, but they were wrought with perfection.

The style was characterized by soft tones of silver, pearl gray, pink, and lilac, usually set off by heavily embroidered lines and often including lettering. The motifs were more conventionalized than those typically associated with the Arts and Crafts movement. Florals and vegetation were common features and the stylized "Glasgow rose," which was probably invented by Jessie Newbery, appeared frequently.

BRITISH TEXTILE MANUFACTURERS

Despite his innovative involvement in the craft of textile manufacture, Morris had little effect on either the production methods or the structure of the textile industry. The basic design vocabulary remained constant: florals still predominated in chintzes, with the occasional addition of animals, birds, and figures. However, the patterns that Morris introduced did lead to an entirely new treatment of these traditional forms. During the 1880s and 1890s, the previously conventional patterns

of furnishing textiles and wallpaper became increasingly stylized, contributing profoundly to the development of Art Nouveau. And designers were becoming known as individuals. Manufacturers of British textiles had, in the past, insisted on anonymity, but by the end of the century they were revealing – even advertising – their designers' names. The example had been set by the Arts and Crafts Exhibition Society, which displayed both the name of the manufacturer and of the designer beside exhibits.

DAY, CRANE, AND VOYSEY
In the commercial textile trade, the patterns of Lewis F. Day, Walter Crane, and C. F. A. Voysey had particular impact. In 1881 Day was appointed art director of the Lancashire textile printers Turnbull and Stockdale. Although his floral designs for them often seem formal and derivative, they were important in conveying the new style to a wide public. Crane's patterns, by contrast, reveal a well-developed skill in portraying birds, animals, and the human form. He, too, designed a range of textiles, and wrote and lectured about ornament and design. Both men also created wallpaper patterns for Jeffrey & Co., the high-class London hand-block printers. Voysey's work was more original than that of the other two. He produced a vast number of textile and wallpaper designs, all reflecting his conviction that simplicity in decoration should be recognized as a source of richness. Initial reference to historical patterns developed into clear, flat colors, combined with florals, naïve figures, and birds. Unlike Morris, none of these men was involved in the production process, but they were dependent on the patronage of enlightened manufacturers to convey their designs to the public.

Left: "La Margarete" wallpaper panel by Walter Crane.

Below right: Wallpaper frieze by Rex Silver, produced by John Line & Sons, London, c. 1905. The stylized, linear motifs, typical of the Silver Studio's work between 1900 and 1910, replaced the full-blown Art Nouveau of the late 1890s and influenced the development of French decorative art in the early 1920s. John Line & Sons was a major hand and machine wallpaper printer.

LIBERTY & CO. AND SILVER STUDIO

Retailers also played a significant role in the process of dissemination, the leader among them being Liberty & Co. of London. In all of the many ways in which the store translated the Arts and Crafts ideal into commercial reality none was more far-reaching than its participation in this field of textiles.

Many of Liberty's most characteristic fabrics, including its famous "Peacock Feather," originated in the remarkable, London-based Silver Studio, which supplied the store continuously until World War II. Founded in 1880 by the fabric designer Arthur Silver, it was subsequently run by his two sons, Rex and Harry. Historic textiles provided the basis for many of their patterns and Arthur, a keen amateur photographer, produced a unique photographic record of historic textiles in the Victoria and Albert Museum which were

sold throughout the 1890s to progressive manufacturers. The studio was frequently required to adapt Morris patterns for machine production, which helped to bring knowledge of his designs, if not his philosophy, to the cheaper end of the market. By the turn of the century, two Silver Studio designers, Harry Napper and John Ilingworth Kay, were providing a strong stylistic impetus for Art Nouveau. Silver Studio designs were sold to manufacturers in the United States and Europe, as well as in Britain, the style-conscious French being among the most enthusiastic purchasers.

European and American Textiles and Interiors

The reverberations of the British Arts and Crafts movement continued to resonate strongly elsewhere in the world, but almost everywhere it was usually distinguished by a strong national identification rather than displaying a homogenous style.

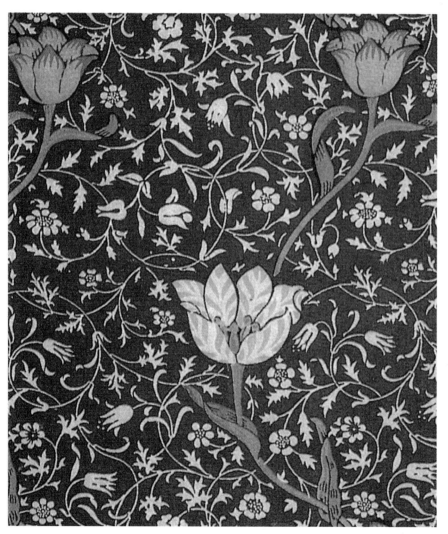

DECORATIVE MOTIFS

The decorative motifs found on surfaces, textiles, furnishings, and objects, many of which were of humble origin, reveal the provincial sympathies of Arts and Crafts designers. The decorative style, closely associated with the folk tradition, made use of geometrical shapes and established natural motifs, used singly or repeated in elaborate patterns or borders. The tulip, rose, leaf, and bird were popular devices, but the prevailing image was the heart. Leaded glass by American Will Bradley, closets by the British designer Charles Rennie Mackintosh, chair backs by C F A Voysey, and firedogs by Ernest Gimson all incorporated the popular image of the heart into their designs.

Broadly speaking, there are three explanations for the popularity of these motifs. Firstly, they were in stylistic harmony with the provincial nature of many Arts and Crafts designs. Secondly, their simple and direct form complemented the shapes and surfaces that they decorated. And thirdly, they were uniquely expressive of the positive, domestic virtues that design reformers hoped to re-introduce to daily life.

Previous page: Portière *by George W. Mahler and Louis J. Millet, U.S.A., 1901. Made in cotton and silk velvet, the design was appliquéd in cotton damask and embroidered in silk.*

Left: "Medway" printed cotton, indigo discharged, by Morris, registered in 1885.

However, despite their humble origins, they were incorporated into the designs with finesse. Accomplished designers were able to successfully combine the seemingly incompatible qualities of naïveté and sophistication.

Patterns that were derived from natural sources, often regional in their character, were equally sophisticated. The chintzes, wallpapers, and carpets that were characteristic of Morris immortalized the wild flowers and diverse plant life that can still be found in southeastern England. The mazy wall stencils and embroideries of Mackintosh provided variations upon the traditional Glasgow rose, which flourishes in Scotland's overcast, damp climate. Frank Lloyd Wright accurately rendered the weeds, seed pods, and trees of the American Midwest prairies in stained-glass windows, lighting fixtures, and carpets. And the thistles, pine cones, ivy, and shells of the northeastern United States were beautifully transformed in subtle tone-on-tone in Candace Wheeler's appliqués and tapestries. All of these demonstrate an inventiveness and originality that resulted from a detailed observation of nature. But, through the skilled application of color, composition, scale, and modeling, they were transformed from the commonplace into the extraordinary.

THE USE OF COLOR

Color, as one constituent of an overall design, was treated variously by Arts and Crafts architects and designers. The British designers

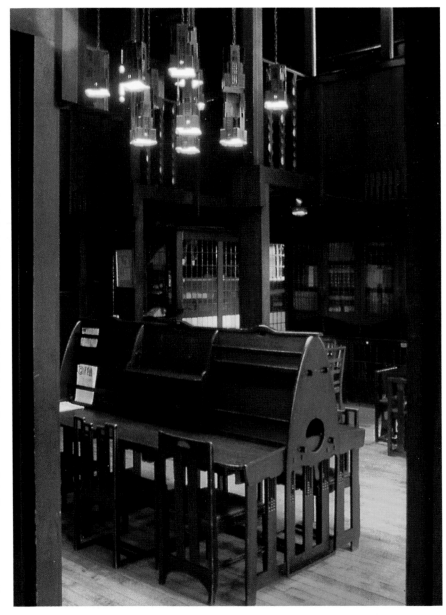

Right: Library, Glasgow School of Art, Glasgow, Scotland, 1877–99, 1907–9, Charles Rennie Mackintosh. The interior expresses a quest for verticality and light in the manner of the Gothic.

Below: "Brita's Forty Winks," illustration for Ett Hem, *by the Swedish painter Carl Larsson, 1899.*

Voysey and M H Baillie Scott, as well as the Swede Carl Larsson and the American Will Bradley, defined interior planes through the bold use of large blocks of vivid color. Another strategy, employed among others by Mackintosh and Josef Hoffmann, was to enliven designs of black, white, and gray with areas of striking color. Another group, including Philip Webb, Edward Ould, Stanford White, and Henry Hobson Richardson, offered a conservative approach. They incorporated chintzes, wallpapers or oriental rugs as subtle, multi-colored accents. However, the majority chose to emphasize the natural tones of struc-

tural materials, such as wood, stone, brick, plaster, metal, and leather, rather than adding bright colors to their designs.

TEXTILES

Like color, textiles played an important role in the aesthetics and practicality of an Arts and Crafts interior. A room's character could be changed by the extent to which textiles were used, with some designers padding every form and draping every surface. Others, including designers from later in the period and architects, chose to keep fabric and cushioning to a minimum.

Below: A love seat by John Henry Belter. Born in Germany in 1804, he emigrated to New York in 1833, where he lived until his death in 1863.

The use of textiles in some Arts and Crafts interiors displayed a continuity with the nineteenth century. Windows were decorated with draperies, while comfortable seating pieces were adorned with buttons, tufts, and trims. Walls above the dado were embellished with tapestries and the floors were covered by patterened rugs. Lambrequins sat on mantels, and cloths hung from table top to floor. The features of the room and frames of seat furniture were, as a result, hidden rather than openly exhibited. Arts and Crafts interiors in England, Scandinavia, and the United States were more likely to display such an expansive use of textiles than in other countries. Enterprises with a vested interest in their use, such as Morris & Co, Liberty & Co, and Associated Artists, made particular use of this style.

It was the woven and printed patterns they contained that distinguished these draped and upholstered interiors as products of the Arts and Crafts Movement. The subtle patterns appeared relatively flat to amplify the flatness of the planes which they covered. In contrast to the undulating, naturalistic patterns of the Victorian age, they tended to be stylized and conscientiously composed. Such stylization contrasted with the impression conveyed by large-scale, realistic patterns – that the user was interacting with living flowers or foliage in a domestic setting.

THE INFLUENCE OF OTHER STYLES
During the lifespan of the Arts and Crafts movement, this varied approach to the use of

Right: A hand-woven carpet by Eliel Saarinen, Finland, 1904.

color and textiles reflected the influence of other styles and movements then in vogue. Some had little impact on Arts and Crafts interiors, while others affected everything from color and texture, to form and motif, to broader issues of planning and arrangement. Among these were the Gothic Revival and High Victorian Gothic styles, the Old English, Queen Anne, Colonial, and Georgian revivals, as well as national Romanticism, and the English Domestic Revival movement.

SCANDINAVIAN TEXTILES

In Scandinavia, gilds and societies along Morrisian lines were formed to preserve traditional craft skills and to stimulate fresh interpretations of them. Schools of arts and crafts were opened in Stockholm, Sweden, and in Helsinki, Finland, and the public was encouraged to open weaving studios and to create work of its own. Design inspiration came initially from folk patterns, but the reawakened artistic spirit soon led to the emergence of new forms. In Finland, Axel Gallen-Kallela employed brilliant, flamelike motifs in his textiles. He produced as bed covers hand-knotted, shaggy-pile *ryijy* rugs of the type originally made by peasants to put on the floor. Gabriel Engberg also contributed decisively to the revival of the *ryijy* with her use of bold geometrics.

NORWEGIAN TEXTILES

Following the lead given by the Paris Exposition Universelle of 1900, which demonstrated how effectively influences

Left: Variation II, *by the German artist Paul Klee, 1924. Klee contributed to the work of the Bauhaus's stained-glass and weaving workshops.*

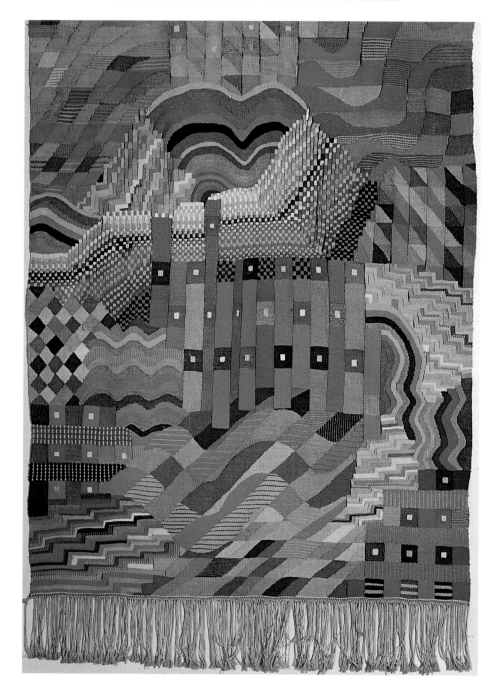

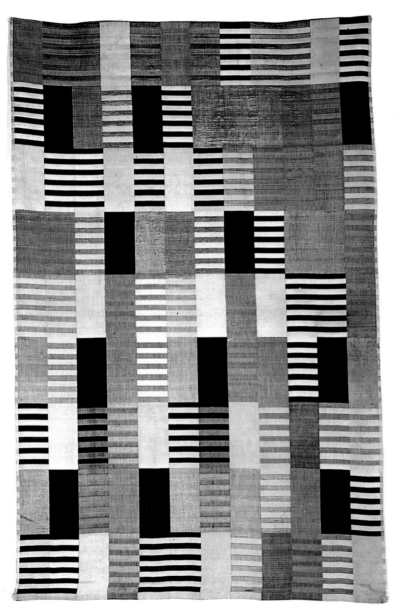

from abroad could be united with native techniques, the Norwegians turned to eighteenth-century tapestries for a lead. They coupled stylized biblical motifs with the heroic dragon found in their own Norse legends to achieve striking results. This fusion can be seen most markedly in the work of the Impressionist painter Gerard Munthe, who led a tapestry revival that parallels William Morris's activities at Merton Abbey. He developed advanced ideas on the use of stylization, which he put into practice in a long series of cartoons derived from folklore subjects. The tapestries were then made up by professional weavers. Munthe's "The Three Suitors," woven for the 1900 Paris Exhibition, for example, reveals the successful amalgamation of medieval tradition that Munthe achieved with his own, contemporarily flattened, linear style.

Frida Hansen, another of Norway's most important designers and weavers, was also initially influenced by a combination of tradition and the new styles that she encountered on a visit to Paris in 1895. In 1897 she founded the Norwegian Tapestry weaving studio in Oslo, where she devised a method of "transparent" weaving, in which areas of the warp were left exposed to contrast with large, stylized floral motifs in bright colors.

Left: A woven-silk tapestry made by Anni Albers at the Bauhaus weaving workshop in 1926.

Opposite page: Slit gobelin with linen warp and cotton woof, woven in the weaving workshops of the Dessau Bauhaus by Gunta Stölzl, 1927–28.

Below right: A cotton carpet designed for a nursery by Benita Otte at the Bauhaus, 1923.

SWEDISH TEXTILES

In Sweden, the Friends of Textile Art Association (Handarbetetsvanner) was founded to give women independence and to revive old textile techniques. The Swedish craft heritage was reexamined under the influence of the writings of Morris and Walter Crane. New designs were devised which enhanced old techniques, and craft and home *slojd* exhibitions were held throughout the country.

EASTERN EUROPEAN TEXTILES

A similar arts and crafts reawakening was taking place in eastern Europe, with traditional folk-art techniques providing sources for

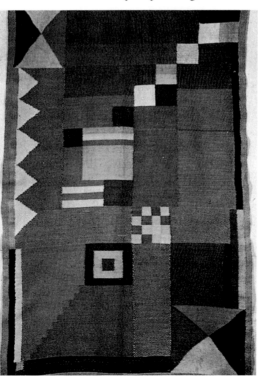

woven textiles and lace. In Hungary, geometrical folk weaves revealed a combination of peasant art with a distinguishable and unique Scandinavian influence.

In Czechoslovakia, the painter, designer, and weaver Rudolf Schlattauer founded a tapestry factory which aroused nationwide interest in textile art. This was evidenced in the relocation of Slovak arts and crafts from rural, peasant villages to professional, urban centers. Polish tapestry-weaving remained a part of that country's folk culture until the early twentieth century, when it also became subject to a more professional approach.

Cottage industries also persisted in Russia, especially in more remote areas. Women spun, wove, and vegetable-dyed linen and wool for garments, which they embellished with drawn-threadwork and other forms of embroidery, using designs handed down through the generations. These were gradually taken up by Moscow artists, such as Nathalie Davidoff and Victor Vasnietzoff, who wanted to help to preserve the village crafts. They, in turn, designed embroideries for execution by peasant women, often based on local legends and fairy tales. Even here, there were marked Arts and Crafts overtones. Ruskin and Morris had made their mark.

GERMAN TEXTILES

The Deutscher Werkbund, a confraternity of craftsmen, architects, and industrialists, was formed in 1907 from a number of *Werkstätte* (workshops) dedicated to the reform of the applied arts. The Werkbund went from strength to strength, with almost 2000 members by the beginning of 1914. Its progress was, however, interrupted by the outbreak of World War I. Following in its tradition, the Bauhaus served as one of the last significant staging posts of

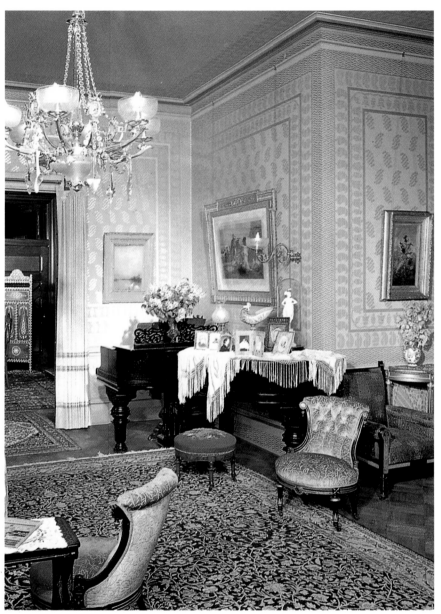

Left: The drawing room at Mark Twain's house, Hartford, Connecticut, by Associated Artists. The textiles, wallpaper, and carpets show how Associated Artists successfully developed its own Arts and Crafts style of interior decoration from historical influences to create an atmosphere of restrained elegance.

Below: A photograph of Candace Wheeler, one of the most prominent designers in the American Arts and Crafts movement.

the Arts and Crafts tradition. It was established in 1919 under the direction of Walter Gropius and had emerged from the amalgamated schools of fine and applied arts in Weimar. The program of the Bauhaus contained a number of ideals common to the Arts and Crafts tradition, the prime point of departure being handicraft. It moved to Dessau in 1925 and closed in 1933.

Weaving, and later wallpapers, were two of the most commercially successful fields of Bauhaus production. One of the principal departures of the Bauhaus weaving style was its rejection of the pictorial mode which had dominated late-nineteenth-century and Art Nouveau hangings, the majority of which were in traditional tapestry weave. Many of the Bauhaus weavings were designed under the influence of the artist Paul Klee, who took a particular interest in the workshop, but while these and other "artist"-designed pieces show a strong individualism, they are all executed in abstract patterning.

The products of the weaving workshop can be divided into four groups – individual pieces, commissioned works, series designs made in quantity at the Bauhaus itself and, fourthly, prototypes for industrial mass production. The workshop was taken over by Gunta Stölzl in 1927 (she had been a Bauhaus student), followed by Anni Albers in 1931, and finally by Lilly Reich in 1932. These three, and other talented designers, including Lies Dienhardt,

Right: Candace Wheeler, portrayed in this marble bas-relief by L. Thompson, was an enthusiastic force in the American revival of embroidery as an art form.

Martha Erps, Gertrud Hautschk, Ruth Hollos, Benita Otte, and particularly Otti Berger, all produced splendid work. Firms which produced Bauhaus textiles included the Polytextil Gesellschaft of Berlin and Pausa of Stuttgart. Wallpapers were produced by Rasch between 1930 and 1931.

THE UNITED STATES

In the United States, where needlework skills had languished after the Civil War, new impetus was provided by the display of London's Royal School of Art Needlework at the 1876 Philadelphia Centennial Exhibition. So impressed was Candace Wheeler, a prosperous, artistically influential woman, that she was prompted in 1887 to found the New York Society of Decorative Art, which she envisaged as an "American Kensington School," with the objective of providing women with the opportunity to produce high-quality work that would not only be valued by society but would

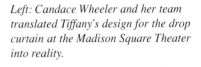

Left: Candace Wheeler and her team translated Tiffany's design for the drop curtain at the Madison Square Theater into reality.

also be both recreational and profit-making. Its scope was wider than that of the Royal School of Art Needlework, but art needlework was its chief focus. Englishwomen crossed the Atlantic to teach technique and design to this society, and to others which it generated in major American cities. Output included lace, ecclesiastical embroidery, hangings, and tapestries, as well as sculpture, painting, wood-carving, and pottery.

ASSOCIATED ARTISTS

Candace Wheeler herself moved dramatically into commerce when, in 1879, she entered into

Right: Samuel Colman, the watercolorist, was a collector of textiles. He traveled with Tiffany in the Middle East and both artists were fascinated by the designs that they saw. Tiffany was to build up a huge collection of oriental carpets. This sixteenth-century needlework carpet is from Turkey.

partnership with L. C. Tiffany to form Associated Artists, which rapidly became one of New York's leading interior-decorating firms. Also involved were the textile designer and colorist Samuel Colman, and the ornamental wood-carver Lockwood de Forest, who worked as a team from their Fourth Avenue atelier, much in the spirit of Morris & Co. They had planned to run a studio following the example of a Renaissance workshop, with Tiffany as the creative center surrounded by assistants working in a variety of media, but ultimately the company had few parallels with Morris's experiment. The company worked mainly in the fields of glass and fabric design; its original purpose was ambitious: to establish an alliance between art and industry and to revive the standards of domestic taste in the United States.

The textiles designed and produced by Associated Artists included luxurious drapes, *portières,* and wall coverings, which made use of embroidery, needle-woven tapestry, and loom weaving. The studios undertook commissions on the highest levels, from decorating the White House in Washington, D.C., for President Chester Arthur, to creating opulent bed-hangings for the London home of Lillie

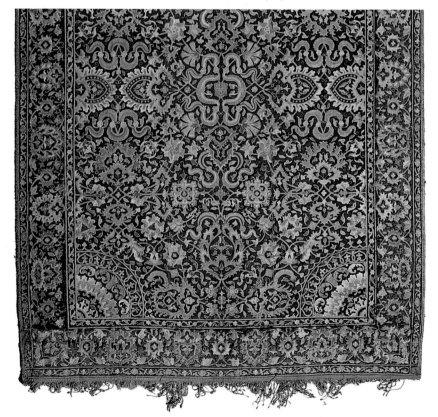

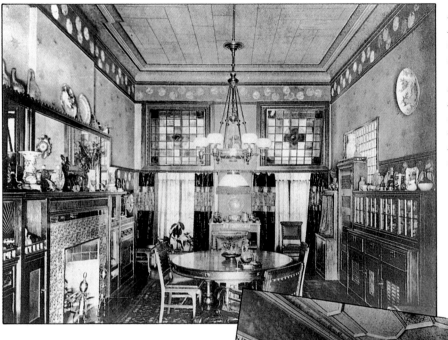

Left: The dining room designed by Associated Artists for Dr William T. Lusk's residence (1882); the drapes and carpet reveal Colman's interest in ornate textiles.

Bottom left: The parlor designed by Associated Artists for J. Taylor Johnson in 1881. The use of sumptuous textiles and wall decorations were to give Associated Artists a reputation as being exceedingly "artistic."

Langtry, which were embroidered in silk with "sunset-colored" roses. The company split early in the next decade, with Tiffany and Wheeler working independently, the one trading as Louis C. Tiffany & Co. and the other (Wheeler) as Associated Artists. Louis C. Tiffany's work is well documented. Less well known, and more germane to the Arts and Crafts tradition in the United States, was the work of his associate, Candace Wheeler.

Candace Wheeler was the prime mover in initiating "genuine" American designs, turning for inspiration to traditional patchwork, indigenous flora and fauna, and events from American history and from literature. These were produced commercially for her by, among others, the Connecticut silk manufacturer Cheney Brothers. She was also personally involved with tapestries and patented a method of weaving in which a needle, rather than a shuttle, carried a soft weft across a durable silk canvas especially made for her by Cheney Brothers. Although the process was too costly to be financially viable, Associated Artists

produced several major pieces, including "The Miraculous Draft of Fishes," and "The Hiawatha Tapestry."

REVIVING INDIGENOUS TECHNIQUES

The last decades of the nineteenth century witnessed the formation of numerous American societies and schools which stimulated interest in textile arts and crafts and promoted the use of old techniques, such as netting and candlewick. Native American arts – particularly Navajo weaves – came to be prized and emulated for their striking patterns and simplicity of production on basic hand looms. Similarly functional ragrugs, which had originally been made from used fabric, were now created from new materials, thus ensuring control of the designs.

By the turn of the twentieth century, however, the influence of the British Arts and Crafts movement had subsided. The United States had succeeded in evolving original designs and techniques by looking at its own heritage. It should be noted, however, that the concepts of a "national art" differed across the country. On the East Coast, Morrisian communities were founded, and furniture and other decorative items were made which had a direct resemblance to the British movement. In California, however, the climate and landscape, and also the impact of the destruction of San Francisco in 1906, led to different interpretations. Morris's return to the medieval European past was supplanted by the recognition of California's own past: its Spanish-Mexican and Native American culture.

BREAKING THE BARRIERS

As in Britain, the Arts and Crafts movement broke the barriers of imitation in commercial areas such as wallpaper and fabric design and graphics. The adoption of Art Nouveau styles by firms such as the York Wallpaper Co. or M. H. Birge & Sons allowed people to see for the first time that contemporary design was available to them.

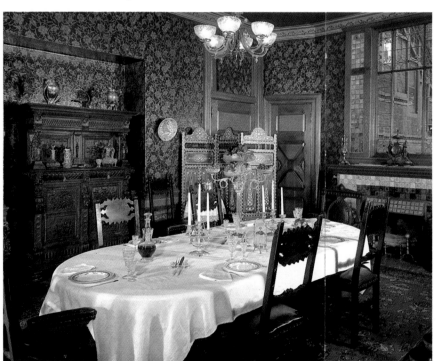

Right: The dining room that Associated Artists designed for Mark Twain's house in Hartford, Connecticut.

ARTS AND CRAFTS MOVEMENT

GLASS AND POTTERY

AN ECLECTIC MOVEMENT

Reactionary, revolutionary, romantic, and rationalist are epithets applicable to the work of the men and women of the Arts and Crafts Movement on both sides of the Atlantic. A survey of the Arts and Crafts Movement, from its origins in the writings of Pugin, Carlyle, and Ruskin to its effective demise in Nazi Germany, shows that it was nothing if not diverse. If the Arts and Crafts Movement is so varied a conglomeration of both theory and practice, what, then, binds it together as a movement?

Opposite: A design for a dado by the British artist Walter Crane.

Below: A potrait of William Morris, a cornerstone of the British Arts and Crafts Movement.

In order to appreciate the factors that bind Ruskin, Wright, Hubbard, Gropius, Morris, and others together and to grasp the long-term significance of the Arts and Crafts Movement, one has first to take into account the aims and intentions of other movements in art over the past century or so.

Around the middle of the nineteenth century, an attitude evolved which maintained that art existed in a vacuum with no direct reference to the society from which it sprang. Art had no particular social use and those that produced it shunned public approval and, in some instances, deliberately courted public censure. This tendency was evident in the art and literature of nineteenth-century France. It was also apparent in the works of Wilde, Swinburne, and Whistler, as well as in the aspirations of Art Nouveau, and it continued in a variety of forms throughout the twentieth century. The tradition continues in our own time, in that perfectly ordinary, intelligent people are quite unable to understand the art produced by their own society.

SOCIAL UTILITY

The notion that art is a highly refined activity with no particular role; that it has its own arcane, internal logic outside the grasp of the ordinary citizen; and that it is practiced by

Right: The front page of the first edition of The Craftsman, *published by Stickley's United Crafts in the U.S.A. in 1904.*

THE CRAFTSMAN

VOL. VI APRIL 1904 NO. 1

COPY 25 CENTS PUBLISHED MONTHLY BY THE UNITED CRAFTS SYRACUSE·N·Y· U·S·A· YEAR 3 DOLLARS

specialists for specialists was vehemently rejected by many within the Arts and Crafts Movement. The movement, albeit in a number of ways, sought to afford art social utility. Under the protection of Pugin, art's purpose was to revive the architectural idiom of the Middle Ages and with it the finer spiritual feelings of the period. For Morris, art was predicated upon fulfilling work – and fulfilling work ultimately demanded vast social and economic change. In addition, art could be purged of much of its sophistication and refinement. For Morris and Ruskin, art became the democratic cultural expression of a community and needed no high priests in the form of artists to exercise the rite.

In the United States, the Arts and Crafts tradition was an aide to establishing a national identity founded upon independence, work, and democracy. In Germany, the Arts and Crafts ideal again had a social application, be it (in Muthesius's case) to fashion a cultural and economic identity for bourgeois Germany or (in the case of the Bauhaus), to propagate, with the aid of machinery, logically designed, mass-produced goods for mass markets.

Public utility and a missionary zeal to improve the lots of producer and consumer are the only call to which all craftsmen and -women associated with the Arts and Crafts Movement could easily rally. The call was, however, quite distinct from others to which artists have rallied: unlike the plethora of styles and "isms" that appear throughout the nineteenth and twentieth centuries, arts and crafts, like the arts of the Middle Ages, were

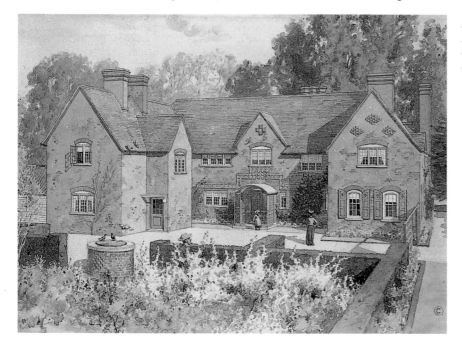

Left: A perspective drawing of Ernest Newton's Fouracre at West Green, Hampshire, by Thomas Hamilton Crawford, 1902.

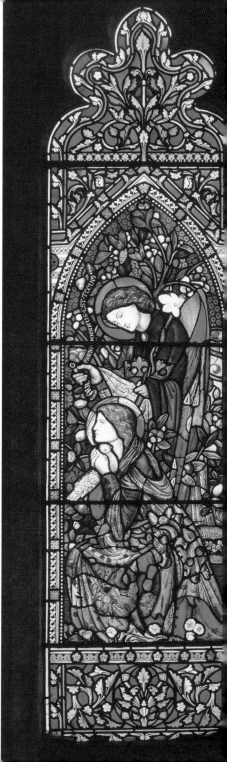

Above: This stained-glass window was one of 15 designed by Tiffany Studios for a church in Petersburgh, Virginia.

Right: The stained-glass Scene from the Annunciation, *by Edward Burne-Jones, 1860, for St .Columba's Church, Topcliffe, Yorkshire, England.*

projected once again into a public rather than a private arena.

SOCIAL PURPOSE

The real nature of the Arts and Crafts Movement was one of social purpose rather than style. This is worth remembering in an age when the outward signs of the movement – its picturesque qualities, its taste for a pastoral idyll and the handcrafted – have made the movement very popular again. The Arts and

Crafts Movement finds its true spirit repeated not in Post-Modernist building in homely brick rather than aggressive concrete, or in the pastoral reminiscences of long-dead Edwardian amateurs, or in the romanticism of fashion houses or advertising agencies that trade in resonant ideals of a picturesque countryside, but in the political, social, and cultural bullwarks against the age of "Gradrind," an age that is by no means limited to either the nineteenth century or England.

THE EVOLUTION OF THE ARTS AND CRAFTS MOVEMENT

The Arts and Crafts Movement evolved and developed during the second half of the nineteenth century. It incorporated a wide variety of artists, writers, craftsmen, and -women, so wide that it is difficult to define "Arts and Crafts" with any accuracy. One has only to consider that some of its precursors were deeply conservative and looked wistfully back to a medieval past, while others were socialists and ardent reformers. Some, like John Ruskin (1819–1900), identified the Arts and Crafts esthetic with Protestantism, while others, such as the architect A. W. N. Pugin (1812–52), saw clear affinities between the revival of medievalism and the Catholic cause. Moreover, the craftsmen and -women connected with the movement were active within a wide cross-section of crafts: as architects, printers, and bookbinders, potters, jewelers, painters, sculptors, and cabinetmakers. Some members of the movement, such as the designers William Morris (1834–96) and C. R. Ashbee (1863–1942), cherished handicraft and tended to reject the opportunity to produce for a mass market. Others, such as the architect Frank Lloyd Wright (1867–1959), positively relished the creative

and social advantages of machine production.

THE SPREAD OF THE ARTS AND CRAFTS MOVEMENT

The Arts and Crafts Movement became even more diverse during the 1870s, when the revival of an interest in the arts and crafts in Britain was exported and grafted onto indigenous traditions abroad. In the United States, the revival of craft traditions had a resonant appeal to a nation with a strong political affinity with individualism and for things handmade and homespun. It is interesting to note that decades before such critics as Thomas Carlyle (1795–1881) or Ruskin were writing about the horror of industrialism and the idyll of rural medieval England, Shaker communities in the United States were producing simple furniture and buildings that echoed many of the creative and social ideals of the Arts and Crafts Movement. Friedrich Engels (1820–95) dissociated himself from the religious faith of the Shakers but admired the near-socialist conditions under which their work was produced and sold.

ARTS AND CRAFTS PRINCIPLES

The revival of arts and crafts in the second half of the nineteenth century embodied a rich and varied tradition of political, religious, and esthetic ideas that found form in a variety of media, yet there were some principles and articles of faith common to the Arts and Crafts Movement in general. The belief that a well-designed environment – fashioned with beautiful and well-crafted buildings, furniture, tapestries, and ceramics – would serve to improve the fabric of society for both producers and consumers is a theme common to the Arts and Crafts Movement in both the nineteenth and twentieth centuries. The idea

Above: An example of the work of the *Kelmscott Press, 1896.*

Below: Morris's "Trellis" wallpaper, 1862.

was expressed by William Morris in the middle of the nineteenth century and repeated constantly thereafter by kindred spirits in Europe and the United States.

WORKING CONDITIONS

Together with the idea that the material and moral fabric of society were connected, there existed an interest in the working conditions under which the artifacts were produced. A building or piece of furniture, according to the aims of the Arts and Crafts tradition, had not only to be beautiful but also to be the result of contented labor, in which the craftsman or -woman could reject the drudgery and alienation of factory work and delight in simple handicraft. The movement's precursors, Carlyle and, more particularly, Ruskin and Morris, had virtually characterized labor as a sacrament. It was through the medium of work, they maintained, that men and women expressed not only their individual creativity but also the essence of their humanity. In his Lectures on Socialism, Morris wrote that "Art is Man's expression of his joy in Labour," an expression that the pressure of industrialized factory work had rendered impossible. Morris

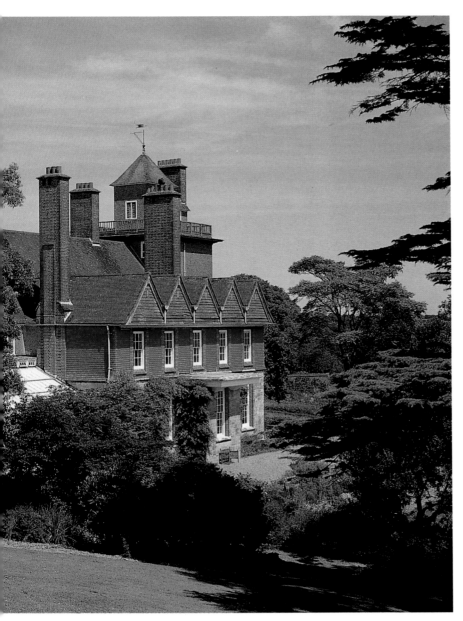

Left: Standen, near East Grinstead, Sussex, designed by Philip Webb in 1892 for James Beale, a London solicitor. The house contains work by Morris, W. A. S. Benson, and George Jack, together with a number of other employees of Morris & Co.

continued: "Since all persons . . . must produce in some form or other it follows that under our present system most honest men must lead unhappy lives since their work . . . is devoid of pleasure." Or, put more succinctly, that in Victorian society, as far as Morris was concerned, "happiness is only possible to artists and thieves."

THE RETURN TO A GOLDEN AGE

It was the desire to improve both esthetic standards and working conditions that generated a further article of faith shared by many active within the Arts and Crafts Movement: the belief that the material and moral fabric of society had been infinitely better at some time in the past, be it the England of the Middle Ages or the America of the pioneer age.

The ethos of industrial capitalism demanded production for profit rather than need and had generated shoddily designed goods in the process at the expense of both their esthetic appeal to consumers and the well-being of the workforce. These miserable conditions were in stark contrast to those of preindustrialized past in which, it was generally believed, production took place under far more wholesome conditions. The crafts of medieval society had none of the engine-turned precision of modern industry, but they retained the sense of humanity that Ruskin so admired. Writing

Right: A photograph of the Hammersmith branch of the Socialist League. Morris is fifth from the right in the second row. May Morris, wearing a light dress, is in the center of the front row. Jenny Morris is second to the left of her.

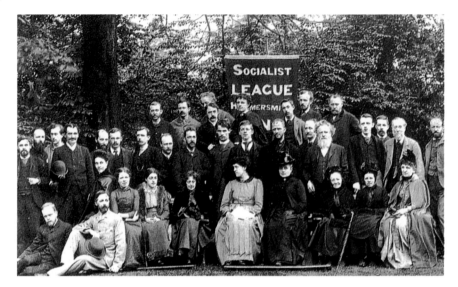

Below: An Arts and Crafts table, casket, and candlestick.

in "The Nature of Gothic" in the second volume of *The Stones of Venice*, published in 1853, Ruskin insisted that "You must make either a tool of the creature or a man of him. You cannot make both. Men were not intended to work with the accuracy of tools, to be precise and perfect in all their actions. If you will have that precision out of them, and make their fingers measure degrees like cog-wheels, and their arms strike curves like compasses, you must unhumanise them."

HUMANITY OVER INDUSTRIALISATION
Preindustrial society, then, was understood to have retained precisely that element of humanity that industrial capitalism lacked. Men and women were not bound by the relationship of master and wage-slave, based on alienating and mechanized factory labor, but lived as a human community centered upon the workshop, where they were employed in useful and creative tasks. The admiration for

some romanticized, preindustrial Utopia was endemic among nineteenth-century critics of industrialism – so endemic, in fact, that an echo of the sentiment even permeates the *Economic and Philosophical Manuscripts* of Karl Marx (1818–83). Not generally known for his romanticism, Marx found and admired in the working conditions of medieval society "an intimate and human side" that was resolutely absent in the factory sweatshops of the industrialized nineteenth century.

TRYING TO RESOLVE THE PARADOX
Not all of the ventures that took place under the banner of the Arts and Crafts Movement were an unqualified success. William Morris, toward the end of his life, expressed profound doubt about the real value of his work and maintained that the undeniably beautiful work produced by his company was undertaken only for the wealthy. There were, in turn, numerous other well-intentioned craft ventures

Left: St. Peter and St. Paul, *a stained-glass window designed by William Morris and Ford Madox Brown, 1865, for Middleton Cheney Church, Northamptonshire, England.*

Below: The Six-mark Teapot, *by George Du Maurier, from* Punch, *July 17, 1880.*

that began with great optimism only to end in bankruptcy. Morris had stumbled on a paradox that affected all evangelistical craftsmen and -women active within the movement in England and the United States: objects made by hand are far more expensive than those made by machine and necessarily exclude the disadvantaged masses for whom they were intended. Ultimately, there came to the Arts and Crafts Movement the realization that the social reform demanded by many craftsmen and -women could not be achieved by the Arts and Crafts Movement alone, and there was a catalog of attempts to resolve this paradox.

A HISTORY OF COMPROMISES

In fact, the history of the Arts and Crafts Movement is, in many respects, a history of compromises, and the various attempted solutions to this paradox throughout the evolution of the movement, from the romantic refuge from industrialization sought by the Pre-Raphaelites and their circle in the mid-nineteenth century to the development of the craft fraternities and sororities on both sides of the Atlantic to the establishment of the European and American design factories in the twentieth century that compromised earlier romantic ideals and came to terms with mechanized industry. Concentrating on the media of glass and pottery, this book illustrates the ideals of the adherents of the Arts and Crafts Movement as embodied in their work.

Above: Part of a scene depicting the Flight into Egypt, designed by Edward Burne-Jones in collaboration with Morris & Co. for St. Michael's Church, Brighton, England..

ARTS AND CRAFTS GLASS

Previous page: A boudoir lamp by Frederick Carder, 1916.

Below: Christ Suffering the Little Children, stained-glass window designed by Edward Burne-Jones in 1862 for the Church of All Saints, Selsey, Gloucestershire, England.

In berating Victorian craftsmanship, John Ruskin declared that cut glass was barbarous. He preferred blown glass because he liked its plasticity, and since plasticity was a property of glass (which, after all, is a "liquid") and since Ruskin believed in the honest use of materials, then it had to follow that cut glass was dishonest. He and his followers conflated good design with morality in design.

They evolved a doctrine which stated that one should go for honest structures and forms and truth to materials; then, as now, such phrases were less clear than they sound. For example, if we agree that the properties of glass are that it is a) transparent and b) essentially a liquid, then it follows c) that your forms should reflect these qualities. But the moral imperative is really arbitrary. Ruskin and William Morris, together with the men and women who followed in their wake, persisted with a philosophical error which confused the properties of a material with its qualities. The material has certain properties – glass has ductility, for example. But we provide the qualities: we say whether a form is sinuous or hard, cruel or soft. True, there are always connections to be argued between properties and qualities, but these are not as binding as those who argue for "truth to materials" like to maintain.

Of course, Ruskin and Morris used morality as an issue in design in another way, from the viewpoint of the craftsman. And here Ruskin had a point in his attack on cut glass.

DANGEROUS WORK
The glass industry was one of the toughest, because even though it was not transformed by mechanization like textile, garment, and metal manufacture, the work was dangerous. The risk of burns was high and inhalation of

Right: St. Philip, a stained-glass window for St. Michael's Church, Waterford, Hertfordshire, England, by Philip Webb, c. 1876.

Left: The Angel Musician, *a stained-glass window by Edward Burne-Jones for St. Peter and St. Paul Church, Cattistock, Dorset, England, in collaboration with Morris & Co.*

Above: A cameo-glass vase by George Woodall for Richardson & Sons, Staffordshire, England, c. 1890.

Right: An acid-etched vase by James Powell and Sons, England, 1913.

acid fumes and contact with poisons added to the health risks. Children, who were employed to feed putty powder onto the polishing wheels during the process of polishing cut glass, were at particular risk: the powder contained a mixture of lead and tin oxides and so we can see that Ruskin, viewing the cut glass as a symbol of unnecessary pain, had a right to condemn it.

The Arts and Crafts solution to the unethical work of industry was to put the craftsman in charge of a project from beginning to end by giving him and his team creative autonomy and responsibility for getting the job done in a manner that was both fair to the client and to the craftsman. This, however, is an expensive approach when the trade thrives on competition through price cutting. The Arts and Crafts Movement was always a luxury movement.

TECHNICAL IMPROVEMENTS

Technically, the nineteenth century was a period of improvements in manufacturing processes in glass. But the most important feature of the age, to which both the Esthetic Movement and the Arts and Crafts Movement contributed, was the range of decorative methods: apart from cutting and engraving glass, new Victorian techniques included those of cased glass and acid etching. There were important revivals, too, including those of cameo glass and Venetian filigree glass.

COLOR

Especially in Britain and the United States, there was a great expansion in consumerism because there were more things available for a lot more people to buy. And what makes things attractive to buy? Color. Roger Dodsworth, a glass historian, notes that by the time of the 1851 Great Exhibition many of the English factories were showing glassworks in a range of colors – oriental blue, rose, ruby, carnelian, and pearl opal. Moreover, the American and English factories developed glass in which one color would shade into another. Naturally, these colors were given creamy, consumer-oriented names – "Burmese," "Peach Bloom," "Amberina."

PRESS MOLDING

Glass has also been a significant decorative art form in the United States for nearly 200 years. In the 1820s, the Americans invented press molding, in which glass is pressed into a patterned mold; this process was swiftly developed as a method for producing a wide range of glass artifacts. These were cheap and imitated quite well the more expensive cut-glass wares. And then, in 1864, William Leighton developed soda-lime glass, which

was clear, like lead glass, but again much cheaper. The combination of soda glass and press molding made the cheap imitation of cut-glass ware even easier and the cut-glass craft companies fought back by making their patterns so complicated that they could not be imitated. And so by the 1880s America, in particular, was producing cut-glass ware of fantastic elaboration.

Right: Detail from The Last Judgement, *Edward Burne-Jones, England, 1876.*

Below: The Sermon on the Mount, *Dante Gabriel Rossetti, England, 1862.*

Right: Detail from The Last Judgement, *stained-glass window by Edward Burne-Jones, 1876, St. Michael and St. Mary Magdalene, Easthampstead, Berkshire, England.*

Opposite: Detail from the south window in the transept of Jesus College Chapel, Cambridge University, England, 1873, designed by Edward Burne-Jones and made by Morris, Marshall, Faulkner & Co.

PHILIP WEBB

William Morris set up in business with Edward Burne-Jones, Philip Webb, and others in 1861. Earlier, Philip Webb had, together with Morris, started designing glass for the Whitefriars Glass House. This company was founded in the late seventeenth century and was taken over in 1835 by James Powell. Around 1860, the company began producing the elegant, plain, well-proportioned glass wares of Webb's designs. These were, naturally, "hand" blown. It is also worth noting that James Powell and his son produced their own designs; some were based on Venetian patterns and, as the century progressed, there was an Art Nouveau influence. In the archives of the company are botanical and herbal works. Plants – indeed, empirical natural science in general – were a major influence on progressive decorative design during the nineteenth century.

THE INFLUENCE OF THE PRE-RAPHAELITES

The influence and ideas of the Pre-Raphaelites are important in their effect on the later style of Arts and Crafts glass. The Pre-Raphaelite Brotherhood of painters, of whom Dante Gabriel Rossetti was one of the core members, was committed to a close study of nature and it evolved techniques to present clear, sharply focused images. Rossetti, of course, influenced Morris's close friend Edward Burne-Jones, who painted some of the earlier Morris furniture. In 1857 he designed his first stained-glass panel for the Powells at Whitefriars and he was involved in the first stained-glass commission of Morris, Faulkner & Marshall.

As Burne-Jones developed his artistic skills, he grew farther away from the close observation of the Pre-Raphaelites and his figures became more expressive, although they showed some of the odd, rubbery, languid quality that characterized Rossetti's painting. Good examples of Burne-Jones's later work are to be found in the stained-glass windows that he designed for Birmingham Cathedral.

MORRIS, FAULKNER & MARSHALL'S
STAINED GLASS

Morris, Faulkner & Marshall produced a large number of stained-glass windows between 1861 and 1875. The general approach of the firm during this period was to allocate the main design of each commission to one of the central designers, with Morris and Webb adding in the decorative background. Morris designed some windows himself; Rossetti did 36; Ford Madox Brown about 130; and the rest were done by Burne-Jones. Stained glass then was big business.

Martin Harrison has described the basic tenet of the Arts and Crafts Movement as far as stained glass was concerned as being a break with the factorylike production lines which the Victorian companies had evolved. The designer was to make or supervise the making of each stage. The other characteristics are a predilection for Pre-Raphaelite-style figures that combine monumentality with languidness; and plant-form backgrounds from Morris.

HENRY HOLIDAY

Many nineteenth-century artists were influenced by the Pre-Raphaelites and many were swayed by Ruskin and Morris, yet among them were those who had reservations about Morris's commitment to the designs of the medieval craftsman. One of those people was Henry Holiday.

Holiday had studied at the Royal Academy Schools, was influenced by Pre-Raphaelite painters, and worked with the architect and

Above: St. Matthew, *stained-glass window designed by William Morris, 1862, Christchurch, Southgate, Middlesex, England.*

Right: The Brachet Licking Sir Tristram, *stained-glass window designed by William Morris, 1861, one of a series of panels illustrating the story of Sir Tristram, made in 1862 for Harden Grange, near Bingley, West Yorkshire, England, the home of Walter Dunlop, a Bradford merchant.*

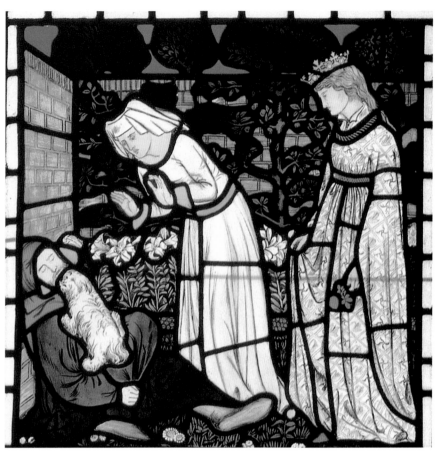

designer William Burges. He took over from Burne-Jones at Whitefriars and then started his own stained-glass studio in 1891.

Twenty years before, Holiday had argued strongly that artists, designers, and architects had to acknowledge the times they were living in. Modernism – above all, science – would not go away, however much one longed for the security of medieval order. He said "We cannot put on thirteenth-century sentiment

. . . When a medieval artist drew the Creator standing upon the earth planting the sun and moon in the heavens, one with each hand, the conception was colossal. But we cannot do this now. Our heads are full of diagrams of the solar system . . . our work is to discover that which is truest and best in our age . . ." Holiday had grasped what Morris had put to one side: the need to find an esthetic and a content that was appropriate to modern times.

WALTER CRANE AND CHRISTOPHER WHALL

One of the most active propagandists of the Arts and Crafts Movement was Walter Crane, the first president of the Arts and Crafts Exhibition Society founded in 1888. Crane, like Morris, was an active socialist and did some stained-glass work. One acerbic assessment of his work is that he was a wispy follower of Morris tinged with Art Nouveau.

According to students of the period, however, the leader of the Arts and Crafts Movement, as far as stained glass is concerned, was Christopher Whall, who began as a painter. In his first ventures into stained glass in 1879, Whall was appalled by the way in which his designs were translated for the medium. He set up a small workshop of his own in which he trained a number of important artist/designers, such as Louis Davis and Reginald Hallward. He also lectured on stained glass at the Central School of Arts and Crafts in London and wrote what was considered until recently to be the standard text on the subject: *Stained Glass Work.*

In accordance with the empirical spirit of the times, Whall urged designers to draw from life and from the model. He was highly critical of stylized figures and critical also of the practice of using the same cartoon over and over again in one design after another.

CHRISTOPHER DRESSER AND CHARLES RENNIE MACKINTOSH

With a few exceptions, Arts and Crafts decorated glass, especially stained glass, did not find a modern voice in Britain. Two of these

Right: Detail of angels from a stained-glass window designed by William Morris, 1873, St. Peter and St. Paul, Over Stowey, Somerset, England.

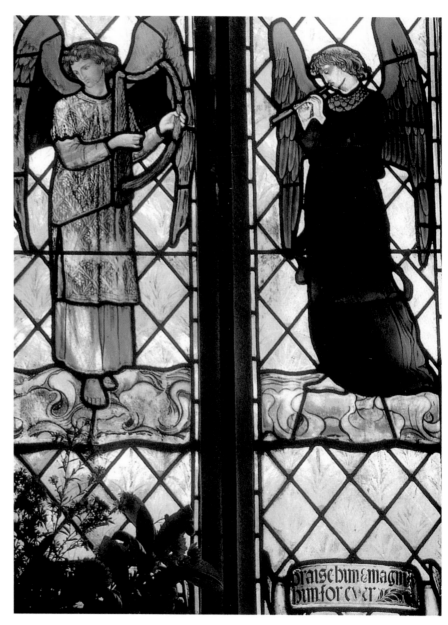

exceptions were Christopher Dresser and Charles Rennie Mackintosh. Dresser began lecturing on botany in 1854. He became a designer and in 1876 set up Dresser and Holme, a company importing oriental wares. In the 1890s, having by then been design director for the Linthorpe Pottery, as well as a designer for Minton and the author of, among other works, *Modern Ornamentation*, he designed glass for James Couper & Sons of Glasgow. His simple, relatively plain, glass volumes are functionalist and modern (they anticipate the Bauhaus esthetic); their geometry is tempered with a grace that comes from an understanding of the fluid nature of glass.

Dresser made a vital contribution to design

in glassware, partly because he was not hemmed in by an ideology that was frightened of the machine or machine production. In glass, he provided an intelligent, modern bridge between the enlightened historicism of Morris and the new age. He designed with modern production methods in mind, which meant acknowledging the division of labor within a framework of predetermined production sequences.

Mackintosh, who trained as an architect, was attracted to Art Nouveau decoration, which he developed into a particularly abstract form. Indeed, his abstraction was criticized when he showed some of his designs at the fifth exhibition of the Arts and Crafts Exhibition Society in 1896.

The rectilinear style developed by Mackintosh, in company with the designers J. H. MacNair and Margaret and Frances Macdonald, proved influential, especially in Austria. There was also a reciprocity of esthetics between Mackintosh's glass designs (as seen in the Willow Tea Rooms in Glasgow) and the contemporary work of Frank Lloyd Wright. The most direct interchange of influence, however, was between Mackintosh and Vienna: designers such as Koloman Moser and Josef Hoffmann were much impressed by what was happening in Glasgow.

THE VIENNA SECESSION

At the turn of the century, the Vienna Secession, the group of Austrian artists and architects which had broken away from the established academy to found its own organization, began exhibiting its own work and that of foreigners such as Mackintosh. The writ of Ruskin and Morris held firm for Secessionists such as Hoffmann, who, with Moser, had helped to establish the art-craft

workshop cooperative the Wiener Werkstätte. Hoffmann stated that the aim of those associated with the workshop was to reestablish good (but simple) craftsmanship and refined but not elaborate design. The Wiener Werkstätte produced glass which was manufactured by glass companies in Bohemia. As the twentieth century progressed, the Secessionist glass designs became more and more geometric and architectural in their form.

AMERICAN ARTS AND CRAFTS GLASS

The nineteenth century, dominated as it was by trade, saw an increase in the number of international exhibitions which, together with magazines, spread ideas from one country to another rapidly. American technology was

Above and left: Wall panels, mirrors, (above) and doors (detail left) for the Willow Tea Rooms, Glasgow, Scotland, designed by Charles Rennie Mackintosh, 1904.

Below: A collection of Loetz iridescent glass, Austria, c. 1900.

Opposite: The Tiffany "Poppy" lamp, U.S.A., c. 1900.

soon superior to European technology, but the styles were Eurocentric, partly because so many immigrants were European and also because travel, especially by the children of the new Americans, to Europe, was popular.

JOHN LA FARGE

One of the American glass painters who was initially close to the British Arts and Crafts Movement was John La Farge, who, as well as having been taught by his father, a fresco painter, studied in Paris. He was, for a while, influenced by the Pre-Raphaelites, but was especially impressed by the flat pattern-making approach to decoration developed by Morris. However, during the 1890s, he developed a much more figural and naturalistic content. La Farge patented a method for producing opalescent glass in 1880 (Louis Comfort Tiffany also developed a similar process independently in 1881). La Farge had a number of major clients, including such millionaire families as the Vanderbilts and the Whitneys, who collected his work.

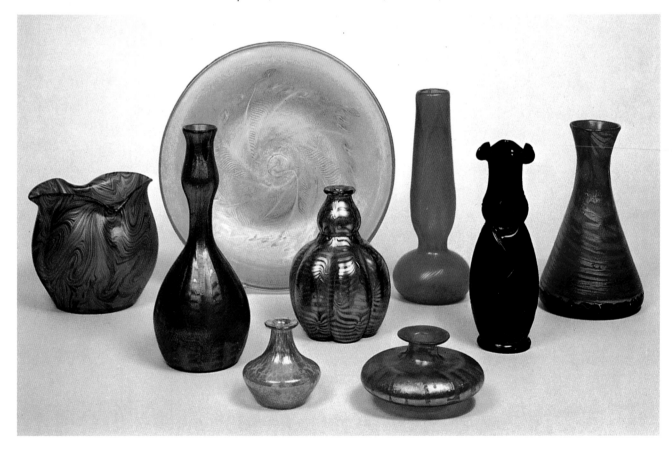

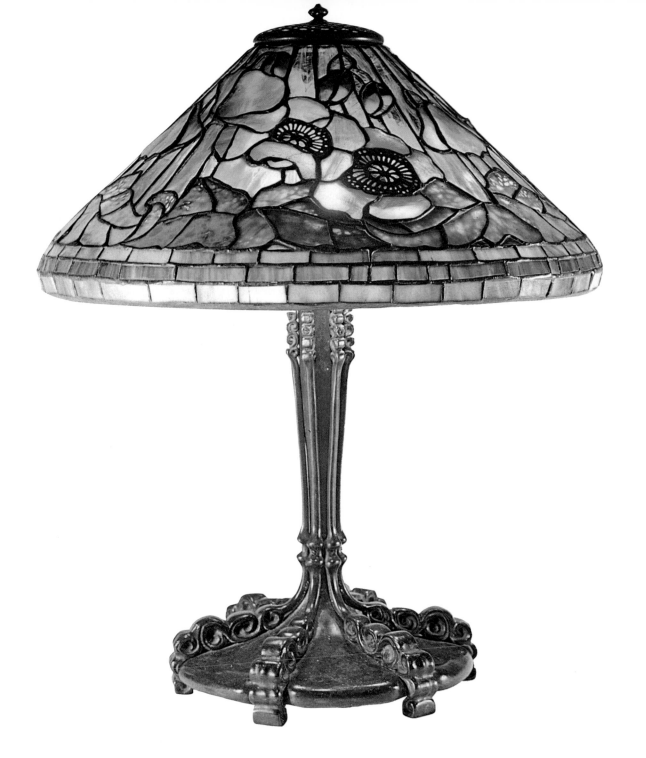

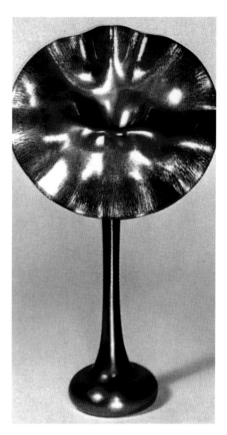

*Above: A Tiffany "Jack-in-the-Pulpit" vase,
U.S.A., c. 1900.*

FRANK LLOYD WRIGHT

British arts and crafts were shown at the Centennial Exposition in Philadelphia in 1876 and the work displayed included items from Morris, Crane, and Fairfax Murray. Later in the century, both Crane and Ashbee began to visit and lecture throughout America and both became friends of Frank Lloyd Wright, himself a founder member of the Chicago Arts and Crafts Society set up in 1897.

Wright admired both Ruskin and Morris but made it clear that he was not antagonistic toward the machine. Indeed, his rectilinear designs for glass show an imagination which sees the machine and its precision and rationality as sources for metaphor and symbolism and thus a cause for celebration. Wright's imagination was, even more than Dresser's, a natural conduit between Arts and Crafts design and the machine age. His esthetic began with organic or botanical forms but moved toward a geometrical order. His leaded glass, as seen in Darwin D. Martin's house in Buffalo, for example, shows an esthetic which has turned the attenuations of Art Nouveau line into a formal arrangement of squares and rectangles.

LOUIS COMFORT TIFFANY

With regard to Art Nouveau and Arts and Crafts in American glass, the most notable practitioner is Louis Comfort Tiffany, who claimed to be influenced by Morris. He had the splendid idea of running a quasi-Italian Renaissance workshop: he would be the master, with a plenitude of assistants, and his ambition was to improve industrial design by injecting art into it. He also wanted to raise the standards of design for items used in the home. These aims paralleled those of Morris.

He parallels Morris in another way. Morris had a genius for pattern and, in particular, for making decorative use of flowers and plants, but on flat, two-dimensional surfaces. Tiffany shared the same ability to compose with nature but he could do it three-dimensionally, like a sculptor. He made his glass and metalware mimic the plasticity of drooping plants and entwining tendrils. He had started in stained glass in the early 1870s and founded the Tiffany Furnaces in 1892. In 1895 he showed a collection of stained-glass windows which had been designed by a number of French painters, including Pierre Bonnard, Edouard Vuillard, and Henri de Toulouse Lautrec.

Tiffany was an eclectic: he had traveled in Spain and North Africa; he was excited by the exotic; and his personal triumph was the patenting of handmade, iridescent glass which he called "Favrile." It proved immensely popular. The exotic, warm-colored lamps which he produced were highly successful and the Tiffany style, a golden or red-blood, womb-like excess, has continued to appeal to Western consumers and has also been much copied.

FREDERICK CARDER

Tiffany had rivals, and one of the fiercest was Frederick Carder, who worked first in England (he was born in Staffordshire) and left in 1903 to found the Steuben Glass works in Corning, New York. Carder was the designer and he developed a range of iridescent and metalicized glassware to compete with Tiffany's.

ARTS AND CRAFTS IN SCANDINAVIA

Elsewhere in the world, in Scandinavia especially, the British Arts and Crafts Movement was particularly influential. In Sweden, Ellen Key published a book, called *Beauty for All*, inspired by Morris's writings. The emphasis on social democracy in Sweden and the interest

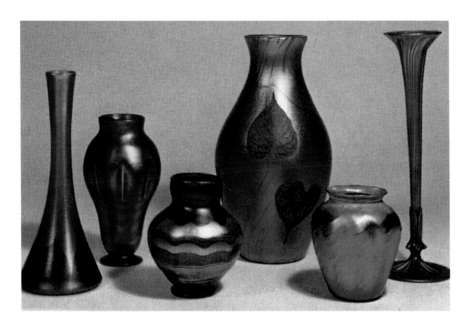

Left: A collection of Tiffany iridescent glass vases, U.S.A., c. 1900.

in creating a humane environment in sympathy both with nature and the need to make life comfortable made the Arts and Crafts ideology, with its concentration upon the home, an appropriate one.

The Scandinavians were not swamped by the ideology of "the machine"; none of its nations underwent an industrial revolution that was remotely equivalent to those seen in Britain, the United States, and Germany.

Whereas the industrial landscape of Britain, for example, had led British designers and craftsmen to take an elaborate and forced view of natural decoration in their work in order to emphasize their ideological embrace of nature and their rejection of the machine, in Sweden the tension between industry and nature was nothing like so acute. For one thing, the natural landscape of the country was still intact.

ANNA BOBERG

Take, for example, the work of Anna Boberg, of Sweden's Rijmyre Glassworks, the wife of the architect and designer Ferdinand Boberg. The characteristic of her work was the juxtaposition of abstract and natural designs, a balancing of nature and art which captures the essence of the Swedish landscape.

GUNNAR WENNERBERG

Although he is known primarily as a ceramics designer, Gunnar Wennerberg was one of the best Swedish glass designers. He did much of his work for the Kosta factory and created overlay glass inspired by Emile Gallé, the highly talented French glass-maker and doyen of Art Nouveau. Overlay glass consists of a core covered with one or more layers of glass in different colors, wheel-cut or etched through these layers to produce a raised pattern

of color that contrasts with the ground. Wennerberg was also interested in the rendering of surfaces to make compositions of different textures.

THE ARTS AND CRAFTS LEGACY IN GLASS

By the end of the nineteenth century one of the virtues of Art Nouveau, from the Arts and Crafts point of view, was that it appeared to put craftsmanship and decorative art on a footing with other arts. In fact, the craftsmen were fooling themselves: the avant-garde in painting and sculpture was already, via Impressionism and Post-Impressionism, in the act of deskilling itself. This rejection of skill continued throughout the twentieth century. Yet the middle classes have consistently preferred the bourgeois decorative arts to the full-blooded imagery of Modernism. Glass in particular has remained a minor, although delightful, art, reflecting middlebrow sensibilities, whatever its form or setting.

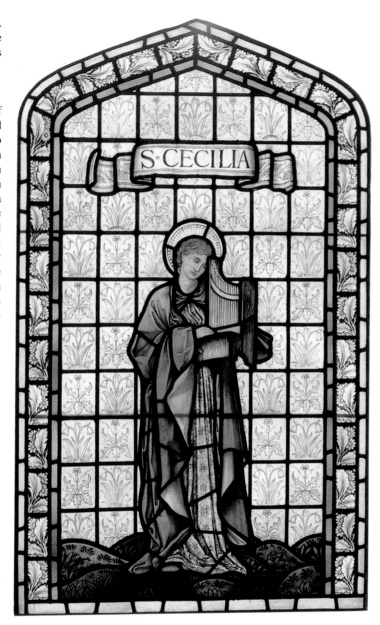

Right: St. Cecilia, *stained-glass panel designed by Edward Burne-Jones, about 1872–73, made by Morris & Co. in about 1897.*

BRITISH POTTERY

Previous page: Baluster vase by Mark V. Marshall for Doulton, London, c. 1910.

Below right: Pot with lid, made by Charles Cox at the Mortlake Pottery, England, 1912.

Pottery was among the most handsome, well-crafted, and innovative of the vast and variegated output of Arts and Crafts designers, from sturdy, luster-painted earthenware to delicate, crystalline-glazed porcelain. It was copiously copied, using a wide variety of techniques, decorated with an extensive range of colorful paints, enamels, and glazes and was enhanced farther with subjects ranging from fantastic, medieval beasts and doughty Viking sailing ships to exquisite pendant wistaria and noble Native American chiefs.

Even the forms were diverse and at times outrageous: a menagerie of Moon-faced jugs and bird-shaped tobacco jars from London's eccentric Martin brothers; an array of crumpled, crinkled, and convoluted vases by George Ohr of Mississippi; a series of square earthenware tiles painted with a verdant arrangement of tendrils and blooms by William De Morgan to a William Morris design; and the "Scarab" vase, an award-winning, massive, lattice-worked extravagance from the American Adelaide Alsop Robineau.

The growth of art pottery in Britain, as in the United States, was stupendous: not only were newly founded potteries creating outstanding and popular vessels, but long-established factories either started creative art-pottery divisions producing lovely works in small quantities, or else marketed wares designed by prominent craft-revival artist/designers.

THE BRITISH POTTERY-MAKING TRADITION

The making of pottery and porcelain had long been an important enterprise in Britain – in Staffordshire and Derbyshire, especially – so it is only natural that Arts and Crafts potters built on, and greatly added to, this firm foundation. Many of the techniques used by

mid-nineteenth-century British potteries were not at all shoddy or second-rate, as in other mass-production media, and their products proved both influential and attractive to other British potters, as well as to Americans.

There was also a growing interest in older production and decoration methods, many of these allowing individuals within large studio situations to design, throw, fire, and paint their wares – that is, to control the entire creative process from start to finish. At the same time, there was an increase in creative teamwork, in keeping with Arts and Crafts tenets whereby, for instance, a vase or charger came to exist through the joint efforts of a skilled potter, who threw and fired the vessel, and an equally talented painter, who decorated it according to the design of still a third person, perhaps a well-known illustrator.

WILLIAM FREND DE MORGAN

The London-born William Frend De Morgan was associated with William Morris's firm from 1863, designing both tiles and stained glass, and in 1872 he founded his own pottery and showroom in Chelsea. At first he painted ready-made blank tiles and vessels, primarily utilizing two techniques, luster and enamel. In the early Chelsea period, from 1872 to 1882, his subject matter was rather eclectic: tiles and dishes decorated with somewhat labored, neo-classical designs, such as *putti,* scrolls, and palmettes, with Morris-inspired, stylized blossoms and tendrils, or with a bestiary full of creatures, both playful and monstrous, often executed in shimmering luster tones of red, yellow, pink, silver, and gold.

The metallic film decorating these luster pieces was much used on the designs of two De Morgan employees, Charles and Frederick Passenger, and also sparked their imitation by

other potteries. They were created in part because of De Morgan's admiration of Italian maiolica from Gubbio, the ruby lusterware of which was especially vibrant. But De Morgan expanded his palette farther, around 1875, adding to his repertory the so-called "Persian" colours – rich, deep shades of turquoise and royal blue, red, yellow, violet, and green (often with black on white slip grounds).

Between 1882 and 1888 De Morgan flourished at a new, purpose-built pottery at Merton Abbey, close to Morris's works; the two men

Above: An earthenware painted dish with peacock motif by the English potter William De Morgan.

sometimes collaborated on tile projects, Morris doing the designing and De Morgan producing and decorating. In 1888, he set up a new factory in Sands End, Fulham, with Halsey Ricardo, an architect, as his partner. The pair worked together until 1898, a decade considered to be De Morgan's richest and most successful period.

Because of failing health, De Morgan had begun to spend time in Italy, where he established a studio in Florence, providing designs for his own firm and for the Italian pottery Cantagalli. In 1898, the two Passenger brothers became partners, as did also his kilnmaster, Frank Iles. De Morgan himself stopped producing pottery in 1907 and turned to writing novels, but his three partners kept the firm running until 1911.

DE MORGAN'S WORK

Along with the Passengers and a talented artist, Joe Juster, among others, De Morgan produced lustered and enameled earthenware of increasing beauty and technical virtuosity, especially in the early Fulham years. He made his own blanks at Merton Abbey – tiles, as well as dishes, bowls, vases, and bottles – and some of their forms, clearly oriental in inspiration, were especially attractive. Besides the plant, flower, and animal designs which his wares featured, De Morgan also favored a beloved Arts and Crafts motif: the sturdy Viking sailing ship, usually a richly ornamented galleon on a glittering sea of stylized

Right: A series of underglazed earthenware tiles by William De Morgan.

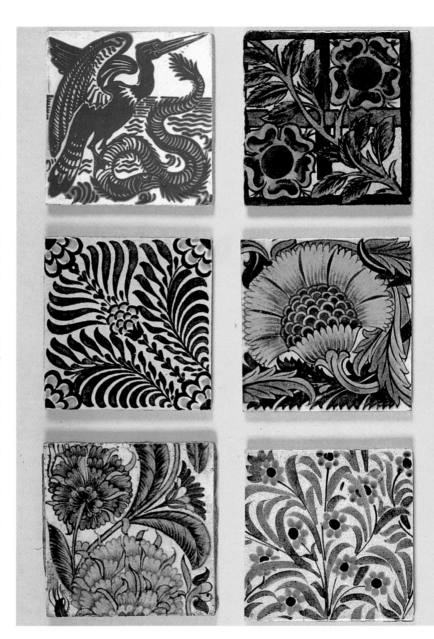

waves. Individual art tiles and panels were always a mainstay of De Morgan's production. His botanical, zoological, and maritime designs were presented alone, in pairs or even as parts of "four-square" designs on single tiles; sometimes they formed a running design or a large pictorial composition.

THE MARTIN BROTHERS

From the kilns of the four eccentric Martin brothers – Robert Wallace, Charles Douglas, Walter Frazier and Edwin Bruce – came some of the most renowned and unusual art pottery of all: salt-glazed stoneware which, among other creatures, took the forms of chubby-jowled, wide-nosed, two-faced jugs, and leering or sneering anthropomorphic bird jars. Robert had studied sculpture, exhibiting from around 1863, but by 1871 he had turned to creating stoneware, first working with Jean-Charles Cazin at the Fulham Pottery, and two years later setting up a studio with his brothers in the King's Road, Fulham. Charles handled the financial and retail ends of the business (a store near High Holborn was opened in 1879), while Robert was the modeler, Walter the chief thrower and firer, and Edwin the chief painter and decorator.

MARTINWARE

In 1877 the partnership moved to Southall, Middlesex, and until 1914 the three creative Martins produced an extensive body of functional and/or decorative pieces, from stoneware vases and jugs to toothpick holders and spoon-warmers. Salt-glazed in shades of cream, brown, gray, blue, and green for the most part, quintessential Martinware took the form of semireal or wholly imaginary bipeds or quadrupeds, but conventionally shaped vessels were also made: tiny vases whose textured,

earth-toned glazes simulated snakeskin, sea-urchin shell and tree bark; larger jugs or vases sporting incised and painted organic or animal motifs; still others in the shapes of gourds. The most interesting Martinware pieces were the grotesques, including hybrid-creature jugs with gaping mouths that served as spouts and curling tails as handles; Heckle-and-Jeckle-like birds, whose facial expressions ran the

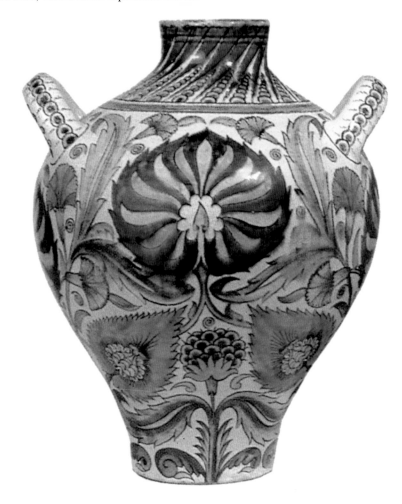

Below: A lug-handled baluster vase painted with stylized motifs in the so-called "Persian" colors by William De Morgan, c. 1888–98.

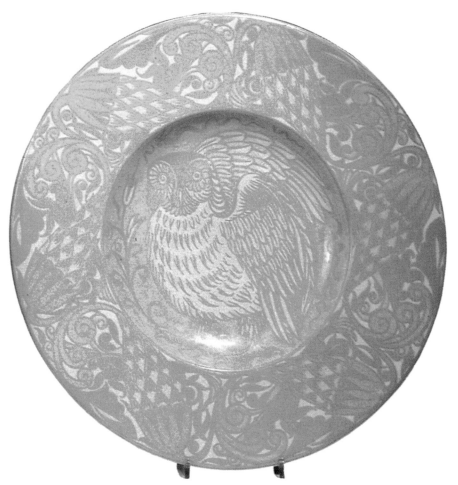

Above: An owl-centered charger, c. 1888–98, whose florid border is a stunning example of William De Morgan's metallic lusterware in yellow and ocher pigments.

disturbed, minds of the brothers. Despite a variety of physical and emotional catastrophes that plagued their ill-starred lives, the prolific, immensely talented Martins produced their wares for over 30 years, garnering praise from clients who ranged from Dante Gabriel Rossetti to Queen Victoria.

SIR EDMUND ELTON

Some of the Martins' animal-shaped vases were faintly echoed in vases created by Sir Edmund Elton at his Sunflower Pottery in Somerset. A self-educated art potter, the gifted amateur produced his "Elton ware" from about 1879: boldly shaped, earthenware jugs, jars, bowls, and vases made from local clays, often decorated with applied avian and floral motifs of medieval inspiration. By the early 1900s Elton was sheathing his vessels with handsome metallic glazes, his most distinctive bearing a glistening, *craquelé* surface, attained by firing a layer of liquid gold over one of liquid platinum. Some Elton vases sported several applied handles and one jug featured a crackled glaze, a spout in the shape of an open-jawed serpent's head, and it also had a taillike handle.

CHRISTOPHER DRESSER

The botanist, designer, and author Christopher Dresser created some outstanding vessels for several pottery firms, mostly in the 1880s and 1890s. Dresser was the main impetus behind the short-lived Linthorpe Pottery in Yorkshire, which he founded in 1879 with the wealthy landowner John Harrison. Linthorpe was managed by Henry Tooth who, in 1882, established the Bretby Art Pottery in Derbyshire with William Ault. Ault in turn started his own eponymously named company in 1887, for which Dresser designed in the 1890s.

gamut of human emotion and whose postures expressed the full range of "body language"; and two-faced, globular "Janus jugs," some with barristers' wigs and sly, knowing smiles, others with droll, man-in-the-Moon grins.

The inspiration for these unique, one-off creatures was partly Darwinian, partly Japanese, partly Victorian Gothic, but always elaborated by the creative, somewhat

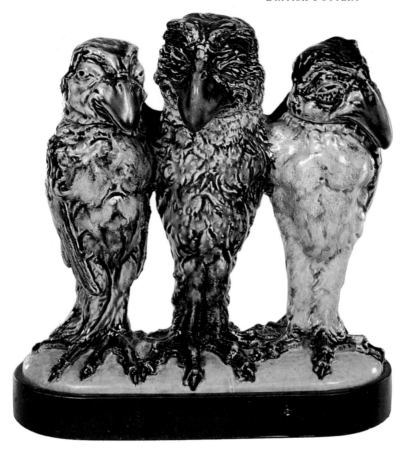

Left: An example of the grotesque birds made by Robert Wallace Martin during the 1890s.

Dresser's designs for Linthorpe were influenced largely by various oriental and ancient motifs. Their glazes were generally dark brown with green, or else solid yellow, blue, or green, their forms often of Middle and Far Eastern inspiration. Some of Dresser's creations for Ault are among his best-known designs in any medium. One vase, available with either a buttercup-yellow or deep-turquoise glaze, sports four handles which are fierce monster heads, from which protrude pairs of inward-curving horns. Another has a double-gourd form with four applied handles shaped as goats' heads. Dresser's designs for Minton and Wedgwood were executed in the 1860s and 1870s and, for the most part, consist of traditionally shaped vessels with oriental or other exotic motifs.

WALTER CRANE

From the late 1860s, the artist and designer Walter Crane designed both tiles and pottery for several major firms, including Wedgwood, Minton, and Pilkington. For Maw & Co. in Shropshire, a tile manufacturer, he designed hand-colored, transfer-printed tiles, and for Pilkington's so-called "Lancastrian ware" he created vases, chargers, and plaques in the early

Right: Three pieces by the Martin brothers of London and Southall. The two-handled vase (1886) features a charming design of daisies and foxgloves against a buff background. The bird-jars, both with detachable heads, are prime specimens from the Martins' stoneware aviary; the leering creature (left) dates from 1891; the hook-beaked flyer is dated 1905.

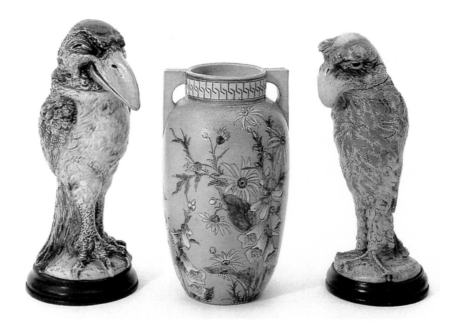

1900s, which were painted by Richard Joyce with rich medieval motifs, such as a jousting knight in silver luster. Another of his designs for Pilkington was a series of six tiles known as "Flora's Train," each depicting a charming "flower fairy" clad in a flowing gown and wearing a petaled hat that echo the form and hue of the blossoms gently entwining each of them. Examples of the *cuenca* technique, these molded earthenware tiles are filled in with colorful glazes, almost like *cloisonné* enamel.

DOULTON & CO.

The British potteries hopped on the bandwagon and set up departments or studios devoted to producing wares in the Arts and Crafts manner. Doulton & Co., established in 1815 by John Doulton and located from 1826 in Lambeth, south London, employed craft-revival designers and painters of note, many connected with the Lambeth School of Art, including many women, such as Hannah Barlow and Eliza Simmance. Until the 1860s, Doulton manufactured decorative bottles and flasks and ordinary household jugs and jars, but the alliance with the Lambeth school, under its headmaster John Sparkes, led to the production of more sophisticated decorated pottery, including porcelain and earthenware. The latter was made at facilities in Burslem, Stoke-on-Trent, where various new glazes were introduced, some imitative of oriental techniques and others of French crystalline ceramic surfaces.

Numerous Arts and Crafts motifs worked their way into the design repertory of both the Burslem and Lambeth works. Out of Lambeth came a wide variety of decorative pieces. At first these were rather heavy-handed histori-cizing vases and plaques, but later salt-glazed and faience wares appeared which were highly inventive in terms both of modeling

Left: A grotesque vase designed by Christopher Dresser for William Ault, c. 1892.

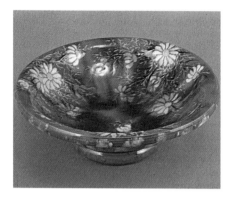

Above: A Linthorpe bowl designed by Christopher Dresser, c. 1880.

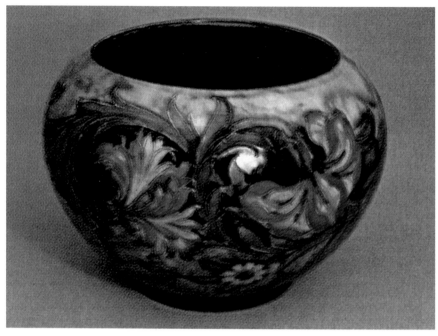

Right: A decorative bowl designed by William Moorcroft.

and the manner and subject matter of their decoration. Hannah Barlow and Mary Mitchell produced wares with handsome, incised decorations, and Eliza Simmance and Florence Barlow perfected the *pâte-sur-pâte* technique, in which a bas-relief design is effected by applying several layers of slip. Advances in modeling were made by Mark V. Marshall and George Tinworth, with handsome, applied elements – lizards, frogs, and blossoms – clinging to vases and jugs in a supremely naturalistic manner.

MINTON, WEDGWOOD, AND PILKINGTON

Minton's Stoke-on-Trent pottery and porcelain works was another long-established firm which embraced the studio-art movement. Founded in 1793 by Thomas Minton, the

Staffordshire company opened Minton's Art-Pottery Studios in South Kensington, London, in 1871, which existed only until 1875. Wares with a distinctive Arts and Crafts bent, however, were produced up to about 1895 at the Staffordshire factory.

Two other solid old firms, Josiah Wedgwood & Sons (established in 1759 in Burslem) and Pilkington's Tile & Pottery Co (founded in Lancashire in 1892) produced Arts and Crafts-style wares. Pilkington made tiles to designs by Walter Crane, C. F. A. Voysey and Lewis F. Day, and in 1902 it added lusterware known as "Royal Lancastrian" to its extensive output. Rich Arts and Crafts motifs, such as knights fighting dragons and proud peacocks, figured on this line, and among the company's gifted painters were Gordon M. Forsyth, Gwladys

Rogers, and Richard Joyce.

Wedgwood, in 1903, forged a 30-year-long relationship with the designer/decorator Alfred H. Powel, who had exhibited at the Arts and Crafts Exhibition Society with his wife Louise. The couple also produced painted earthenware at their own potteries. One of Alfred's most handsome vases for Wedgwood, made in 1920, is covered with a brightly painted medieval landscape on a cream-colored earthenware ground. Although its date is somewhat late, its motif and sentiment clearly and lovingly hark back to the 1860s and 1870s.

THE DELLA ROBBIA POTTERY

After William De Morgan's firm, the one organized most along Arts and Crafts guidelines was the Della Robbia Pottery, established in Birkenhead in 1894. Its cofounders were the painter and poet Harold Rathbone and Conrad Dressler, a sculptor who was largely responsible for Della Robbia's architectural commissions. The company was formed to produce architectural decorations, but colorful and attractive utilitarian pieces soon formed a significant part of its output.

Rathbone was strongly averse to repetition

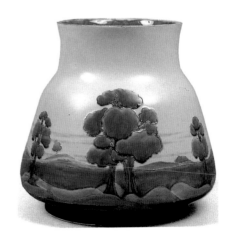

Below left: A vase by William Moorcroft, Cobridge, Staffordshire, c. 1916. Moorcroft produced this popular pattern for years, ever brightening its palette and smoothing down its surface. The toadstool motif appeared on Moorcroft's wares until the 1930s.

Below: A "Florian-ware" vase by William Moorcroft for James A. Macintyre, Burslem, c. 1902. In strong and muted shades of blue on a white ground, the vase features a lovely landscape outlined in high-relif slip.

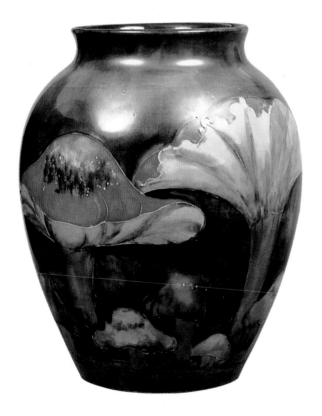

Right: An example of early twentieth-century glazed ware from the Ruskin Factory, Birmingham.

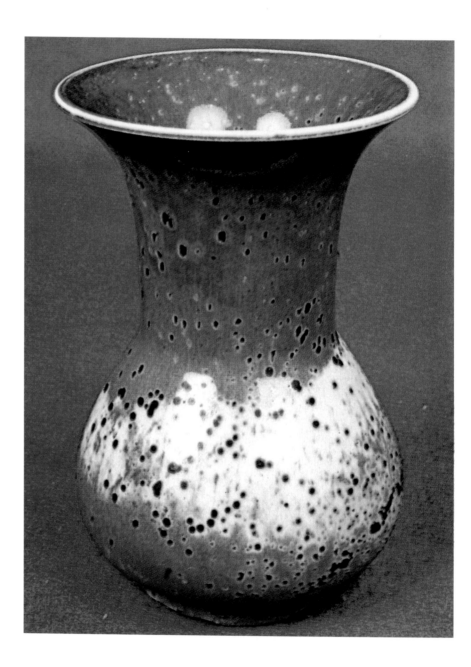

and perfection in his works, preferring each piece to be judged on its own. He was equally determined that his employees use their talents to the fullest, expressing their own ideas and enjoying their work. For the 12 years of its existence, the Della Robbia Pottery produced a diverse body of functional and decorative hollowware and architectural elements.

Various decorating methods were employed, among them painting, applied relief, and molding, but a conventional maiolica technique was the most common (lead glazes applied over a white slip). Rathbone farther demanded that an incised (or *sgraffito)* outline be scratched onto each piece to delineate which sections were to receive the glaze. Colors were rich and lustrous, a pale-blue-green being the predominant hue, with bright yellows, reds, and oranges, black, cream, blue and green being common. Motifs included Renaissance-style portraits, Celtic interlace, Islamic and heraldic patterns, floral and foliate designs, even grotesque creatures; forms ranged from round

plaques and platters to rectangular clock cases to a fish-shaped spoon-warmer.

WILLIAM MOORCROFT

A more commercially successful venture than Della Robbia was begun in 1913 by William A. Moorcroft, a Staffordshire potter who had been associated with James A. Macintyre & Co. at Burslem from 1897 until he started his own pottery at Cobridge. His art-pottery line for Macintyre, "Florian ware" (introduced in 1898 and made until around 1904), proved highly successful and provided the basis for many of his own later Cobridge designs.

Moorcroft's wares were very much his personal product: he developed them, designed their shapes and decorations, and oversaw those who actually worked with the clay and paint. His name is today most identified with the handsome, distinctive designs that cover his expertly shaped pieces. From early wares with a high-relief slip outline to later works with smooth, shiny surfaces, his firm designing hand can be clearly discerned. The floral

Right: Nine pieces by the Ruskin Pottery, Birmingham. The pottery was renowned for its flambé *glazes, fired onto vessels at a high temperature. This group shows the variety of colors and shapes, most of the latter of oriental inspiration.*

patterns – of poppies, lilacs, cornflowers, violets – adorning Florian ware were sometimes busy and overstylized, but after 1904 the blossoms became more softly muted, more at one with their backgrounds, whether white or colored. Among the nonfloral designs, the stylized peacock feather was one that was especially attractive.

One of Moorcroft's best-known patterns, the "Hazledene" tall trees in a landscape, was introduced in 1902 and remained popular throughout the 1920s. Two other of his famous patterns, "Claremont," with its bold, colorful toadstools, and "Pomegranate," originated in the late Macintyre period and were produced into the 1930s, when the Moorcroft palette (which now included rich *flambé* glazes) was rife with lustrous greens, reds, oranges, and yellows, often against a characteristic deep-blue ground. Moorcroft's forms ranged from baluster and waisted vases and classically shaped ewers and tazzas to elaborately lidded *bonbonnières* and architectonic clock cases.

"TORQUAY POTTERY"

The wares of several south Devon potteries producing so-called "Torquay pottery" from around 1870 were handmade from local clay in the Arts and Crafts manner and were decorated with paints and glazes also made locally, if not on the premises. These included the Watcombe Pottery, the Aller Vale Pottery, and the Long Park Pottery.

THE RUSKIN POTTERY

Another small firm, the Ruskin Pottery, was established in 1898 in Birmingham by Edward Richard Taylor and his son, William Howson Taylor. Its output was acclaimed for its extensive range of handsome, *flambé*

Right: A "Barum-ware" blue-glazed earthenware jug in the shape of a bird by Charles H. Brannum, Barnstaple, north Devon, c. 1879. Prior to this art-pottery line Brannum made ovens and kitchenware.

glazes. Fired at extremely high temperatures, the vessels often gleamed with breathtaking combinations of mottled hues, both strong and muted, these were enhanced by stunning, stippled effects resulting from the use of copper salts; luster glazes, too, were employed.

BRANNUM, THE FOLEY POTTERY, AND THE OMEGA WORKSHOPS

From 1879 the Barnstaple, north Devon pottery of Charles H. Brannum produced a line of art pottery known as "Barum ware" – simply shaped vases and jugs decorated with flowers, animals and other devices in colored slip on white ground; later pieces were molded in avian and other creatures' shapes.

Another noted pottery was the Foley Pottery, a Staffordshire porcelain manufacturer. In the 1930s Foley commissioned designs from such painters as Duncan Grant and Vanessa Bell, whose own Omega Workshops created distinctive art pottery. The workshops' director, Roger Fry, and his colleagues were determined to show the public the advantages of decoration by artists of quotidian objects, including pottery vessels, most of which were made at Harold Stabler's Poole Pottery in Dorset.

LIBERTY & CO.

There existed dozens of smaller firms which also created wares in the Arts and Crafts manner. Many of these wares were sold at Liberty, the London retail emporium which offered well-crafted, but generally mass-produced, objects to an eager public. Among the various art-pottery lines that Liberty stocked were Burmantoft's Faience, Barum ware, Pilkington's Royal Lancastrian, William Moorcroft's Florian ware, Royal Doulton, and the designs of the Bretby, Aller Vale, Foley, Poole, Farnham, and Della Robbia potteries.

AMERICAN AND
CONTINENTAL POTTERY

Previous page: An earthenware dish produced at Valby, Denmark, by Thorvald Bindesbøll, 1901.

Below right: A Rookwood earthenware jar with colored underglazes, decorated by Hattie E. Wilcox, 1900.

In the United States, the halcyon days of art pottery encompassed the period from approximately 1870 to 1930. Not only were vessels such as vases, cups, bowls, chargers, and *jardinières* produced in endless varieties and huge quantities, but there was also a boom in art-tile production. These objects were at times more sophisticated and innovative in style, technique, and decoration than their European counterparts, although they were, of course, greatly indebted to them.

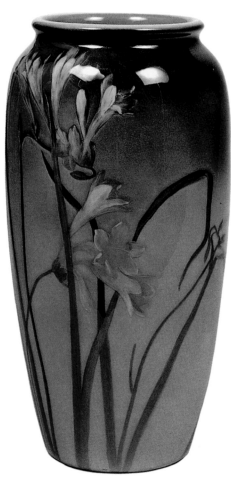

While some American potteries found success in a matter of years, others failed in just as brief a time or were taken over by other firms; only a handful lasted for more than a decade or two.

MARY LOUISE MCLAUGHLIN

The history begins in Cincinnati, Ohio, where in 1873 Mary Louise McLaughlin, a daughter of that city's foremost architect, took a popular class in china painting at the local school of design. By 1876 she was exhibiting her overglaze-decorated wares at the Centennial Exposition in Philadelphia and in 1879 she organized the Cincinnati Pottery Club (sometimes called the Women's Pottery Club). One of the local women whom she invited to join her group was Maria Longworth Nichols, who, in 1880, started her own pottery. Called Rookwood, it would become America's foremost maker of art pottery.

McLaughlin's career, which lasted only until about 1904, was neither as long nor as commercially successful as Nichols's, but her contribution to the creative atmosphere that enveloped china-mad Cincinnati cannot be overemphasized. Although her underglaze-slip wares, called "Cincinnati Limoges" because of their resemblance to the French porcelain,

were expertly executed and attractively decorated with lush floral scenes, they were ultimately less decorative and sold less well than Rookwood's later wares. In the early 1880s McLaughlin decorated some Rookwood-thrown and -fired pieces in underglaze paint, but in 1883 she became involved instead in other pursuits. In 1898, however, she returned to pottery-making, experimenting with hard-paste porcelains that she called "Losanti ware." At first, she painted decorations on these pieces and later turned to carved floriate and foliate motifs, which had pale glaze colors in the Art Nouveau vein. Although her career was far from the financial success that Nichols's was, of the two she remained the experimenter and the stalwart individual artist potter.

MARIA LONGWORTH NICHOLS

Maria Longworth Nichols (later Storer) first came into contact with pottery via Karl Langenbeck, a ceramics chemist, with whom she carried on china-painting experiments in 1871. Highly ambitious, she turned what had started out as a mere hobby into a thriving business. Soon after establishing her Rookwood Pottery, she was employing a talented group of men (who did the throwing and firing, as well as the decorating) and women (decorators, in the main) and was producing a line of handsome glazed wares.

One employee, Laura A. Fry, is credited with inventing an ingenious atomizer method for spraying colored slips onto the green, wet, clay body, achieving a smooth finish on which several colors could be laid and relief-slip design applied. Fry's technique was used for the so-called "standard"-glazed Rookwood pieces, which often featured *japoniste* floral and insect designs on green, yellow, amber, and taupe grounds.

Left: A Rookwood vase which was exhibited at the Paris Exhibition of 1900.

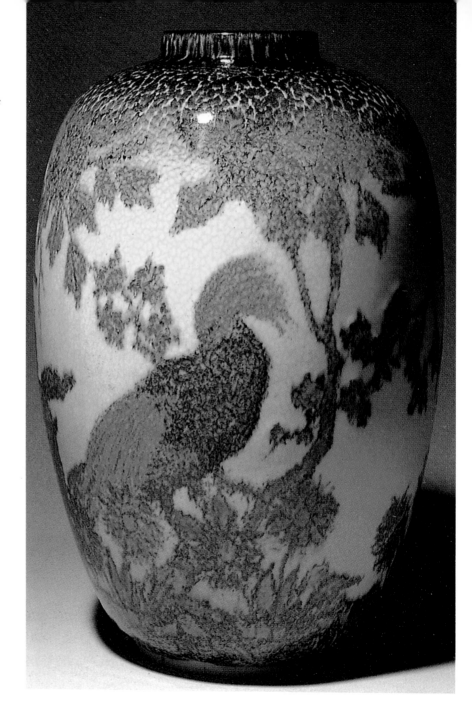

Right: Of all its wares, Rookwood's vases are among the best known; this one is decorated with a bird and foliage.

ROOKWOOD PIECES

Various other glazes and lines were introduced in subsequent years – the cool "Sea Green," the pastel-dominated "Iris," and several matte types (including "Vellum"). Besides classically shaped vessels, Rookwood produced pieces which bore a resemblance to such organic forms as gourds and lotuses. Another speciality was a flat, rectangular plaque, usually painted with a "Vellum"-glaze landscape, a hazily Impressionistic mountain scene, perhaps, or a gaey-green Tonalist river view. In addition to highly popular depictions of nature – floral sprays, landscapes, fish, birds, and even bats in flight – there were also vases painted with portraits of noble Native Americans, these for the most part by one of Rookwood's finest decorators, Matthew A. Daly, in somber tones against an amber standard glaze. Other decorators included Albert R. Valentien, Carl Schmidt, Kataro Shirayamadani, Harriet E. Wilcox, and Artus Van Briggle, who later started his own pottery in Colorado Springs.

Rookwood pieces were occasionally embellished farther with silver: a mug of 1898 was painted with brown-green hops by Sara Sax and capped with a silver collar by Reed & Barton of Taunton, Massachusetts; and an elaborate, trumpet-necked vase was overlaid with a chased-silver floral mount by Gorham Manufacturing Co. of Providence, Rhode Island. Many pieces made between 1905 and 1915 were decorated with monochromatic, earth-toned matte glazes. Stylized floral forms and Arts and Crafts motifs, such as the peacock feather, were used on these solid wares.

THE WELLER POTTERY

Other potteries sprouted in and around Cincinnati during Rookwood's heyday, including the Avon Pottery, T. J. Wheatley and Co., and the Lonhuda Pottery, opened by William A. Long in 1892 in Steubenville, Ohio, which was bought by Samuel A. Weller, who ran a commercial ceramics factory in Zanesville, Ohio. As the Weller Pottery, it became a significant force in American art pottery, as did Zanesville ("Clay City") itself. In addition to producing traditionally shaped

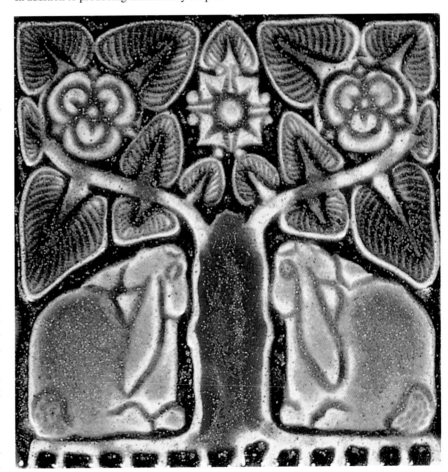

Below: A Rookwood tile, featuring a pair of rabbits flanking a tulip tree. It was made in 1911 and has a high-gloss glaze rather than the matte finish usually employed by Rookwood.

Right: A bowl by Frederick Hurton Rhead at Rhead Pottery, Santa Barbara, California, c. 1915. He used an inlaid process and an Egyptian scarab motif.

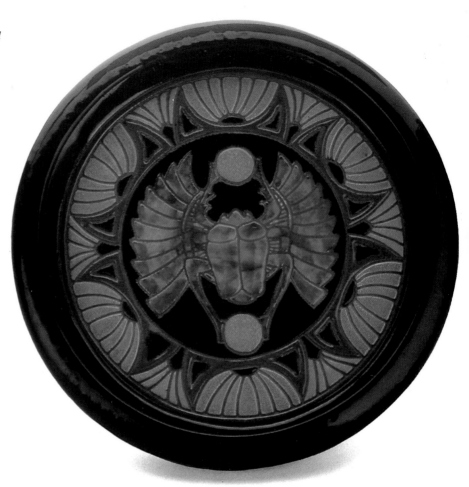

wares with painted underglaze decoration, Weller molded some of his pots with leaf and insect designs, covering the whole piece in solid green, blue, or brown matte glaze. He also hired Jacques Sicard, and the talented Frenchman's "Sicardo ware" – lovely, luster, floral designs on iridescent grounds of amber, green, and aubergine – transformed standard Weller vessels into shimmering confections.

THE ROSEVILLE POTTERY

Frederick Hurten Rhead, a British-born ceramics designer, also worked for Weller from 1902 to 1904, creating several lines characterized by stylized natural forms. Rhead's best-known undertaking, however, was the art directorship of Zanesville's Roseville Pottery, established by George F. Young in 1892. The company's first art-pottery line, known as

Left: A tile by Arthur Osborne for the Low Art Tile Works of Chelsea, Massachusetts, c. 1880. Osborne designed this long, vertical tile of a shepherd and his dog and flock using the clouded, or pooled, glaze effect characteristic of many Low tiles; it was obtained by allowing the glaze to collect in the tile's crevices.

Above: A tile by Grueby Faience Company, Boston, c. 1905. Grueby created hand-decorated tiles, like this square, featuring a vintage galleon.

"Rozane," was hand-painted on slip on a dark ground and then brightly glazed; later wares were covered with matte glazes and often featured molded floral and leaf decorations. Immensely prolific, Roseville managed to produce its popular, relatively inexpensive wares until 1954.

OTHER POTTERIES

In Ohio, other noted potteries were J. B. Owens's operation and the Mosaic Tile Company, while other Midwestern potteries included the Overbeck Pottery in Indiana and Pewabic in Detroit, Michigan. In the Chicago area, the Gates Potteries of Terra Cotta, Illinois, produced a line of green-glazed art pottery from 1900 called "Teco," which was often designed by sculptors and architects (at least one piece by Frank Lloyd Wright).

THE GRUEBY FAIENCE CO.

The Boston area was especially rich in potteries, including the Chelsea Keramic Art Works and the Chelsea Pottery, the Grueby Faience Co. being its most prominent. William H. Grueby had worked at the tile-maker J. and J. G. Low, in Chelsea, Massachusetts, before establishing his own firm in east Boston in 1894. From around 1898, the majority of his vessels and tiles were covered with distinctive glazes; they came in shades of yellow, blue, mauve, and brown, but the dark-green hue, with a mottled effect like that on a watermelon rind, was by far the best known and soon the most imitated. The thick-walled, faintly organic vessels – highlighted with molded veining and floral and foliate elements, sometimes in another color – were beautifully proportioned, simply decorated, and subtly hued masterworks. Most were designed by George P. Kendrick, thrown at a wheel, and

finally decorated by one of a number of talented women painters, including Ruth Erickson and Lillian Newman.

Grueby also manufactured architectural tiles. Mostly hand-decorated, these tiles – sometimes single, sometimes in series – bore floral, landscape, animal, and maritime motifs. In 1907 the Grueby Pottery Company was set up to produce only art pottery; in 1913, however, it was dissolved. A new firm, Grueby Faience and Tile Company, was then established, which produced tiles only. It was bought in 1919 by the C. Pardee Works of New Jersey, which moved the operation to its own tile factory in Perth Amboy, New Jersey.

THE J. AND J. G. LOW ART TILES WORKS

The J. and J. G. Low Art Tiles Works in Chelsea, founded in 1878 by a father and son both named John, produced European-style, high-gloss, solid-colored tiles, as architectural elements and also as examples of fine art. Floral-design and animal and figural reliefs dominated its output. Among the latter were handsome, bas-relief profiles and genre scenes, known as "plastic sketches," modeled by Arthur Osborne. These were produced as artistic entities and were sold in fancy metal frames. A "natural process" of tile embellishment was also developed by Low, in which tiles were ingeniously adorned with impressions of actual grasses or leaves by carefully pressing the plant forms into the clay. The Low factory closed down in the early 1900s.

THE MARBLEHEAD AND PAUL REVERE POTTERIES OF MASSACHUSETTS

In the early years of the twentieth century, two Massachusetts potteries were founded as community-minded, social endeavors. The Marblehead Pottery was established to provide

occupational therapy for "nervously worn-out patients" and Arthur E. Baggs was put in charge of the workshops. Marblehead's first products were unveiled to the public in around 1908 and displayed simple shades, subtle, matte glazes, and stylized organic, animal, and maritime motifs, sometimes painted directly onto a piece, sometimes lightly incised into it. The designs were often so conventionalized as to appear semiabstract; straightforward geometrical patterns were used as well. "Marblehead blue" was its best-known matte glaze, but gray, brown, red, yellow, and green also appeared, sometimes three or four at a time on the earthenware bodies; tin-enamel glaze was used later on. Marblehead was always a very small enterprise, even at its peak in the 1910s, when it added maiolica to its output; operations ceased in 1937.

Boston's Paul Revere Pottery was founded in around 1906 in order to teach disadvantaged girls a craft which was both enjoyable and remunerative. Under the direction of Edith Brown and Edith Guerrier, the Saturday Evening Girls' Club flourished and soon moved to larger premises in Brighton in 1915. The earthenware products it produced were colorful, matte-glazed, useful wares – breakfast bowls, pitchers, tea tiles, and nursery sets – their floral, animal, and sailing-ship designs often outlined in black.

ADELAIDE ALSOP ROBINEAU

One of the luminaries of American art pottery was Adelaide Alsop Robineau, who spent most of her adult life in Syracuse, New York. She married the French-born Samuel E. Robineau in 1899 and the pair, together with George Clark, bought the journal **China Decorator**, whose name they changed to *Keramic Studio*; under Adelaide's directorship the magazine

became a great success.

In 1903 Robineau herself began to experiment with various pottery techniques and glazes in the conventional *Beaux-Arts* style. She later became taken with Art Nouveau, however, and less traditional, more curvilinear, and highly dramatic designs began to creep into her work. She subsequently studied with Charles F. Binns at Alfred University, Alfred, New York, and was soon creating delicate, thin-walled pieces of porcelain with exquisite crystalline qualities. The Robineaus tried to

Above: A vase produced by the Paul Revere Pottery, Boston, after 1908.

Right: The "Fox and Grapes" lidded vase by Adelaide Alsop Robineau, Syracuse, New York, c. 1920. It evokes stylized, medieval aspects, as well as the curvilinear aspects of Art Nouveau.

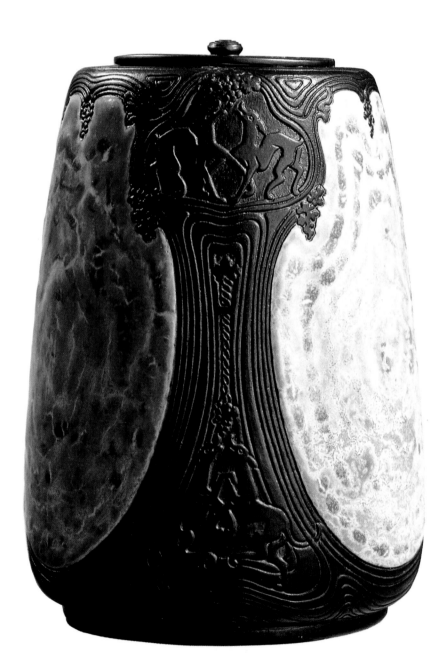

mass-produce her designs, but the fragile pieces did not translate well into large quantities. She turned her attention once again to individually crafted pieces and these one-off masterpieces, like her "Scarab" vase, sold at such exclusive outlets as Tiffany & Co. in New York and won awards at many major worldwide exhibitions. Her later works consisted less of highly decorative subjects and patterns and more of simpler, often oriental and Mayan motifs.

THE FULPER POTTERY
The Fulper Pottery had the longest life of all the American art potteries. Established in around 1815 (as the Samuel Hill Pottery) in Flemington, New Jersey, it first produced industrial drainpipes and tiles, later making domestic pottery. In 1909 the founder's grandson, William Hill Fulper, Jr., added art pottery, called "vase-kraft," to its line. With its sometimes monumental, oriental-inspired shapes, the range proved extremely popular, and its ingenious lamps, whose mushroom-shaped shades bore openwork designs filled in with stained glass, were especially admired.

Although Fulper's forms were sometimes considered too clumsy, there was no disagreement on the beauty and variety of its glazes – matte, luster, *flambé,* crystalline, spotted – which were given such fanciful names as "Leopard Skin," "Cucumber Green," and "Mission Matte."

THE SOPHIE NEWCOMB COLLEGE
In New Orleans, a pottery department was established in 1895 at the Sophie Newcomb College for Women, which developed into the source of some of America's loveliest art pottery. Its director was Elisworth Woodward, and Mary G. Shearer, a china painter who had

trained with Rookwood, was instructor of design. A true Arts and Crafts spirit imbued the group, which soon evolved from a clutch of enthusiastic amateurs working with limited equipment into an organized, quasiprofessional community of talented experts.

A distinctive Newcomb style resulted, whose guidelines were simplicity, sensibility, and individuality. A strong sense of regionalism prevailed as well, and the flora and fauna

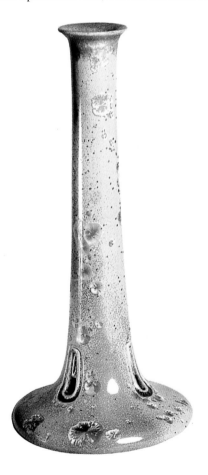

Below left: A tall, crystalline-glazed vase by Adelaide Alsop Robineau, Syracuse, New York, c. 1920. This vase recalls Robineau's earlier, thin-walled porcelain vessels, also covered with exquisite, crystalline glazes, resembling colored blossoms of frost on pale, speckled grounds.

Above: A hexagonal advertising tile by Ernest A. Batchelder, California.

Right: Vessels by the Newcomb College Pottery, New Orleans. At left is a covered pot, c. 1900–10; at right is a daffodil-and-leaf-decorated vase, dating from after 1910.

depicted on Newcomb's lovely, useful wares were indigenous to the area. There also grew up a characteristic Newcomb palette: soft blues, greens, pinks, yellows, and creams. At first the simply shaped, low-fired, bisque vessels were underglaze-painted with stylized floral motives, their outlines often previously incised. The early, glossier wares later gave way to popular, matte-glazed wares under the influence of Paul Cox. His more muted glazes led to an overall softening of the pastel colors, as well as to a less conventional decoration.

The vases of Sadie Irvine, a gifted student who later ran the pottery department, were some of Newcomb's finest. Her most famous design, a vase featuring a dreamy landscape of moss-covered oaks, a pale-yellow Moon peeping from behind the pendent moss, appeared in various permutations on many Newcomb vases.

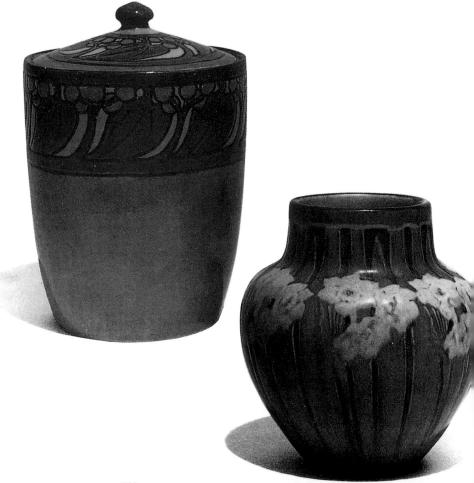

GEORGE OHR

George Ohr, who worked at Newcomb for a short time, was noted for his strangely shaped, highly experimental pots. Covered with vari-colored glazes, alone or in mottled or spotted combinations, these pieces featured such humorous elements as folded necks, crinkled ears, pinched sides, or compressed rims.

Ohr worked in Biloxi, Mississippi, the coastal site of some especially desirable clays, where he perfected a method of throwing earthenware vessels whose walls were as delicately thin as those of porcelain.

ARTUS VAN BRIGGLE

As refined and sophisticated as Ohr's pots were bizarre were the vases of Artus Van Briggle's pottery in Colorado Springs. The Ohio-born Van Briggle worked for Rookwood from around 1887 and Maria Longworth Nichols was so impressed by the paintings that he exhibited at the 1893 Chicago World's Fair that she sent him to Paris to study at the Académie Julian. There he enrolled in sculpture classes, as well as painting, and his modeling in clay stood him in good stead, not only at Rookwood but also later at his own small pottery.

Van Briggle's first wares at Colorado were produced in 1901, and their deeply sculptural qualities placed them firmly in the Art Nouveau vein. The matte glazes which he had been working to perfect at Rookwood were present as well, sometimes in two tones. Floral and human forms figured heavily on his wares, perhaps his best-known piece being the vase sometimes called "Lorelei," with the long tresses and arm of a languorous woman curving round the neck of the blue-green, matte-glazed vessel, and the rest of her robed body draping around the sides. Van Briggle

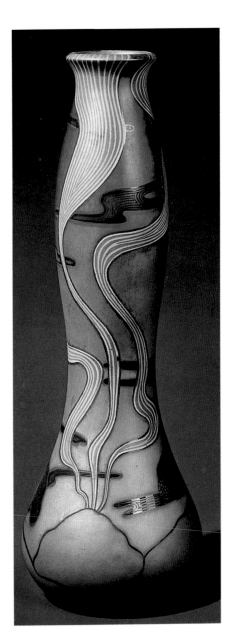

Left: A Hungarian Zsolnay vase in lustered stoneware, designed by Joszef Rippl-Ronai, c. 1890.

died in 1904, but his designs continued to be produced by his wife and they proved so popular that a new, enlarged facility was built in 1907.

ERNEST A. BATCHELDER

A creative potter who worked on the West Coast was Ernest A. Batchelder. He was a devoted admirer of the Arts and Crafts Movement, having studied at the Birmingham School of Arts and Crafts and having visited C. R. Ashbee's Guild of Handicraft. Batchelder was interested in oriental and Native American art, as well as in the medieval designs that inspired his British counterparts. After teaching at schools in Massachusetts, Missouri, and elsewhere, he set up his own craft school in 1909 in Pasadena, California.

Although he is best known for his striking, medievalizing tile designs – cast, usually monochromatic squares featuring distinctive, conventionalized plants and animals – there were also tile series carved with landscapes that included local flora. He also produced vessels such as *jardinières* bearing bestial and avian motifs, as well as florid designs of intertwining leaves or *japoniste* branches and trees.

CONTINENTAL POTTERY

Most of the pottery being made in France, Belgium, Germany, Scandinavia, and elsewhere on the European continent was in the Art Nouveau vein. More akin to Arts and Crafts was the homely, tin-glazed earthenware made the Zuidhollandsche firm at Gouda in The Netherlands, which was sold by Liberty & Co. in Britain, and ceramics by Hungary's Zsolnay Ceramic Works at Pecs, renowned for its iridescent luster glazes, especially its dark greens, blues, and reds.

In Belgium, Alfred William Finch, who was

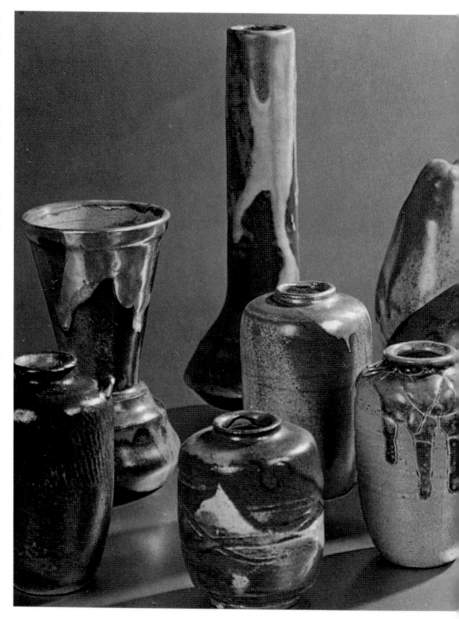

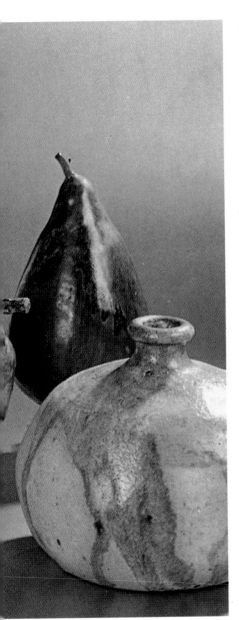

of English extraction, designed earthenware at Boch Frères's Keramis workshop. His work was sold through Henri van de Velde, the influential Belgian architect/designer who was devoted to the ideas of Ruskin and Morris. Even more directly influenced by Arts and Crafts ideals was the Wiener Werkstätte, founded in 1903 by Koloman Moser and Josef Hoffmann and modeled on C. R. Ashbee's Guild of Handicraft. Although the pottery produced by Wiener Keramik for the Werkstätte was clearly in the Modernist vein, with a preponderance of geometrical and other stylized motifs, the foundation on which the Viennese association was based was as idealistic as that of the Della Robbia Pottery.

FRENCH POTTERY

Of the French factory art potters, several directly influenced or even taught art potters in Britain and the United States, among them Jean-Charles Cazin, who worked in London from 1871, and Taxile Doat, the Sèvres potter who, in 1909, worked at the University City Pottery in St. Louis, Missouri. Auguste Delaherche, who designed for Haviland, produced pieces which relate to many examples of American art pottery. There is a relationship, too, between Clément Massier's lustered earthenware vases and bowls, produced at his atelier in Golfe-Juan – particularly in their experimental spirit – with De Morgan's pieces (a Massier employee, Jacques Sicard, was later a designer for Weller in Zanesville, Ohio).

THE INFLUENCE OF ARTS AND CRAFTS
ON POTTERY

Although the Arts and Crafts Movement did not influence continental pottery in the same way as it did in Britain and America, a number

Left: French stoneware vases and pears by Georges Hoentschel, Emile Grittel, and Henri de Vallombreuse, c. 1900.

Below: A French stoneware vase by Albert Dammouse, c. 1900.

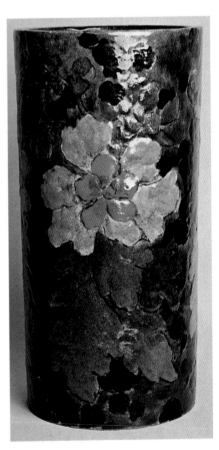

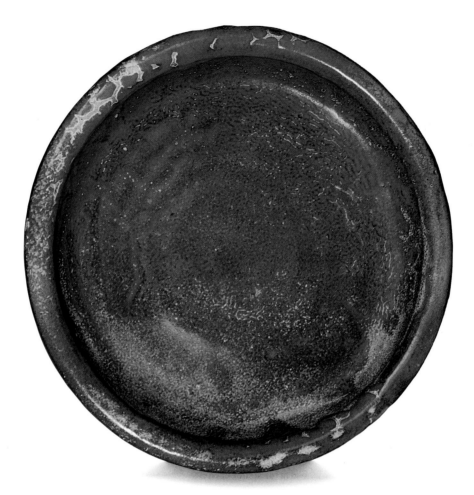

of potters worked both in Britain and America, bringing the traditions of fine continental work.

In America, the pottery scene was extraordinarily diverse, with small companies setting up and fading away and the larger companies producing work that attempted to jump on the Arts and Crafts bandwagon. American pottery covered the whole gamut of pieces, from domestic pottery through to high-art pottery, and a renaissance in the production of decorative tiles. Both in Britain and America the Arts and Crafts Movement stimulated a huge development in art pottery which may be seen as advancing the interest in craft pottery which exists today.

Above: A French stoneware dish by Ernest Chaplet, c. *1900.*

MAJOR CRAFTSMEN AND DESIGNERS

ALBERS, Josef (1888–1977)
German painter and designer who worked at the Bauhaus.

ASHBEE, Charles Robert (1863–1942)
British Arts and Crafts architect, designer, and writer. He founded the Guild of Handicraft in 1888.

BAILLIE SCOTT, Mackay Hugh (1865–1945)
British architect and designer. He worked extensively abroad.

BARNSLEY, Sidney (1865–1926)
British furniture designer and craftsman working in the Cotswolds.

BEHRENS, Peter (1868–1940)
Austrian architect and designer. Behrens had a profound influence on modern architecture.

BELL, Vanessa (1879–1961)
British Painter, muralist, and interior designer. A member of the influential Bloomsbury group, Bell was the sister of novelist Virginia Woolf.

BENSON, William Arthur Smith (1854-1924)
British architect, designer, and metalworker; he was encouraged to start his metalwork shop by William Morris.

BING, Samuel (1838–1905)
German writer and entrepreneur who opened his shop, La Maison de l'Art Nouveau, in Paris in 1895.

BRACQUEMOND, Felix-Henri (1833–1914)
French painter, etcher, and ceramicist.

BRIGGLE, Artus van (1869–1904)
American studio potter; he worked at Rockwood and subsequently set up his own pottery in Colorado.

CHAPLET, Ernest (1835–1909)
French ceramicist.

COLONNA, Edward (1862–1948)
German designer and decorative designer working in the United States and France.

CRANE, Walter (1845–1915)
British designer, painter, illustrator, and writer. A socialist, he was president of both the Art Workers' Guild and the Arts and Crafts Exhibition Society.

CZESCHKA, Carl Otto (1878–1960)
Austrian painter, architect, and designer; member of the Wiener Werkstätte.

DAUM, Auguste (1853–1909)
DAUM, Antonin (1864–1930)
French glass designers, brothers.

DAY, Lewis F. (1845–1910)
British Arts and Crafts designer and writer. A founding member of both the Art Workers' Guild and the Arts and Crafts Exhibition Society.

DECK, Theodore (1823–91)
French art potter.

DELAHERCHE, Auguste (1857–1940)
French ceramicist in the Art Nouveau style. He was associated with Samuel Bing.

DOAT, Taxile (1851–1938)
French ceramicist working at Sèvres and the University City Pottery, Missouri.

DRESSER, Christopher (1834–1904)
British industrial designer who, after achieving a doctorate in botany, turned to design for industrial production.

ENDELL, August (1871–1925)
German architect and designer.

ERP, Dirk van (1860-1933)
American Arts and Crafts metalworker.

LA FARGE, John (1835-1910)
American stained glass designer and artist.

FINCH, Alfred William (Willi) (1854–1930)
Belgian ceramicist working in Finland.

FISHER, Alexander (1864–1936)
British Arts and Crafts enameler. He
studied in France and subsequently set
up his own school in Kensington, London.

FURNESS, Frank
American architect working in Philadelphia.

GAUDÍ, Antoni (1859–1926)
Spanish Art Nouveau architect and designer.

GIMSON, Ernest (1864–1919)
British architect and designer; he set up
his own workshops in the Cotswolds
with Ernest and Sidney Barnsley and
Peter Waals.

GRANT, Duncan (1885-1978)
British painter, muralist, and designer.

GREENE, Charles Sumner (1868–1957)
American architect and designer.
He worked with his brother Henry,
showing an eclectic appreciation of Arts
and Crafts ideals.

GROPIUS, Walter (1883–1969)
German architect and designer; director of
the Bauhaus 1919-1928.

HOFFMANN, Josef (1870–1956)
Austrian architect and designer — a
founder member of the Vienna Secession,
he founded the Wiener Werkstätte in 1903.

HOLIDAY, Henry (1839–1927)
British painter and stained glass designer.

HUBBARD, Elbert (1856–1915)
The founder of an Arts and Crafts
community, the Roycrofters, in America,
where he organized workshops, lectured,
and wrote.

JENSEN, Georg (1866–1935)
Danish silver and jewelry designer.

JOUVE, Paul (1880–1973)
French designer.

KLIMT, Gustav (1862–1918)
Austrian painter and designer associated
with the Vienna Secession.

KLINT, Kaare (1888-1954)
Danish architect.

KNOX, Archibald (1864–1933)
British silver designer who was the
inspiration behind Liberty and Co.'s
"Cymric" and "Tudric" lines.

KOEHLER, Florence (1861–1944)
American Arts and Crafts jewelry designer.

LALIQUE, René (1860–1945)
French designer, trained as a goldsmith. He
opened his glassworks in 1909 and was best
known for his jewelry and glass designs.

LOOS, Adolf (1870–1933)
Austrian architect and designer and pioneer
of Modernism. More famous for his ideas
than his work, he was opposed to the
decorative Art Nouveau movement.

MACDONALD, Frances (1874–1921)
Scottish artist and designer and a member
of the Glasgow Four.

MACDONALD MACKINTOSH, Margaret
(1865–1933)
Scottish artist and designer and a member
of the Glasgow Four. Wife of Charles
Rennie Mackintosh.

MACKINTOSH, Charles Rennie
(1868–1928)
Scottish architect and designer — leading
figure of the Glasgow Four.

MACKMURDO, Arthur (1851–1942)
British Arts and Crafts architect and designer.
Founded the Century Guild in 1884.

MACNAIR, James Herbert (1868–1955)
Scottish artist and the lesser-known
member of the Glasgow Four.

MARTIN, Robert Wallace (1843–1923)
The Martin brothers (Robert, Walter,
Edwin, and Charles) began producing
stoneware at Fulham, England, moving to
Southall in 1878.

McLAUGHLIN, Mary Louise (1847–1939)
American pottery and porcelain decorator.

MORGAN, William de (1839–1917)
British ceramicist, connected with William
Morris and known for his lustreware.

MORRIS, William (1834–96)
British writer, poet, and designer. Founder
of Morris and Co. and the Kelmscott Press;
leader of the Arts and Crafts Movement.

MOSER, Koloman (1868–1918)
Austrian painter, designer, and graphic
artist involved in the founding of both the
Vienna Secession and Wiener Werkstätte.

PRUTSCHER, Otto (1880–1949)
Austrian architect, furniture designer,
jeweler, and designer. Worked at the
Wiener Werkstätte.

RIEMERSCHMID, Richard (1868–1957)
German architect, designer, and founder
member of the Deutscher Werkbund.

RIETVELD, Gerrit Thomas (1888–1964)
Dutch designer and architect; a member of
the de Stijl group.

ROBINEAU, Adelaide Alsop (1865–1929)
American ceramicist; she edited the
Keramic Studio and worked with Taxile
Doat at the University City Pottery.

ROHLFS, Charles (1853–1936)
American furniture designer and craftsman
working within the Art Nouveau idiom.

ROSSETTI, Dante Gabriel (1828–82)
British painter, poet, and leading light of
the Pre-Raphaelites. He was also involved
in the formation of Morris, Marshall,
Faulkner, and Co.

RUSKIN, John (1819–1900)
Influential British social critic, his writings
were the main inspiration for the Arts and
Crafts movement. He also championed the
Pre-Raphaelite movement.

SAARINEN, Eliel (1873–1950)
Finnish architect and designer.

SAARINEN, Eero (1910–1961)
Finnish designer working in America.

SERRURIER-BOVY, Gustave
(1858–1910)
Belgian architect and designer influenced
by Arts and Crafts Movement ideals.

SPARRE, Louis (1866–1964)
Swedish furniture designer.

STICKLEY, Gustav (1857–1942)
American writer and furniture designer. He
founded *The Craftsman* magazine in 1901,
publicizing arts and crafts ideals.

SULLIVAN, Louis (1856–1924)
American architect, the pioneer of the
modern office block, and father to the
Prairie school of architecture.

TIFFANY, Louis Comfort (1848–1933)
American designer and interior decorator.
He specialized in stained glass and art
glass as well as mosaics, jewelry, and
metalwork. Acknowledged as a genius and
innovator of the Art Nouveau style.

VELDE, Henry van de (1863–1957)
Belgian theorist and designer. He helped
found the Kunstgewerbeschule in Weimar
in 1906.

VOYSEY, Charles Annesley (1857–1941)
British Arts and Crafts architect and designer.

WEBB, Philip (1831–1915)
British architect and designer. Associated
with Morris and Co. from its foundation, he
designed many country houses.

WILSON, Henry (1864–1934)
British Arts and Crafts architect, sculptor,
and silversmith.

WRIGHT, Frank Lloyd (1867–1959)
American architect, writer, and interior
designer, pioneering an integral, structural
style of interior decoration. He was the first
major "modern" American architect.

INDEX

ACKNOWLEDGEMENTS

The material in this book previously appeared in:

Arts & Crafts Movement – Furniture and Metalwork, Arts & Crafts Movement – Textiles and Interiors, Arts & Crafts Movement – Glass and Pottery, The Art of Louis Comfort Tiffany, The Arts & Crafts Movement, William Morris

Quantum Publishing would like to thank Rod Teasdale for jacket design and Dorothy Frame for indexing.